PATAPSCO

For Joanne

With best wishes,
Ali Kahn
and
Peggy Fox

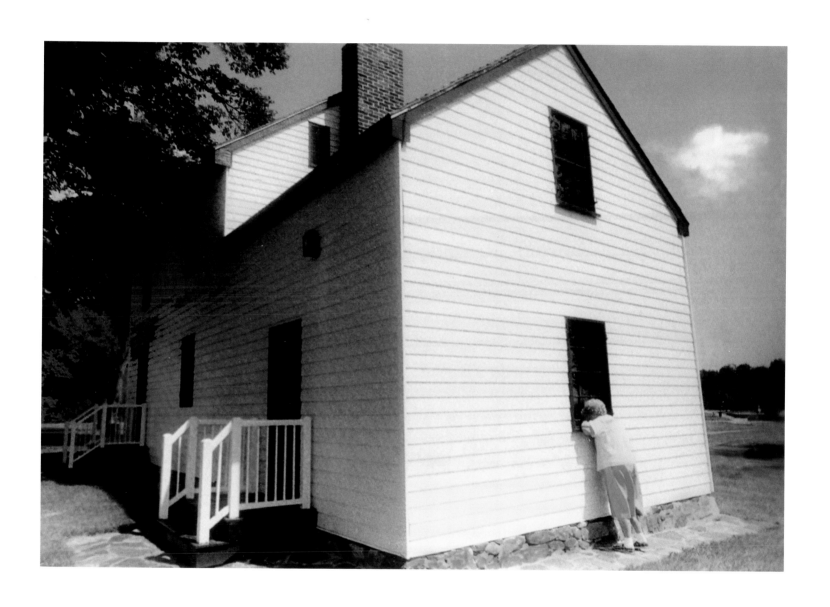

Center Books on American Places

George F. Thompson, series founder and director

PATAPSCO

Life Along Maryland's Historic River Valley

Text by **Alison Kahn**

and

Photographs by **Peggy Fox**

with an introduction by Robert Coles

THE CENTER FOR AMERICAN PLACES

at Columbia College Chicago

in association with the Maryland Historical Trust

For the people of the Patapsco

"If you would find yourself, look to the land you came from and to which you go."
STEWART L. UDALL

"How will we know it's us without our past?"
JOHN STEINBECK

"A place is a story happening many times."
KWAKIUTL

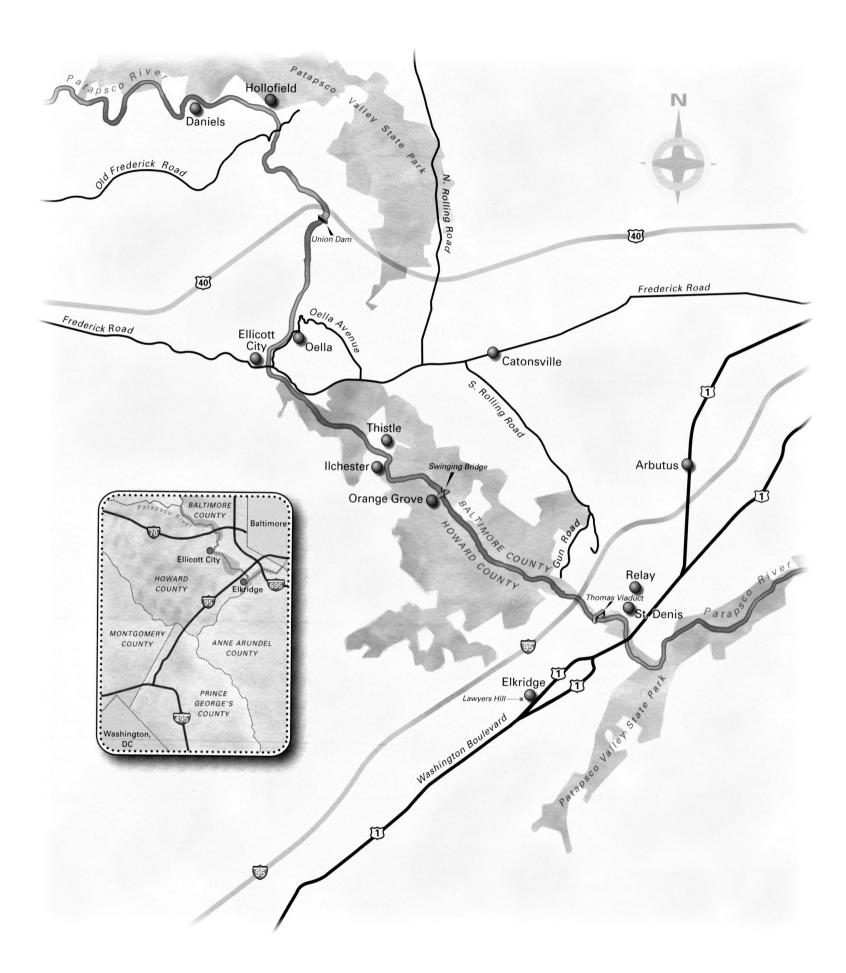

CONTENTS

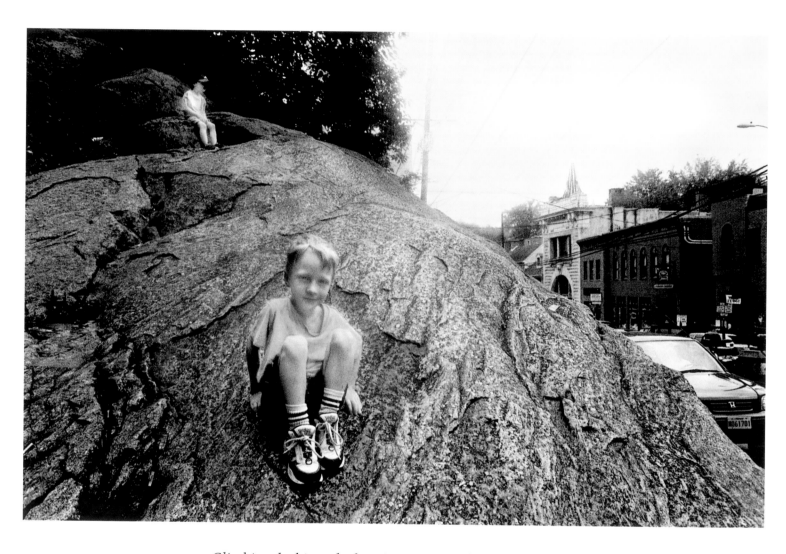

Climbing the big rock along Main Street, Ellicott City, 2003.

FOREWORD

by Robert Coles

Shortly before he died, the photographer Walker Evans took some time to ponder not only the past (his work down South with James Agee, his work in New York City) but the future of an America so strong and influential across the planet and, also, so diverse by virtue of the many regional traditions that contribute to a country's rich and lively complexity. We were sitting and going over his own work one day when abruptly he wanted to think ahead, of others who would follow in the documentary tradition as it has embraced with words and pictures the numerous American scenes that together make for a nation's continuing social history: "I worry sometimes about our country—that it will get lost," he told me. "Future Americans may study their history lessons, but will they be able to *know* the past, see things as they were, hear people talking about how it went, day by day, for themselves?"

A pause, a look outward through a nearby window, and then a few words of personal reflection, speculation:

I guess I tried to capture a few moments, a few places, a few Americans living out their lives, a minute or two of them—a click or two of the camera and a record gets built. Of course, as I hear academic people put it, there's the objective and the subjective: what's sitting out there has layers and layers to it, and what interests one person may escape the notice of someone else. I guess that's just common sense, but as Jim Agee used to say, 'There's a lot of good sense in common sense.' Then he would go on to say that people—'just plain folks,' he'd call them sometimes—can teach you tons of knowledge by what they have to say, and the way they look and do their talking, their telling of their stories.

In a sense, what follows in the pages ahead is yet another expression of the careful social observations Evans and Agee offered in *Let Us Now Praise Famous Men* (1941). Maryland's Patapsco Valley thereby has joined the lucky company of Hale County, Alabama—both places that become, in the hands of an attentive writer and an alert photographer, something quite else: social texts that keep helping us find ourselves—how we go about our ways, with what hopes, promises, interests, worries. A valley's portrait becomes an aspect of a nation's ongoing story. Two outsiders, keen to look and listen, review their days of learning, pick and choose from what they remember experiencing and putting on record through a tape recorder's "ears," a camera's "eyes"— the great challenge to these two human beings, who, in wielding their instruments, become companions, become agents of a human actuality set down for others to consider, behold, and take to heart.

Once, while sitting in the home of a Boston factory worker, trying to understand how his life goes, and too, that of his family—his wife and his five children—I suddenly heard the tables turn on me with this comment: "You keep asking about *our* opinions, what we think and what we want for ourselves, our kids. Well, we've been wondering about *you,* what you are going to do with all you've heard us say. You're looking in at us hereabouts, then you've got the picture—but, you know, if you keep on visiting people, you become part of the picture yourself. Isn't that the case?"

I lowered my head, assented first with a nod, and hastily spoke one more time of my interest in understanding his ideas about the racial tensions then besieging the fast-changing neighborhood of South Boston, which he and his family had long called home. Yes, he knew "all that"—he well remembered my earlier introductory explanations—and then gave this terse but ever-so-knowing and appropriate statement: "We get what you're trying to do—we only hope you'll do justice to us, give us a fair shake, after we're gone for you and you give us over to the people who pay attention to what you tell them." So it went: the documentarian receiving with those words a substantial (indeed, unforgettably savvy and sobering) education in how doing documentary work gets accomplished—who learns what from whom.

 So, too, for us now, as Alison Kahn and Peggy Fox, two talented observers of their fellow Americans, render for us through words and pictures a particular valley's goings-on as they transpire on the streets and within buildings, along the trodden paths of the countryside.

Perhaps two of the pictures that grace us in this book offer and encompass its overall achievement: the lady looking in a house's window (page ii) and the barefoot elderly man seated on a river's bridge (page 132), looking up, receiving the sun's warmth, seeing above and beyond, and thinking thoughts privy

to himself alone. Like those Americans, we the viewers are allowed a spell or two of our own contemplation as we connect with them, courtesy of these words and photographs. To be human is to look within ourselves and to scan the world nearby—in both cases, thereby finding a clue or two about how this world works for others and, needless to say, for us, the creatures of language, the creatures who wield gadgets and who look within by looking without.

To Alison Kahn and Peggy Fox, then, for giving us *Patapsco*, we owe gratitude for a splendid, observing effort exceedingly well done, but also for the compelling summons they tender us. Through meeting these Marylanders in their valley, we get a boost toward ourselves—our similar journey through time and space in America.

PATAPSCO

Peg and mortar detail on an outbuilding, c. 1800, Elkridge Furnace Inn, 2005.

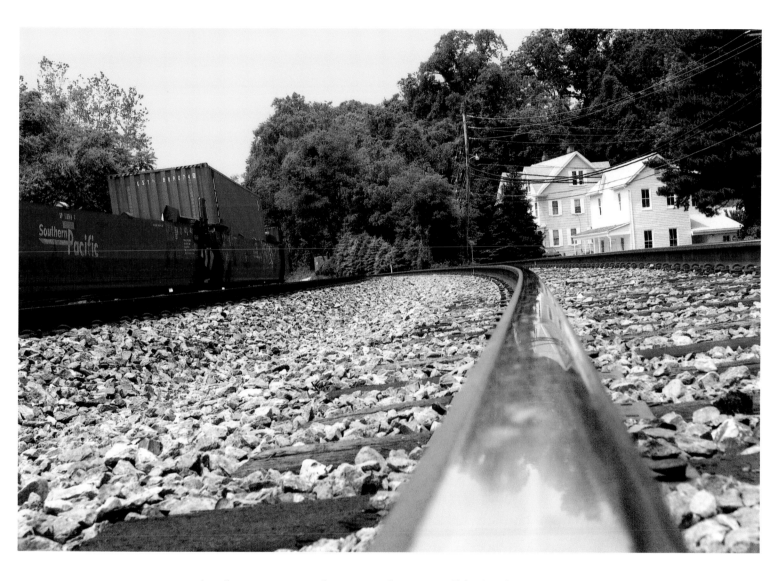

A freight train passes the 1835 Relay House (blue), a former rest stop for B & O passengers, 2004.

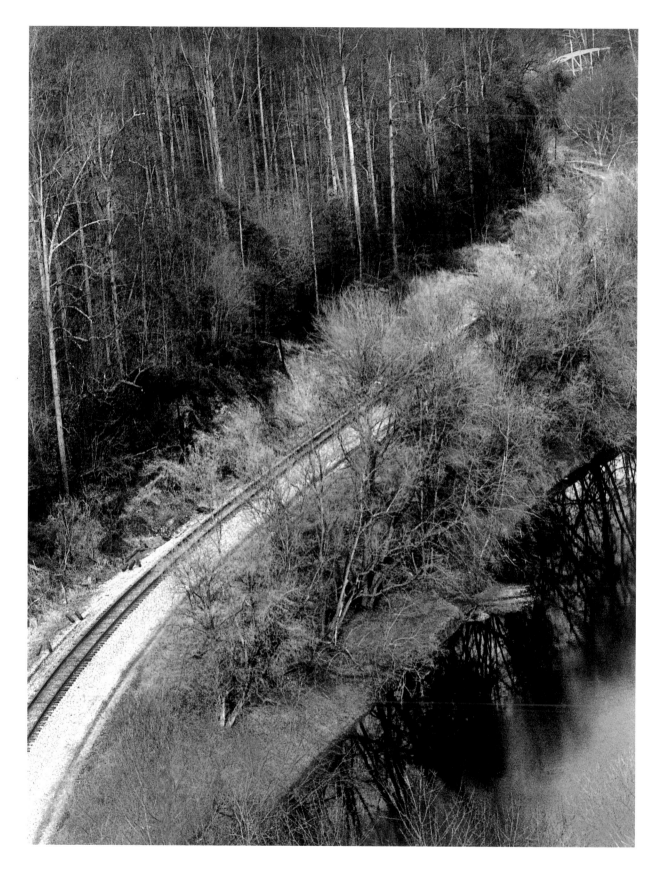

B & O tracks and bridge to Daniels, Patapsco Valley State Park, 2001.

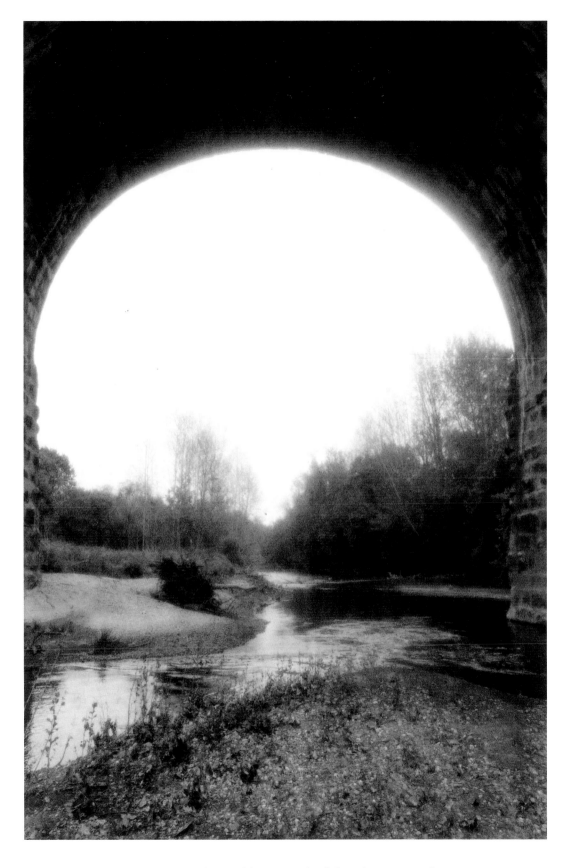

The Patapsco River framed by an arch of the Thomas Viaduct, 2001.

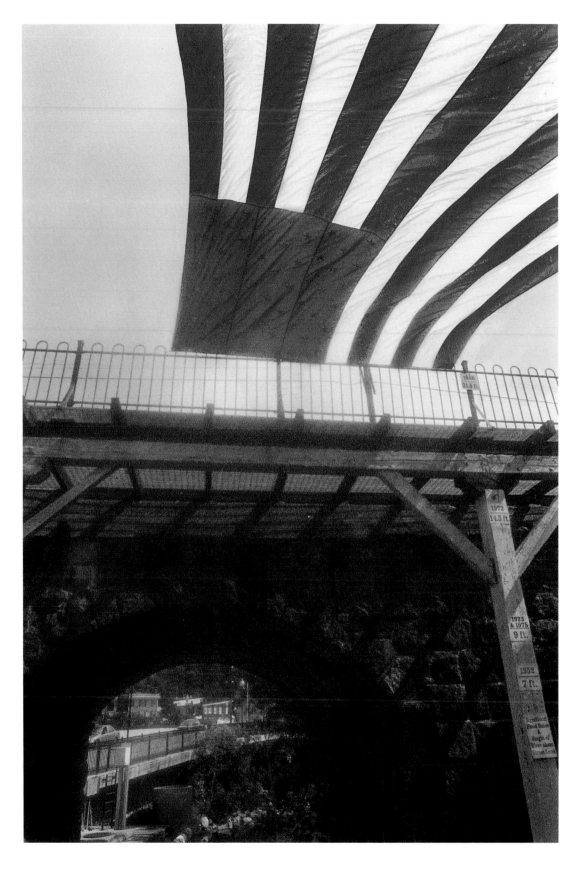

A flag unfurls from the Oliver Viaduct, the railroad bridge at lower Main Street, Ellicott City, with a view of Oella. Markers show the dates of major floods and high-water levels, 2001.

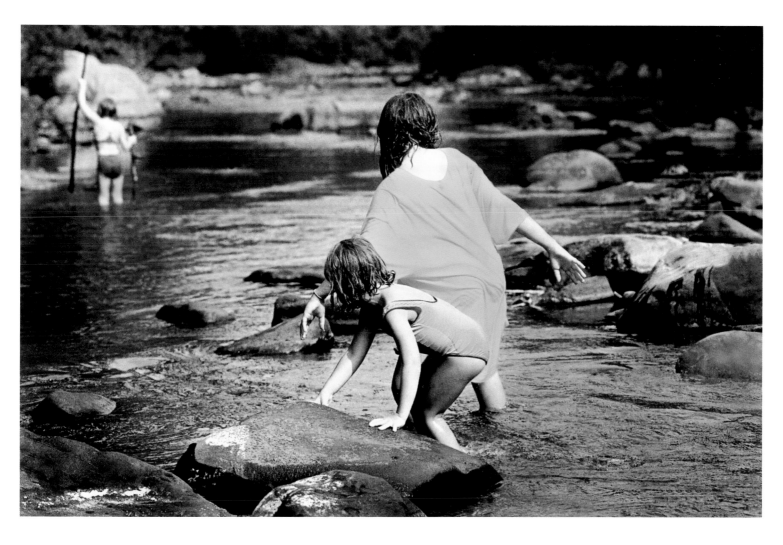

A timeless draw of rocks and river, Oella, 2005.

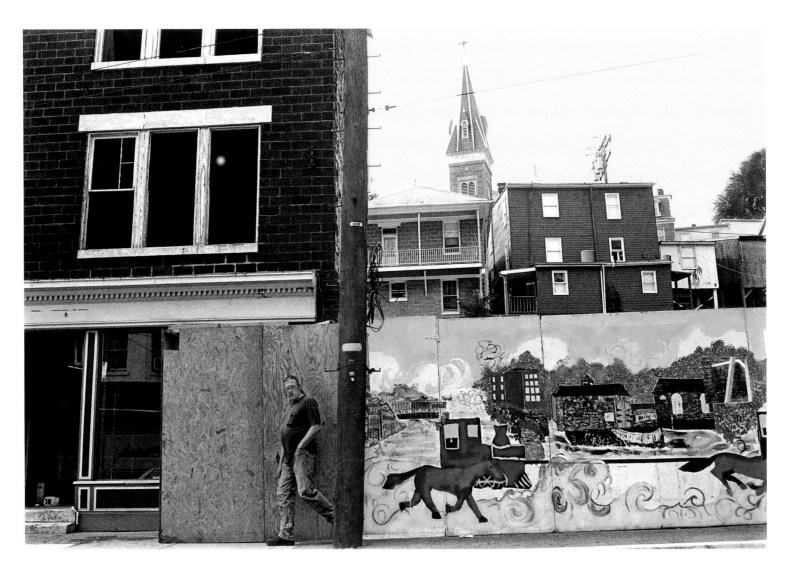

A mural brightens a fire-damaged block along Main Street, Ellicott City, 2000.

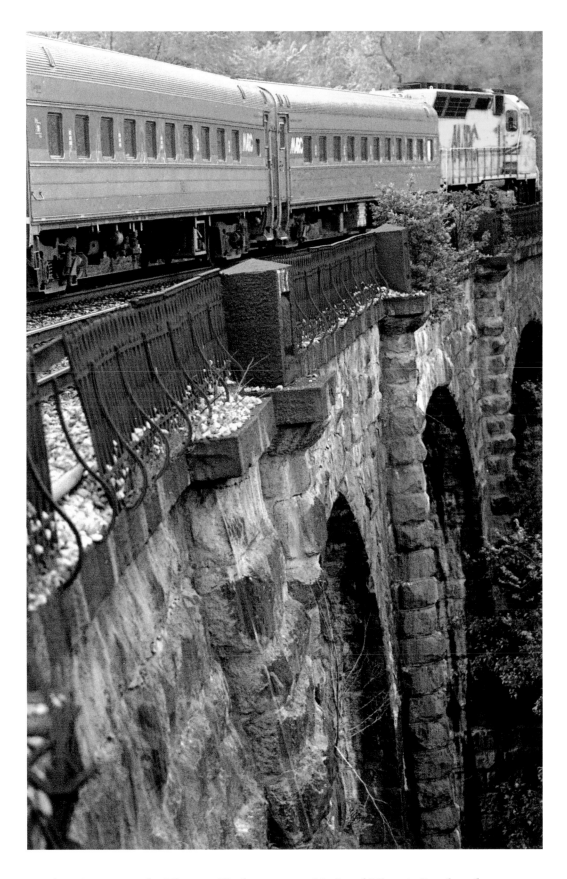

A train crosses the Thomas Viaduct, now a National Historic Landmark, 2003.

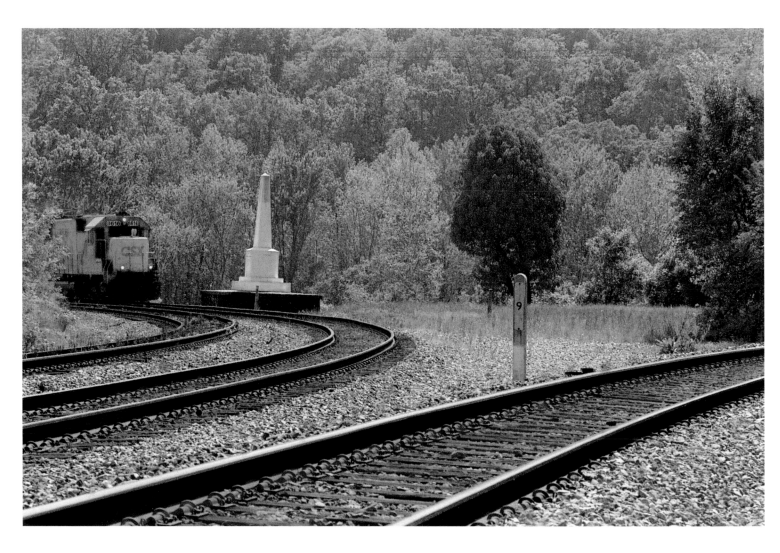

*A freight train approaches Relay, where an obelisk honors the builders of
the nearby Thomas Viaduct, 2004.*

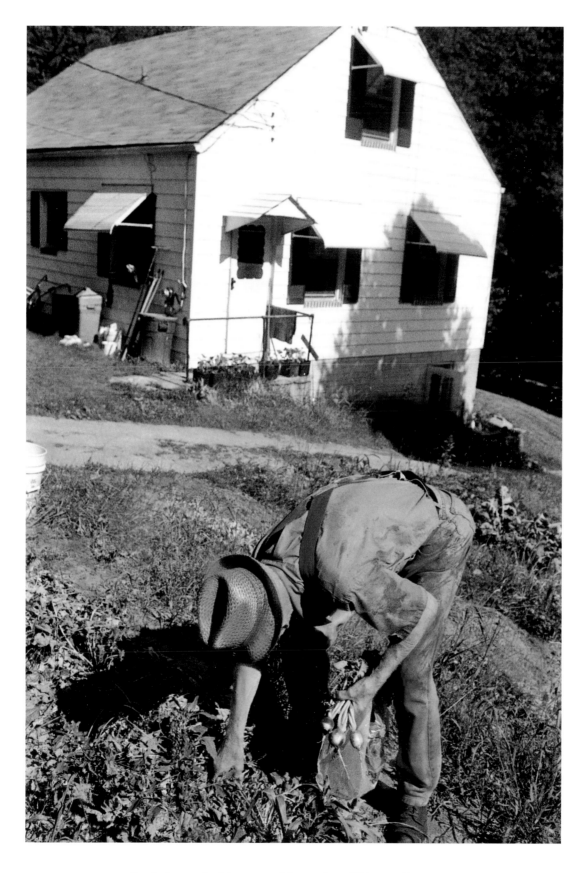

Paul Corun in his vegetable garden, Ellicott City, 1997.

View from the Hollow: the former Oella Methodist Church and Oella mill, 2003.

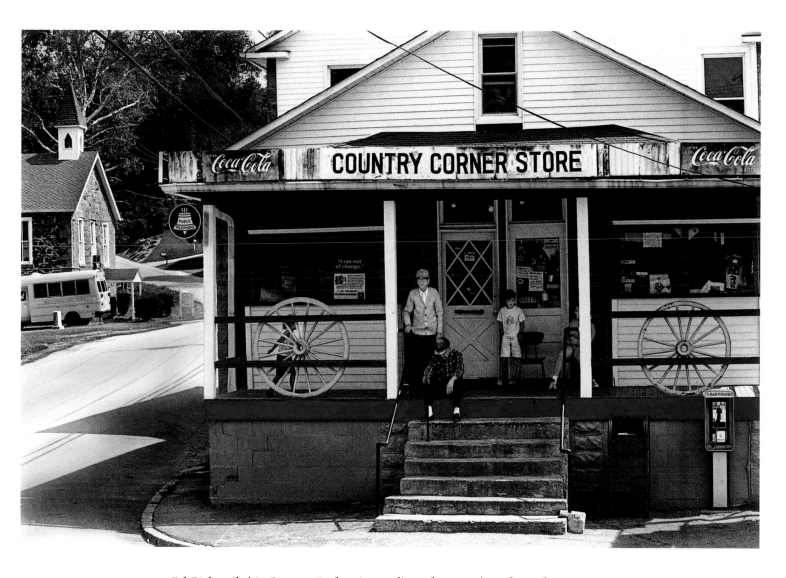

Ed Fisher (left), George Tucker (seated), and young friends at the Country Corner Store, built in 1910 for workers at the Oella mill, and Mt. Gilboa A.M.E. Church (far left), 1997.

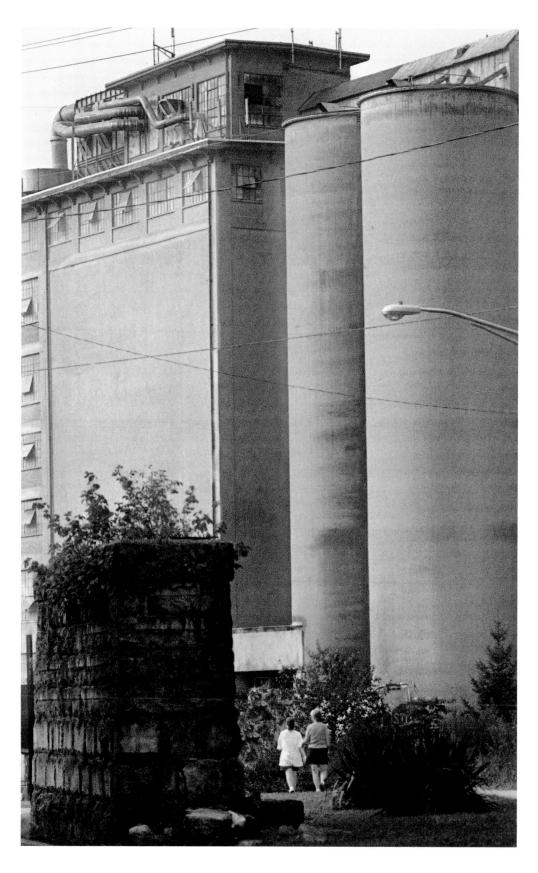

Wilkins-Rogers wheat and corn mill, previously the Doughnut Corporation of America and site of the 1772 Ellicott flour mill, 2003.

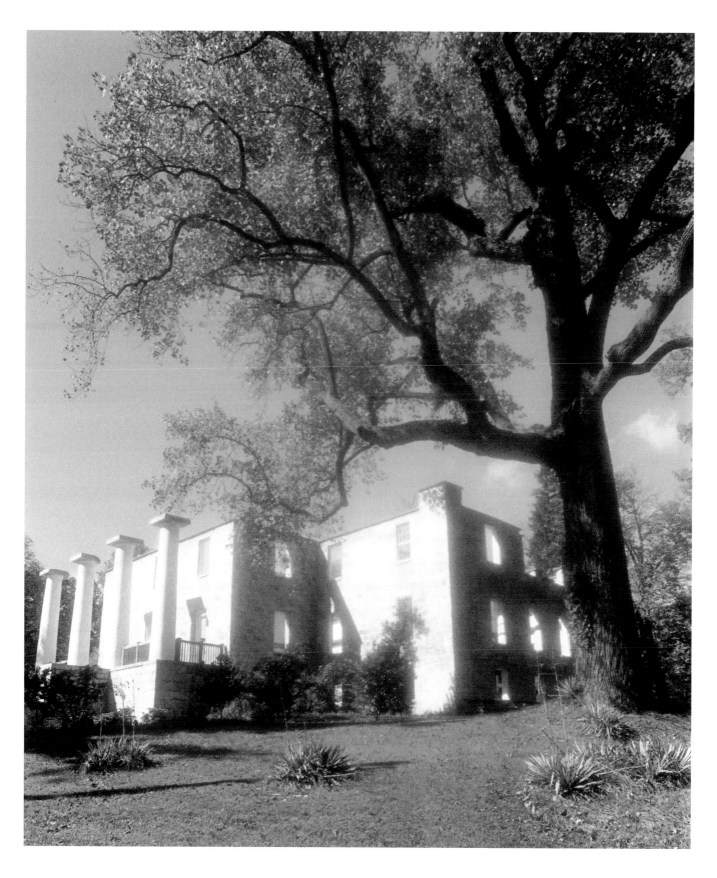

Ruins of Patapsco Female Institute (1837–1890) above Ellicott City,
now a historic park, 2001.

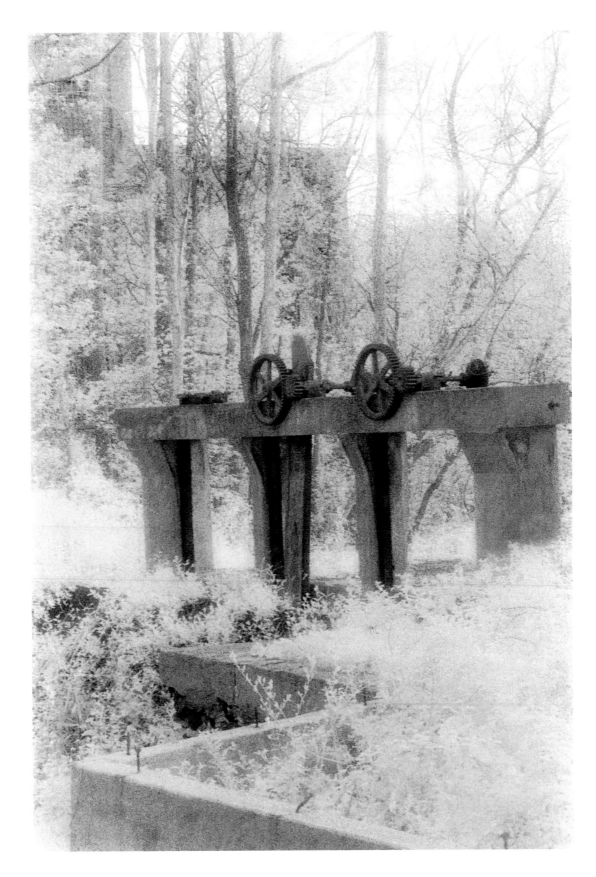

Millrace gates, Oella, 2002.

Workers' dwelling, c. 1809, and outhouse, Herring Hill, Oella, 2002.

Frame house with a crowning view of the 1843 Howard County Courthouse,
Ellicott City, 2004.

Neon window in a granite wall on Main Street, Ellicott City, 2003.

Twin Aladdin Company kit houses, c. 1912, Reservoir Hill, Oella, 1997.

Gravestones, Melville Chapel United Methodist Church, Elkridge, 2004.

Victorian filigree, Relay, 2001.

Outhouse, Oella, 2000.

Estate on Lawyers Hill, Elkridge, 2000.

INTRODUCTION

A small sign near the shoulder of the interstate between Baltimore and Washington, D.C., says Patapsco River. You can easily miss it and, for that matter, the river, too, if your mind is somewhere else. Or if you are not from here. But there it is—a sign of *place* in the peripheral view, a point of reference for both stranger and local.

Just beyond the marker, below the bridge, comes a break in the endless green and then the quick flash of mottled blue or gray, depending on the light and the sky and the season. And then the green resumes. You've moved on. The moment has passed, the river is history.

Up here on the highway, time is motion measured in miles. The world streams by, a blur of places bypassed by the fast road and suspended between journey's start and end, between past and future, places of *mind* like the Patapsco Valley, where time is measured in memory. If you happen to belong here—to Oella or Ellicott City or Elkridge or Relay, or some other town in the river valley—this is the still point, the center from which your story flows. From which flow all the stories of the people of the Patapsco.

The Patapsco Valley is a giant trough worn away by the river and each of the communities a built and bounded space that corresponds to a point on the map. The valley is also a concept, an idea of a place held in the mind. There are no road signs that point to this other Patapsco Valley. Invisible to outsiders, it lies beneath the surface, behind all that is apparent and present. It is seen only through the mind's eye of those who know it from the inside, whose identity is steeped in this place and its past.

We came here, a writer and a photographer, outsiders off the highway, searching for the place and its story in the memories and faces of its elders. These

bearers of tradition became our guides through unmapped territory, our eyes on disappeared landscapes and life ways. From the words and images gathered by interviewing and photographing these people and their place comes this portrait of the valley. It is a composite shaped by unique moments, exchanges, and sensibilities. It presents three responses to place from three points of view: the interviewer, the photographer, and the people of the valley. By interweaving these strands, the tension between outsider and insider, between present and past, comes to light.

The stretch of valley between Elkridge and Daniels claims parts of Howard and Baltimore counties, which share a natural border at the river. (County loyalties are strong here, depending on which side of the Patapsco you call home.) A swath of green and lush woods, Patapsco Valley State Park, Maryland's oldest, hugs the river for nearly thirty-five miles and sprawls more than 14,000 acres. Here at the fall line—where the cascading river drops and opens to a slow and silted-up lower course—rolling hills and rocky outcrops give way to fertile flats of sand, clay, and gravel.

It is a luxury to stop and linger in such a place, a place between here and there. That which was indistinguishable becomes distinct, particular. If you are fortunate in your explorations, you find a way inside this place. And if you are more fortunate still, you discover its stories, which can transport you—in this case, to a rural world born of river, road, and rail.

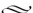

The Patapsco is an old river. More than 100 million years ago, the earth heaved and faulted, rumpling the hard underlying rock of central Maryland's piedmont. This action set in motion the long, slow birthing of a river, the confluence of countless seeps, springs, and streams that eventually would flow from the hills down to the coastal plain and into the sea, before Chesapeake Bay was born. The river's currents scoured steep-walled gorges out of the crystalline rock on the high land above the fall line, then tumbled to the sedimentary lowlands. Forest covered its banks and surrounding ridges, anchoring soils and sheltering life.

Before the valley had a history or a name, a past evolved from the land itself. Dig down through the layers of earth and rock and you plumb the geophysical memory of the place, chapter by chapter, story by ancient story. Eventually, people entered the valley, imposing time on the landscape, transforming the wilderness into a lived-in place, endowing it with meaning and narrative—with culture.

Over the centuries, they came and went. Some passed along their knowledge and their stories; others, like the Native peoples, vanished, taking their sto-

ries with them. Piscataway, Susquehannock, and others cut paths through the wilderness and invented ways of harvesting the river and the land for survival. They gave the river an Algonquian name that sounded something like *Patapsco* and the name stuck to the valley as well.

European settlers saw the river's value first as a shipping channel and then as a base for industry. They cleared fields for farms and plantations that produced the dark bounty of good soils, namely tobacco, and a labor market for slaves. When tobacco depleted the soils, farmers introduced grains, planting the seeds of an alternative cash crop, which helped undermine slavery. On the fringe of farms and towns, free African Americans claimed plots of land on which to build their own separate communities. All of these people preserved the past in layers of memories.

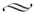

Place shapes people. The Patapsco Valley, with its particular contours and climate and resources, has colored how its people live, what they do, and how they see themselves.

Along the river's banks, a string of old mill towns marks the birthplace of industry in Maryland in the 1700s. One of the nation's earliest industrial centers, it anticipated the Industrial Revolution of the next century. Beginning in the eighteenth century, merchants came to the valley and built gristmills, paper mills, and textile mills at the river's falls and fords. They dammed and diverted the Patapsco's waters and dug millraces to drive the mill wheels. And they laid a network of rural roads, often following old Indian paths that stretched across the region, linking mills to markets.

As markets expanded and the United States pressed westward from Baltimore right through the Patapsco Valley, new and better overland routes appeared, guided in part by the river. The pioneering Baltimore National Pike ran from the port city to Cumberland by way of the mills that would spawn Ellicott City. It would later feed into America's first federally funded highway, today's historic National Road—US 40—at Cumberland, in 1808.

The gentle grade of the river through rough upcountry also set a natural course for a railroad—the nation's first—that would push through the heart of the valley. Along the tracks of the Baltimore and Ohio, rail stops, such as Relay and St. Denis, sprang up.

Over time, around the Patapsco's mills and rails, working communities grew. They rooted in place and acquired the aspect of permanence. Whether they survived or not was another matter, left to the vagaries of economy, flood, and fire.

Beyond these historic villages lie the remnants of the valley's farms—

memorials to agriculture's preeminence before the highways and strip malls and housing developments intruded and carved up the landscape. Change is the only constant here now. In these rural tracts, you can see the Patapsco's natural contours. But to know its ways and stories, you must talk to the men and women whose lives spanned the better part of the last century—and whose memories hold unrecorded details of the past.

People respond intimately to their environment. And in the process of expressing their responses, they create the customs and rituals and livelihoods that tie people to a place and to each other. Sometimes these traditions mold the image of a region or even become synonymous with it. In this way, people also shape place. Like the open land itself, its features fading, the past is vanishing with its keepers. As they go, the body of knowledge they bear goes, too.

Memory is stratified. Age blurs the top layers and clarifies the deepest. With age, we tend to view the past through a filter of nostalgia that transforms the actual into a rosy mirage—*the good old days*. Peel away the filtered memories, listen past the nostalgia, and darker stories of poverty, racism, worker exploitation, and other hardships may surface.

Memory makes mistakes. It is not a vault for the direct deposit and storage of facts; rather, it is a vital and imaginative process through which we continually make sense of our lives. It is what we *perceive* to have occurred. It is true because we believe it to be so, want or need it to be so, at the moment of remembering. As our circumstances and outlook change, so our hindsight and memories change. If we forget—and we do—it is either by choice, by repression, or simply because we cannot hold onto everything that has been.

Memory is selective. It can be summoned at will or triggered by some catalyst—a melody, a scent, a photograph. It floats to the surface, a teasing trace that drifts like smoke across our consciousness only to dissipate and vanish. It overwhelms with vividness and detail and startling immediacy. Memory primes our senses and emotions, sometimes with an aching intensity. It is ours to rifle through and replay, a sort of personal media file for private viewing.

The interview is a theater for remembering, and the oral historian is the director of the event. She elicits memories with her questions, and her intent shapes the exchange. The storyteller's recollections are entirely personal, but *what* he or she recalls, and *how* it is related, happens in response to the interviewer's questions, to the unique moment and context in which the memories are probed and evoked. They are acted on by myriad influences, from personal chemistry to the physical space, to the state of mind or body.

Oral history, then, is a collaborative and subjective process. From the ex-

change between interviewer and interviewee comes a unique record that captures their dialogue, along with the narrator's personality, cultural values, and personal past, all of which inform her voice. In concert, the voices of a community express their ties to a place and to one another, connections that can transcend common space built on shared history, experience, and tradition.

We may save an old building to preserve a physical piece of the past, but a building, no matter how aesthetically pleasing, is inanimate, silent. Only people can express the life and textures of the past. Oral history captures these details, creates a record, gives our places a voice. The process helps us to reconnect with a place and with each other. Through narrative, we are reminded of where we have been and who we are; if we listen, it can illuminate where we are going and what we may keep or lose. Oral history, too, imposes time on the landscape, enhancing our perception of place and the transitions between old and new. In the process of remembering, we discover the extraordinary in the ordinary. We discover our common humanity.

The past is as near as a memory or an afterimage. It ghosts the present like a painted-over picture that peeks through the image on a canvas, exposing the artist's earlier effort. In art this is called *pentimento*, a change of mind. The men and women in our book have, through their stories, given us a glimpse of another Patapsco landscape, a place of memory barely visible now beneath that which is present and much changed.

VALLEY PLACES

Of the Patapsco Valley's many historic places, we documented five: Oella, Ellicott City, Elkridge, Relay, and Daniels, which differs from the other four in that the village no longer exists. That the *community* has survived, however, despite dispersion and loss is a testament to the bonds of identity and tradition. It is an epilogue of sorts, an ode to a lost place—to all of the Patapsco's disappearing places.

During the course of our fieldwork, we interviewed and photographed nearly sixty men and women. Unfortunately, we could not include everyone's voice in this collection. An oral history is, by nature, an incomplete work: there is always someone else to interview, always another memory and another version that remains untold.

Those whose voices you hear represent a cross-section of the Patapsco Valley in terms of their work and education, their race and gender, their experience in and contributions to this place.⋆ Farmer and merchant, minister and teacher, policeman, firefighter, domestic, and millworker—together their recollections express the long view of the valley's cultural legacy and reveal a sense of identity rooted in the river named Patapsco.

Each black-and-white portrait is a story that distills the essence of the individual in his or her place. There is narrative in the details. Striking in their novelty, but also in their familiarity, their ordinariness, the details mimic memories.

⋆*Author's note:* The interview texts were drawn from verbatim transcriptions. While they preserve the speaker's words and cadences, they have been edited to eliminate some of the vagaries of speech for easier reading and for narrative flow. Occasionally, I inserted bracketed information for clarification.

The color photographs, on the other hand—all originally black-and-white and enhanced by the computer—reveal a bigger environmental picture and the photographer's personal and poetic response to the place, both real and imagined. With color, she evokes the pentimento image, a landscape of memory imbued with sensuality and nostalgia—with ambiguity and ambivalence. In these, she presents an unfinished story, inviting our imaginings.

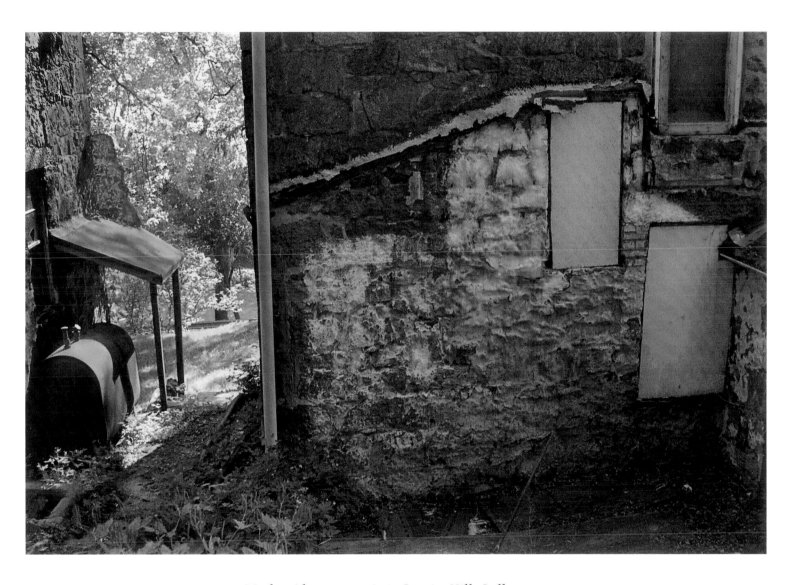

Workers' houses, c. 1808, Granite Hill, Oella, 2004.

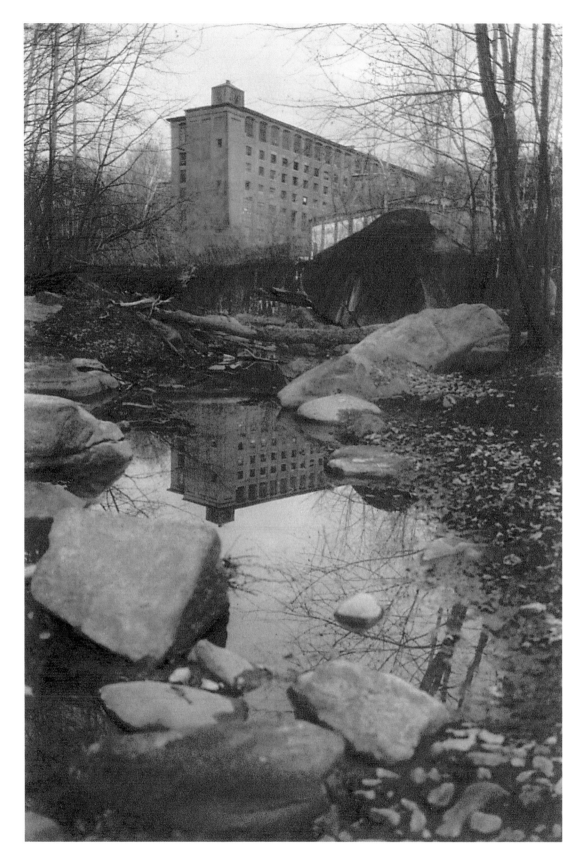

The drought-drained river mirrors the Oella mill, a remnant of the valley's industrial landscape and legacy, 2001.

OELLA

If you come from a relatively flat place, topography has a certain allure. It is the thing you notice first about Oella (after its curious name). Here the piedmont unexpectedly heaves up with such force, you might think you're in Appalachia, or maybe New England. It has something to do with the tectonics, the sheer verticality of the place.

There is more than one way to find Oella. The best route winds up from the river, past the now respectable restaurant-bar they once called the Bloody Bucket, up a steep grade past vintage mill buildings in mid-facelift. The road narrows to a single lane at a deep bend where the woods and the rock and the old walls press so close you can smell the past. When you reemerge seconds later into the light and the road gradually opens and uncoils for a quick stretch, you are there.

The village, a hodgepodge of old and new, clings like a barnacle colony to the rocks above the Patapsco. Hewn of the same tough stuff as the land, it has weathered storms and bust and change and still it survives—nearly two centuries after Maryland's first chartered textile mill, Union Manufacturing Company, opened for business at this bend in the river. The mill spawned a company town that came to be called Oella, after the first American woman to spin cotton. For a brief time the nation's largest cotton works, the mill was sold at auction in 1887 to William J. Dickey, who turned it into the largest woolen mill in the South.

In the 1960s, fashion embraced double knits, leaving wool on the outs. Today, the industry is gone, its machinery silenced by progress and changing markets. But the massive brick edifice of the W. J. Dickey and Sons mill still anchors the village. The millworkers' homes, many of which predate the Civil

War, still punctuate Oella's heart. Neat lines of red-brick row houses hug the road. Stone and clapboard cottages outcrop from ledges overlooking the gorge and peek through the trees. A testament to Maryland's industrial revolution, Oella today is a preserve that remains imperfectly whole, despite the recent sweep of gentrification.

Up the hill above the mill, the old country store still stands at the crossroads near the edge of town where the streetcar used to run. And where Oella's African Americans, among them Benjamin Banneker, have lived on what began as a ten-acre bequest to freed slaves in the mid-1700s. Across from the store and rebuilt in granite, Mt. Gilboa A.M.E. Church, where generations have worshiped, is still here, too, at the heart of a village once called Africa.

Old roads carve around Oella's rock. Their rollercoaster turns and abrupt angles betray paths surveyed centuries earlier for horse and foot traffic, for a more circumscribed life. Today these paths have been paved over for vehicles built for speed and distance. The nineteenth century left its footprints here in these foundations and footpaths, and in Oella's secret places—Pleasant Hill and Granite Hill, Herring Hill and Brick Row, Log Town and the Dutch Hotel and the Hollow. The old walls are being restored, having been spared from the floods that decimated lower-lying neighbor towns and rescued from condemnation after the mill shut down in 1972. These walls live and breathe, sheltering Oella's new wave and the last of the old.

Along with the dramatic setting, it is the small-town feel and the flavor of the past, generously garnished with modern amenities, that draw the new folks, many of them commuters to Baltimore or Washington, D.C., or urban refugees looking to exit the fast lane. They talk about finding community here.

The oldtimers, on the other hand, speak of change and loss, of the *old* Oella when everyone was united in poverty and prayer and purpose. When everyone had an outhouse in their backyard. And when everyone knew your name and you knew theirs. *Now it's all strangers,* they'll tell you, *everything's different.* But they, too, enjoy amenities that came in with the *new* Oella. The place was wired for cable even before it was hooked up to city water and sewerage in 1984, finally replacing the notorious privies that are still strewn about yards and woods. These privies, once the butt of Oella jokes, are now, for the oldtimers, icons of the place, symbols that authenticate the old life—indeed their own lives—as only they themselves can know and tell.

It is the delicate tension between new and old that keeps Oella in balance—for now. The past is underfoot and interlaced with the present. Cutaways expose the accumulated strata of decades upon decades: Along the roadside, remnant mossy stone walls shore up new foundations. Brambly banks camouflage the remains of antique technologies—a half-sunken pumphouse here,

a stone-lined culvert there. Bold new constructions, wrapped in Tyvek like Christo creations, contrast with rustic originals. And shabby chic replaces the just plain shabby.

Meanwhile, day after day, the old men, black and white, still convene for coffee and company up at Jay's Country Corner Store to confab about the state of the world and the nature of things. And to hear them, you can believe that everything will be all right.

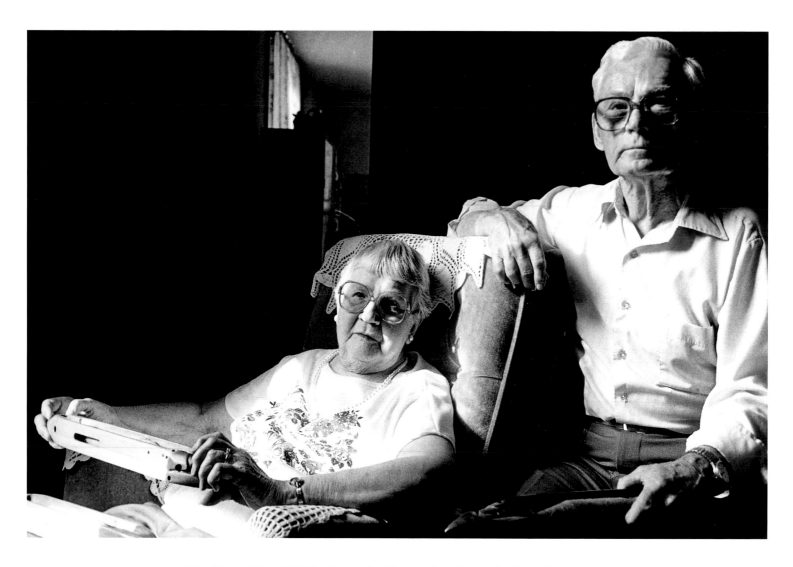

Neighbors Hazel Wallenhorst, holding a shuttle, and Ed Godfrey, 1997.

Margaret "Hazel" Wallenhorst
(b. September 23, 1912)
Edward "Ed" Godfrey
(b. February 2, 1915)

Millworkers at W. J. Dickey and Sons

HAZEL: We lived here when the first mill burnt down. I remember that vividly—I was only four. My father came in the house and he told my mother, "Pack some suitcases," he said, "it's bad." And there was snow on the roofs of the houses—because my father had taken my two sisters and I sled riding. Them days you could sled ride in the road, you know, we had no cars in Oella. My father, he went down to see how bad things were, and old Mr. Dickey that owned the whole village and the town, he stood and cried. And my father said, "Don't worry about the mill. Let it go and save the houses for the people." The whole town would have gone if we hadn't had snow on the roofs. They said the sparks flew for miles. And so the mill burnt down. They always said they thought it was deliberate that the mill was set on fire. This was back in 1918 or '20.

❧

HAZEL: I went to work when I was fifteen in the rebuilt mill. We worked ten hours a day, five days a week—and five and a half hours on a Saturday. And I made nineteen cents a hour. You were supposed to be sixteen, but they let a couple of us sneak in and, when they came around to check (the people that checked how old people were that worked places like that), we hid in the washroom. When we knew they were coming, a couple of the girls and I, we'd hide in the washroom 'til they'd say, "Okay, they're gone," and then we'd come out and go to work.

Well, if you know anything about a mill, the yarn is started out from scratch, and then it goes to what they call the carding room and the spinning room. What I did was what they call "drawing in." The big warps were made, and then the design was supposed to be a certain way. They had a pattern that you had to draw it in that way and I hand-drawed for years. And then you what they call "reeded" it in. Then it went to the weaving. There are shuttles that would go back and forth, see, with the pattern and the colors. They made woolen cloth for suits and all. My father was a weaver for umpteen years, that's what he done.

❧

ED: The Dickey mill made "navy blue," which was wool cloth for navy uniforms, and it was very closely woven cloth. It had to be woven so tight that the reed was banging against the cloth all the time, and it was rough stuff to work with. Sometimes it would make fifteen or twenty picks and another end would break, and the loom would never run for very long. They got

down to the point where you couldn't even keep two looms going. As soon as you got one fixed and running again, the other one would stop, and just back and forth and back and forth all the time. It just had to beat so hard in order to get the wool packed in there to make it windproof.

Early on, the mill didn't run a full year. There were three or four months that they simply didn't have the orders, so you had to find work elsewhere. So what you would do, we would pull the door to (you didn't bother to lock the door at all) and you went to Philadelphia and found work there. And then when the mill picked up again, you'd come back from Philadelphia, you'd open the door again, and start living in the house and working in the mill. And this was it.

ED: Oella had a band—and it was a good band, too. We had a Mr. Frye was the bandmaster and he was basically an uneducated man, but he was a great musician. We were always in the fireman's carnival parade in Ellicott City every year. And after the song became popular, the only cotton-picking thing we played was "Roll Out the Barrel"—all the way up and down Ellicott City. We'd start at the top of Main Street where the streetcar turned around, and down through Elli-cott City, and up New Cut Road to the school ground where they had the carnival—and playing "Roll Out the Barrel" all the way up. I never got so tired of playing anything in all my life!

HAZEL: They had this place in Ellicott City where you could go in and buy ice cream sodas. Before my husband and I were married, we'd go down there at night. He would get a bottle of beer for ten cents, and he smoked so he'd get a pack of Wings, I think they were called. And I could get a Coke for a nickel, so we'd spend twenty-five cents an evening. We went together, him and I, almost three years because we didn't have the money to get married.

He was Catholic and I'm Protestant—well, half-assed, you know. So when we got married, them days they wouldn't marry you in the Catholic church, they would marry you in the rectory. Old Father Ryan, he almost married me to my brother-in-law, Carter. Got the names mixed up!

I wasn't paying too much attention to the ceremony. The priest had a canary that he let it fly in the rectory and I was afraid that that bird was gonna shit on my new hat. You know, in them days, well, you didn't go in the Catholic church without a hat.

The steeple of Oella Methodist Church, 1998.

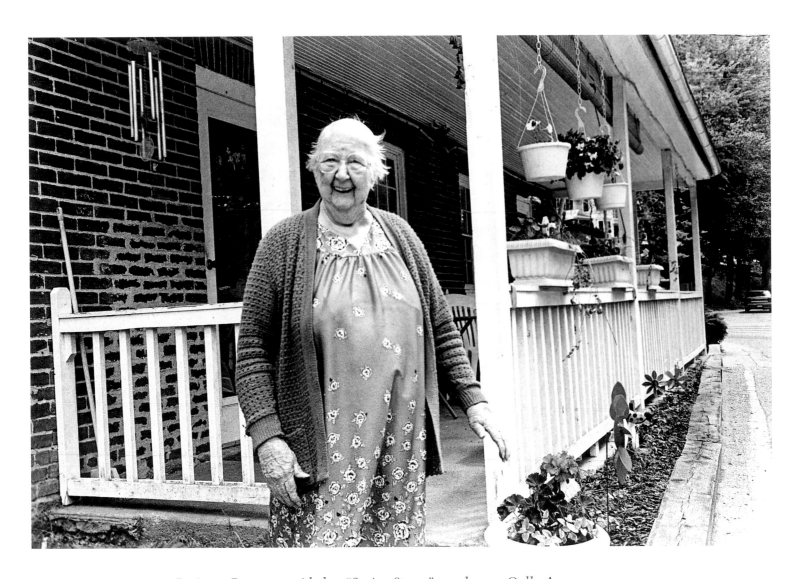

Patience Easton outside her "Spring Street" row house, Oella Avenue, 1997.

Patience Easton

(b. September 7, 1910)

Millworker at W. J. Dickey and Sons

They had a whistle up there they used to blow about five-thirty in the morning, then about six o'clock. And then when they had the lunch hour, they'd blow it at twelve-thirty, and then at one o'clock when you went back to work.

But they blew that whistle when the mill burnt down. They blew that whistle for about an hour or more because it woke everybody up. Well, my father was always the last one upstairs 'cause he always brought the lamp up, and he had just got in bed when the whistle went off and blowed. So that's when the fire started. Well, I looked out the window and saw that one end of the mill was on fire, where the elevator was at that time. It was grim looking.

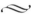

When I first went to work, we worked ten hours a day. And then they cut it down to three eight-hour shifts. But then you got a ten-minute break in the morning and one in the afternoon—well, you got one in the morning or you take it for your lunch hour. We had half an hour for lunch. But when I first started work, we had a whole hour for lunch, 'cause I used to come home for my lunch. They changed when they put the eight-hour shifts on. They just worked you through eight-hour shifts—from six to two, two to ten, and ten to six.

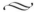

We had electricity before the war. They had a [river] branch come down on the side of the hill up here, and they built a dam up there and we used to get our water. Well, half the time we didn't have any water 'cause we had to get it from the spring. After it rained, you turned the spigot on, you'd get worms and bugs and all come out of your spigot and everything. You couldn't cook with it or drink it or anything. We would take a bath in it, you know, if it wasn't too many bugs and all in it.

Mama used to have a big tub and we'd all get in the tub on Saturday night in the kitchen. I remember getting in that tub. She'd close the kitchen door and we'd all, just one at a time, get in there and she'd give us all a bath on Saturday nights.

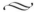

After the old school was shut down, they had a clinic up there for babies, 'cause that's where I took my baby in. He got the whooping cough from up there. One woman had two boys that had the whooping cough and she brought them down there. And one girl took

my baby around everywhere, so he caught whooping cough and then he got bronchial pneumonia with it, so he was only about two months old when he died. Well, that's been some sixty years ago.

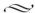

Everybody that comes from the flatlands calls these mountains. We call them hills, but they call them mountains. If we get all our flowers and all in, it's beautiful around here. My son's gonna put me some flowers and all out there. He asked me what kind I wanted. I'm just gonna put me some impatiens. I got me two hand baskets out there, so I'm gonna put some petunias in those and hang them up, and then I got two jardiniers out there, two big clay pots. I'm gonna put some geraniums in those and plant them. And the boxes along my fence, there'll be geraniums and a golden vine. It gets so daggone long, I have to cut it off every once in a while.

Boys in a tree, Short Brick Row, 1997.

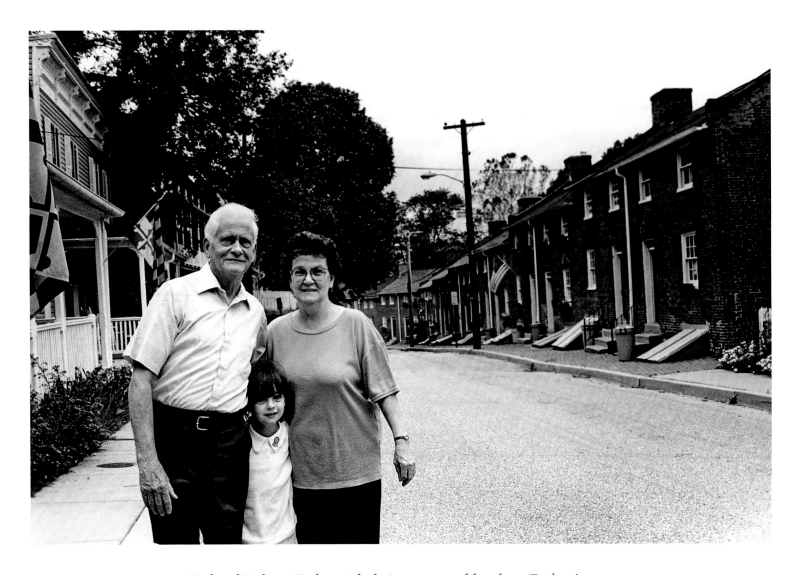

Carl and Dolores Taylor, with their great-granddaughter, Taylor Amoss,
Oella Avenue, 1998. To the right is Long Brick Row, Oella's architectural
signature, c. 1830–40.

Carl Taylor

(b. March 28, 1927)

Dolores Taylor

(b. December 1, 1931)

Millworkers at W. J. Dickey and Sons

DOLORES: I met Carl one Halloween night around a fire. It was a bunch of us girls there and a carload of boys rode by. They stopped and we sat around the fire and had fun and carried on, you know. We went together off and on for five years, and he come out of the service and we got married. So our children were born here—not in this house, they were born on Stone Row.

I worked in the mill. He worked one shift and I worked another. And we had three children at that time, from '51 to '55, I had three babies. Yeah, I worked six to two mostly, 'cause he'd go in two to ten or ten to six. We lived right across from the mill so you didn't have to leave your children. You could see them.

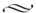

CARL: Oh, when you first went to Oella—from the looms in the weaving room slapping together, you thought you'd never sleep again. You could hear it clean over in your house. But you got used to it, I mean, you never even noticed it after four or five weeks. It just blended right in with the noise.

I started in the carding room, filling boxes. A lot of people don't know what a carding machine is, but you put the raw wool in a box and it tears it up and cards it out, and that goes to the spinning room to be spun into thread. Well, it really got hot, 'cause you couldn't open the windows and they didn't have no air-conditioning. Had a humidifier unit, kept the dust down—or the lint. 'Bout everyone chewed tobacco in the carding room on account of the lint flying through the air, you know? That kept it out of your throat. I still chew.

DOLORES: Catonsville didn't like us because we had outhouses and pumped water. Our kids weren't prepared for the hassle at school, you know, the different attitudes that the kids had. I guess it was kinda rough, you know. They didn't have outhouses over there, but we did. But they weren't a bit cleaner or anything else than we were.

Carl and I've spent our whole life in Oella. They'll probably carry us out the door when we leave. I don't see anything wrong with the way my kids were raised. We took the best care of them that we could. They never done without nothing to eat, clothes, or anything else. Carl and I like it, we wouldn't go anywhere else. See now, it's Carl and I, it's our children, our grandchildren's close by, and our great-grandchildren. My mother lived up off [Route] 108 and she just passed away, so it was five generation of us—there's four now.

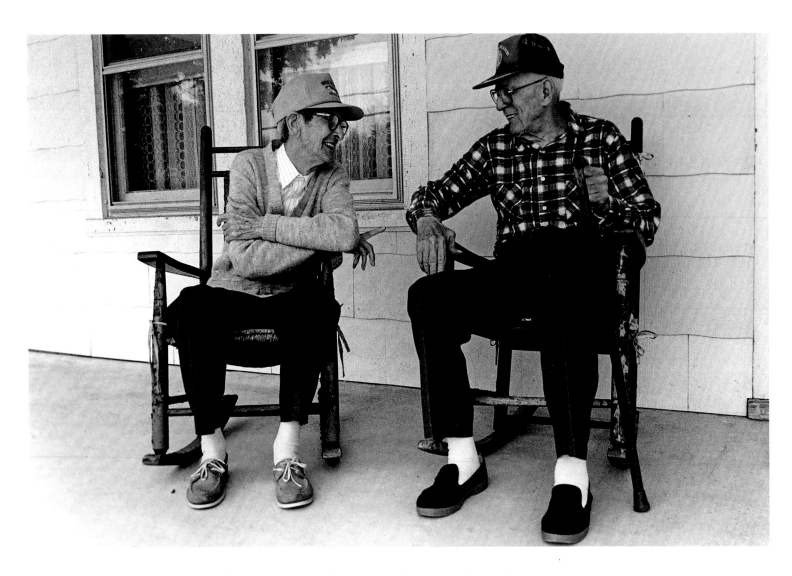

Ed Fisher (left) on his porch with George Tucker (right), 1998.

Edwin "Ed" Fisher

(b. March 22, 1908)

George Tucker

(b. October 4, 1911)

Millworkers at W. J. Dickey and Sons

ED: When I moved up here and we had a bathroom in there, a shower and everything, I didn't know how to act.

GEORGE: Well you see, you didn't have running water there in the mill housing.

ED: No, you had to carry the water from the pump.

GEORGE: You didn't have bathrooms in the house there.

ED: You had a big basin, take it up in your bedroom and set it on your cedar chest, take a sponge bath. I moved up here, good God, I took a bath every day. My daughter Sylvia'd say, "What's Dad doing?" And they'd say, "Upstairs taking a bath." "Holy smokes," she'd say. "He took one bath down there a week, now he takes one every day!" And good golly, instead of going to a outhouse now, you get a bathroom in there, you set in there and you're warm.

And if two or three people was drawing water ahead of you, you could hardly get any water. It came from a spring over on the other side and it wasn't enough pressure to make it come all the way through. If two people were drawing water ahead of you, you'd only get a trickle.

GEORGE: I worked at the mill, worked nighttime, and in the mornings in the summertime specially, we would go up the [mill] race and take a bath before we went home. And we didn't have no bathing suits or nothing. We just went up there when we got off work—six o'clock in the morning—go up there and take a bath before we went home. We kept soap and all up there at the head gates. You know where the bridge goes over the river at [US] Route 40? That's where the head gates were, and we would jump in the race up there and we'd be down in nothing flat 'cause the race was so swift.

But above that was called Long Green. Now they used to pack their lunches, the families that lived in Oella, and go up there in the summertime—the best swimming you could ever have, it was actually sandy bottoms. It was better than [Chesapeake] Bay shore.

ED: We used to catch suckers under the rocks with our hands. And down there at Hartman's Rock—I never will forget—Bud Rich and I was there. And I had an awful time. I thought, *well, I got you now.* And I felt something go around my arm. I said, *whooo!,* and I threw it and almost hit Bud—and he run across the

river with his new clothes and everything on. And I never caught any more fish with my hands.

GEORGE: Oh, we'd catch frogs, too.

ED: Mr. Tipton and I, we had a granite sack with a drawstring in it and a flashlight. You hear a old frog croaking, you hold that light in his face and grab him and put him down in that bag. One night, Bill Petticord was along, and we only had one flashlight, one of them burn out. And Mr. Tipton says, "Look at that snake!"—it was a *eel*. And Bill took off up to the race bank and we were down there, didn't have no light or nothing. So finally he came back, but hey, we got a granite sack half full of frogs. We put them in a tub with just a little bit of water, and put a screen over them with a cinderblock on them, and they croaked all night.

And then the next night—we didn't get off from work 'til quarter after five—I was the killer and Mr. Tipton skun them. I'd get one and hold him by the legs, and I had a piece of broom handle about that big—whacked him on the head, his tongue would come out, and he'd skin him. And my wife Edna got so mad.

One time, Mr. Tipton had just come from the hospital with blood poisoning in that arm—and Edna and I used to take a walk every Sunday up the race bank. And we had been up to the head gates and there was a little animal down there on the race bank, and Mr. Tipton says, "What is that, Ed?" I said, "I don't know." He said, "Run down there and see."

I didn't know what the hell it was. I looked at it, and I kicked it, and kicked it in the race. Comes swimming back out and—"Oh," he says, "that's a young groundhog. Get him by the tail and turn him over." I grabbed him, he said, "Now hold your foot on his chin, now take this knife and *stick* him." And I stuck him like you would a pig, you know, and I held him a couple while and finally he went limp. He said, "Now I'll show you how to clean him." And Mrs. Tipton looked, she says, "You clean that thing and I'll leave home before I cook it."

So he showed me how to clean it and everything, and opened it and cut it up, put it in saltwater, drawed the blood and everything out, and we parboiled it and made a pot pie out of it. And Mrs. Tipton said she wasn't gonna do it, she'd leave home first, but when she ate some of it, she was glad she fixed it. It was delicious, just as good and tender—it was only a little groundhog. Man, it was good. But them frogs is what's delicious. But you got to eat them when they're hot or they turn raw again—same with eel.

ED: My father was working the night the mill burned down. It started in the elevator shaft and it was just like a draft, it just went right straight through. The windowpanes in the house that we lived in in Shop Row melted out in the back and they carried all of our furniture out and laid it on that bank in front. And the sparks did more than what if they were left in the house. Them sparks flew to Catonsville. And they think them two Germans in the end house did it, but one of them got away from here real fast, soon as the mill burned down, and one stayed.

When the new mill was ready to go into operation, Dickey wrote everybody, every employee, letters to come back to work. He even paid someone to move people back here. People had moved away to Winchester and Chambersburg and Shippensburg. Let me tell you, they took care of their employees. I'll tell you, they were mighty fine people to work for.

ED: Before they had a bookkeeper in the company store, you could go in the office if you needed five dollars and get five dollars, and they'd take it out of your pay. But you could only spend it at their store. They had you indebted to the company.

Well now, if you took the Dickey coins to the store and you bought sixty cents worth of stuff, then they'd give you forty cents in these coins back. They wouldn't give you good money. After they got a bookkeeper, then

they kept books and you got stuff on credit, and they'd take it out of your pay each week. Now if you knew somebody was going to the store, you could give them the coins and get them to give you real money for it. That's the only way you could do that.

GEORGE: When my wife worked at the store, Harry Dickey came up there, said, "Catherine, get all the books and all of the papers and take them downstairs and destroy them. We're no longer gonna…"

ED: Run the store.

GEORGE: And she destroyed all of the records. See, the reason why that was done is because people didn't have no money, 'cause Dickey owned everything and they went to the store to get everything. You could go to the store and buy furniture—not at the company store, but you could go downtown, and they would finance all this stuff and take it out of your pay.

What's-her-name had wrote a song about that: "Load sixteen tons…" That's how this worked, that's the company store. "You owed your life to the company store." That's what you would do. A lot of people didn't get no money. Now in the store, you would come in and get all your stuff, and it was mostly all paperwork. You'd have to give them a ticket, too, you know, what you was getting and then they would take it out of your pay on payday.

ED: I'm gonna tell you something. One time I got my paycheck. You were paid off in paper money and silver. And I was supposed to have twenty-four dollars and something in there, because I was spinning and I was one of the highest-paid spinners in there. Anyhow, I got it home, and I opened it up, and I said, "Sweetheart, come here." It was a hundred and some dollars in there. I said, "I didn't make that much money." She says, "Well, just take the whole thing back and give it to them."

So I took it down, I walked in. I said, "Miss MacKenzie, you made a mistake in my pay." She said, "What do you mean I made a mistake in your pay?" I said, "Well, count it." And she said, "Well, my, my. How did I do that?" And she took that out and left my money in there, and she never said thank you, go to hell, or nothing. And I thought, "You put it in there again, baby, and I'm gonna keep it!"

GEORGE: I went down there one time, I was talking to Will Dickey. Well, what I was talking to Will Dickey was about me leaving. And he didn't want me to leave—under no circumstances did he want me to leave there. And he wanted to know why, you know, so he called me into his office. He didn't fire nobody too much; most of the time they quit and he wanted to know why. I had a better job—and it was a *cleaner* job. And what the hell, why would I stay there? I had a better job. I told him so and he said, "Well, I'm sorry to see you leave, but I can't stop you from bettering yourself," he said. "I don't blame anybody for bettering theirself. But," he said, "if you ever want a job, you just come back to see me," he said, "and I'll find you a job somewhere." Will Dickey told me that.

And thank God I never had to go back to ask him for a job. But I did see him out to the picnic woods a couple times after that and he always came, shook hands with me, and asked me how I was making out. I told him fine—which I was. I'm sort of glad that I left Dickey's because I got a better job at the Doughnut.[*]

[*]Doughnut Corporation of America in Ellicott City.

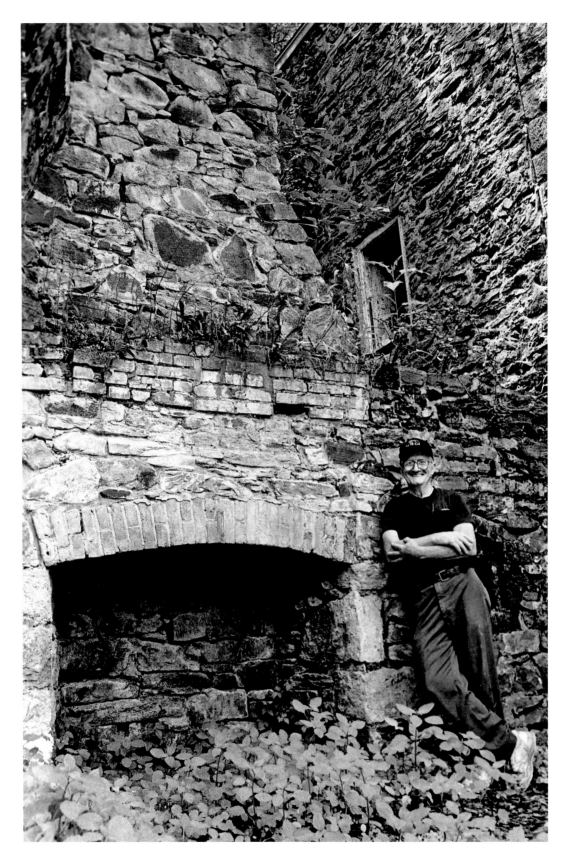

Bill Byrnes leans against the foundation of the workers' residence known as the Dutch Hotel, c. 1810, which featured large cooking fireplaces, 1997.

Harry "Bill" Byrnes

(b. January 29, 1928)

Millworker at W. J. Dickey and Sons

We made the flag—we run all the wool for the flag for the New York World's Fair. That was in '65, I believe, when they flew it up here. It was so big it bent the pole! Some ladies around here made it. Oh, I can tell you that we got newspaper clippings of the women working on it, sorting it, doing the flag. But it was so heavy it bent the poles. The size of it I can't remember, but it was huge. We made it all the way to the yarn. These women, I think they wove it with small weaving machines—well, mostly by hand, in other words.

My father-in-law, he'd been there for quite a few years so he got me a job up there. So then I went to work in the dye house and worked there for five years, and then I got out of the dye house and went to the carding room, and that's where I wound up.

Oh, I had to dye I think it was nine kettles. Now I mean big kettles—500 pounds of wool to a kettle. And we had some old flat wooden kettles with a propeller in the back of them, you know, and a motor sitting on top. That circulated the water. And had this screen basket went down inside of it, and you had to mix the dye and cipher it in out of a drum. You mix it and boiled

it up in a drum, and you cipher it in real slow through these ciphering units. And then you process.

You'd be in dye for one hour. Then you had to put acid in during that time—certain intervals, put acid in. You put acetic acid and nepheline acid, then ammonia, you put that in. And the last thing after it was all dyed, most of your blacks would come up kind of red. And they had what they called a chrome, and it was real orange like, and it was like salt. It would melt if it got, you know, too warm. Like a hot day, it would turn to sticky liquid, and that would seal it and turn it to a black. That was the finishing process of it.

And I had all those kettles, and fast as you dump one load and got that one finished, they'd cool it off with cold water, rinse it, drain it again, and dump it and start right over in another batch. On the navy and the army materials, I could put three kettles out a day on those because they were faster getting them done than you could the regular wool. It was so much better material, I think, and that was the best stuff you could buy at that time for army and navy cloth.

The last five years the navy contract kind of kept us in business, 'cause we'd have been gone before then. That was the only thing we was running—navy. When

I run the carding room, we had navy and some kind of filter cloth we was making, and that 'bout to tear our machines up making that stuff. It was terrible. It had that Dacron and stuff in it? It was so tough, and our machines was for wool. We just didn't update ourselves to change over from the Dacrons and the rayons and stuff like that.

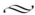

The ammonia and acids, I think, was the worst part. That ammonia would knock you flat. If somebody happened to leave the barrel open and you walked around the corner with two buckets in your hand with dye, and you was breathing normal, man, that stuff it would almost pop your eardrums.

You finally learn, when you go around corners where you knew that ammonia barrel was, you'd hold your breath, 'cause a lot of people would leave it—or if they'd spill it on the floor. And the floors were always damp from all the dyeing, and the water, and the washes. It was always damp. And as soon as that ammonia hits it, a smoke would come up off of it.

The dye went right in the river at the time. They didn't have sewerage. That went right in the river at the time, 'cause when we turned those blacks [dyes] loose, lot of people would be down the river swimming and you could see it coming, the excess dye and stuff, solution off the colors when you dump them loose to dry them. But that's the only color that you could re-ally see the water change when you dump the solution, off the blacks mostly. It would look bluish like. You could see it get real dark, and you see the people hit the bank.

～

I remember one time when I was working here, we had a washout on the banks of the race. The bank gave way and washed a certain section out, and the whole group just got together and got dump trucks and sandbags, and went to the river down the River Road, and bagged up sand and put a big pipe through it. Made dams and put pipe through it. Piled sandbags on one end and great big copper pipe and hooked it back up. And then they put a new wall back in and put it back in business.

We repaired it every year there when the mill closed down. It always closed down two weeks every year and they would work on it, you know. If they had a weak spot, they'd put stone and granite bags in there like that, and sand and stuff, so it would fill it tight. But this particular time it just collapsed. I don't know what happened, but they was calling everybody in the morning and said that we didn't have any work, the mill would be closed down. So then they all got together, just anybody wanted to come in and work, help dam it up. I guess we had three or four hundred people working on it. Had a group down there bagging it, a group hauling it, a group taking it down over the hill, and a group stacking it, so it took quite a few people.

Cyclist and mill buildings, Oella Avenue, 2008.

Bunky Merryman below his home in the Hollow, 1998.

Wallace Earl "Bunky" Merryman

(b. December 6, 1928)

Millworker at W. J. Dickey and Sons

When I had to work on the [mill] race, I had to in the morning punch in at seven and I had to walk a mile and a quarter up to the dam every morning and turn the water on three gates. Once the water comes down the race, the gate warden down here turned the turbine on that burned electricity for the mill. That's how they run the turbine. Yeah, I had to go back up at three, put the gates back down, close them up, and come on back down.

I remember when that boy got drowned up there. He jumped in nine foot of water and couldn't swim, and the guys that tried to save him, they went back and got help. Time they got help, he was already under. I had to go back up there to open the race up, let the water come down, and it couldn't even get open because somebody shot a bullet hole in the lock where I had to put the key in. So the fire department, they come down there and they tore the door off. After they got the door off, they done go for the body.

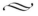

When they had dye in the dye house, the dye come out of them kettles, went into the river, and when it come up by that turbine down there, it made the whole river green, red—all different colors. And the fish couldn't live in it. They was jumping clear out of the water. You'd go down to get suckers and gather them up by your hands, there were so many of them. People was eating them with that dye in them, yeah. Never got sick or nothing. Guess it wasn't in there long enough for them to get into their blood and stuff like that, 'cause once that water's coming down the river and coming out of the turbine, it'd clear up quick.

Yeah, one time everybody up on this Hollow used to raise hogs. They can't do that no more. Yeah, everybody had hogs up behind their houses back in them days. I raised turkeys up there when I was living next door and only paying thirty-five dollars a month. But after that they just quit raising hogs, everybody did. Couldn't even raise a chicken.

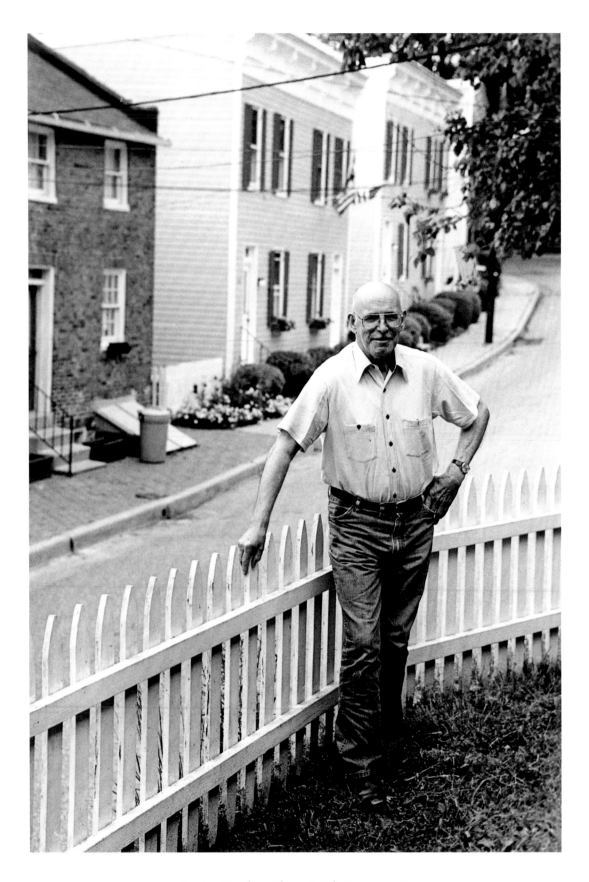

Junior Harden, Short Brick Row, 1998.

Ernest "Junior" Harden, Jr.

(b. September 21, 1925)

Millworker at W. J. Dickey and Sons

I worked in the carding room, run what they call finishers, and was a card stripper. Well, the finishers, that's where the wool comes out on the spools. Then they take it upstairs and they spin it, and then they send it down to the weaving room to weave it and all that. But then in the card stripper, we had to clean all the insides of stuff all out and get all the old stuff off of the old wool and everything.

You didn't have no ventilation 'cause you couldn't open the windows, because the wind would blow one color into another—'cause it's all different colors, you know, each card had a different color and you couldn't have it. It was no picnic.

Well, when you lived here, it was all the same, everybody had the same—you didn't have nothing. And everybody knew everybody like family, because if you didn't work in the mill, you didn't live here.

I been living in this house since 1958. But like I say, I've been here all my life. Used to live down there, I lived across the street when I was married, and I lived here when my marriage broke up.

At first we had outhouses, you know, had to carry water and all—had to for years. Outhouse is up there on the hillside. Yeah, then you got your water. You had a pump down there and you carried your water up. You stood it out here—you had water buckets sitting right out there. I still got the stand and everything out there.

Yeah, go out there and have to go up on the hill in the wintertime and all that. But it didn't bother me before. The only time it bothered me is when you had company, and it was embarrassing, you know, what we called a "thunder jug" and all this kind of stuff. Oh yeah, but the people who lived here, you know, they accepted it. That's why I say I hope we never have to go back to that way of living again. But up 'til then, it didn't bother me. I figure that's life, you know?

See, with me, I never tried to get ahead. If I could survive, I'm satisfied. That's the way I was, you know. "Why don't you get out and go down there?" I said, well, I'm satisfied. Just let go of it. I worked at General Electric. They have, like, promotions and everything? Uh-uh, I'm satisfied just the way I am. Punch my time card, you go home, I'm done. I mean, that's the way I am. I never wanted to be number one. If I can survive, that's all I want. And that's all I'm doing is surviving.

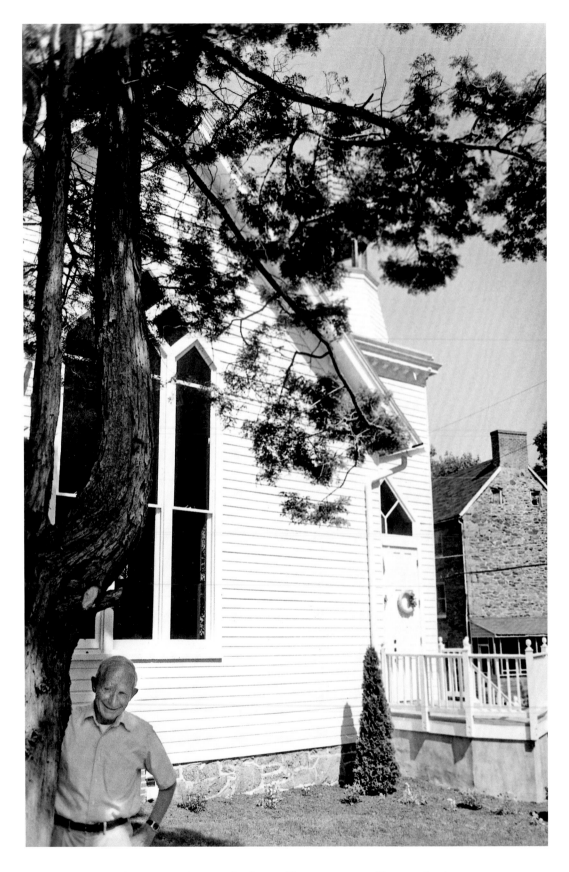

*Charles Wagandt outside the Oella Company office at the former
Oella Methodist Church, 1997.*

Charles Wagandt

(b. February 25, 1925)

President, Oella Company, Inc.

My mother was a Dickey, so I'm half Dickey and half Wagandt. The family worked on the old British system of primogeniture. Great-grandfather William James Dickey founded the mill business in 1838, so therefore his eldest son became the subsequent head of that business. And then *his* eldest son followed as head of the business, and it was expected his son would eventually assume the presidency. Some relatives worked there, too. But it was going down from eldest son to eldest son. Really kind of startling when you think about it.

I really didn't think much about the village. I was just coming here to work in the morning and leaving in the afternoon. Obviously, there must've been something about it that did intrigue me or else I would not have, in 1973, bought the village from my family.

What happened, the mill had been sold. So, here we got the village. In the meantime, the state had grabbed up some land that we were considering selling to a developer, but they bought it for the Patapsco Valley State Park. But there was still this acreage around the village itself, and the village. The family told me to go out and try to sell the village. Well, nobody was going to buy this village—at least, we couldn't find anybody who would be willing to pay for it when there was no public water and sewer here. There was a failed attempt at a cooperative, but the developer would not invest any of his money.

I said to the family, look, *I'll* buy it. I'll take the chance if you take back a mortgage, which I later paid off. I wanted to preserve the architectural integrity of the streetscape and make it possible for the millworker tenants to live in improved housing at rents affordable to them. And then there was the potential for new housing, primarily in clusters to preserve the natural environment. It was the smart growth concept before it became a popular buzzword.

There's the story—I guess it's more legend than anything—but there was a man by the name of Googie W. He and his partner were digging out the outhouse pits, putting the material into a wagon for disposal. And while Googie was shoveling away, his coat fell into the outhouse pit and he started to go in after his coat, and his partner said to him, "You're crazy, Googie. What are you doing—going in after your coat? You can't use that coat ever again!" And Googie replied, "Hell, I'm not interested in the coat. My lunch is in the pocket!"

It took eleven years to get the water and sewer into the village. While the county was considering public utilities, we had one case when some officials came out in the middle of one hot summer day to see the conditions here. We went behind what's called Long Brick Row. And it just happened that on that particular day, the outhouses were being pumped out and there was a malfunction in the system—the hose had broken for some reason or other. As a result, this material from the outhouse pits was being sprayed all over the trees—and being very humid that day and very hot, the stench was pretty overwhelming.

Now I was very, very embarrassed at the time. But really, nothing better could've happened because it made a statement like no other as to the need for bringing in public water and sewer.

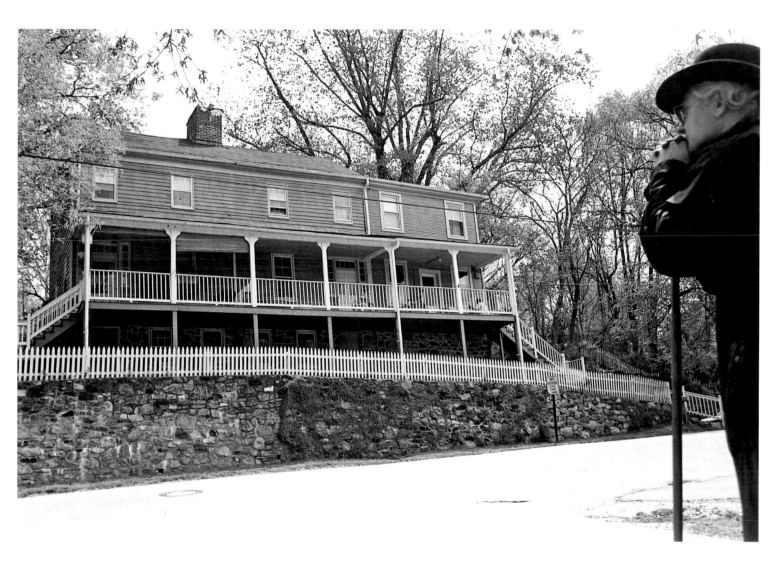

A visitor regards a pre-Civil War workers' house with an addition, c. 1900, 1997.

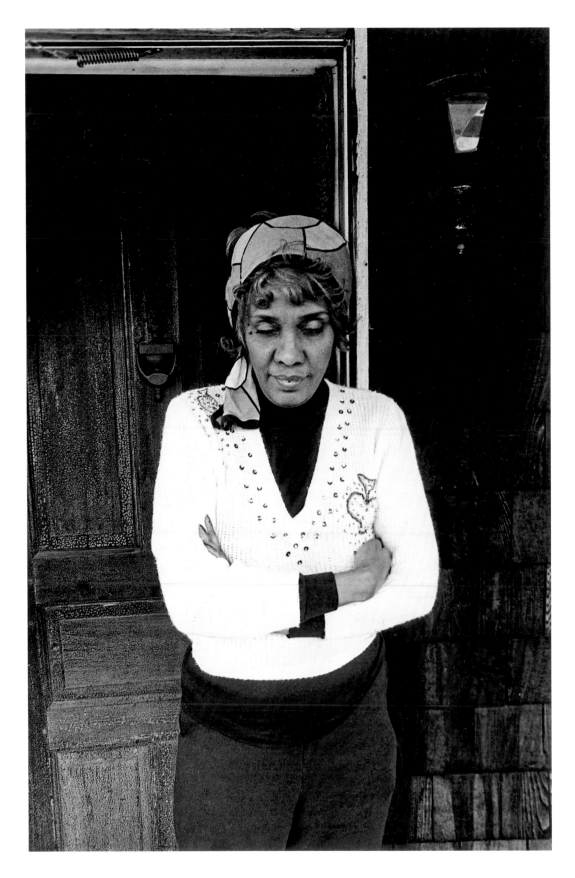

Susan Saunders, 1998.

Zola "Susan" Saunders

(b. September 4, 1946)

Nurse's aid and bookkeeper

I'm a descendant of the Hall family. The first was Shadrick Hall, and he was released from slavery in 1680 by Walter Hall, his slave owner. And he was given thirteen and a half acres of property in Oella. Oella seemed to be the haven for releasing the slaves and giving them property. I don't know why, but this was the spot. And nobody bothered them, no whites bothered them at all. They lived very happily here in Oella.

There was another family, the Brown family, that was released from slavery. Well, one of the slaves there, Fannie Brown, she became a teacher, and she married one of the ministers that preached at Mt. Gilboa church—Reverend Briscoe. And she taught at the church, because the church was also a schoolhouse during the week. My mother went to school there, and all my uncles, and even my oldest brother who is seventy-five, he went there. They taught 'til the sixth grade and then they would go to Banneker in Catonsville.

Yes, Miss Fannie Briscoe, she died when she was ninety-nine. I was her last pupil. My mother sent me down there every day and she would pay Miss Briscoe five dollars a week to teach me how to read and write and count. I went there for two years—and she was mean. She had a ruler. If you messed up what you were writing, what she taught you, she would get real mad and crack you over the knuckles with the ruler.

~

Right where the church is, right where Mt. Gilboa church is, the Ku Klux Klan used to hold meetings in the church cemetery. They used to burn crosses in the cemetery. This was in the '20s. They would burn crosses in the cemetery, and in the '30s, one of the Klan members who was a policeman in Baltimore County, he buried his dog in the cemetery. And some of the elders of the church got really angry, and they went to somewhere in Towson and told them that this policeman had buried the dog in the cemetery and they wanted it out. So they made him get his dog out of the Mt. Gilboa cemetery. But he was a member of the Klan. This is what my mother told me, and my oldest uncle told me, too.

~

Blaine Hall, he was the local celebrity. His mother was white. His father was my great-grandmother's brother, his father's name was Jacob. He had a brother who passed for white and became a pharmacist in Baltimore City and owned his own pharmacy. He went to Johns

Hopkins University. At that time, blacks weren't allowed to go to Johns Hopkins University.

That lot down there near Lydia [Harris]? That was the local baseball diamond, and on Sundays all the black people in the neighborhood would come there and watch the guys play baseball. And, of course, the streetcar line was there and the people from Catonsville would come up, too, the blacks from Catonsville. And a black guy from Baltimore City came out. He was a scout, and he picked Blaine to come and play baseball for the Baltimore Black Sox and the Lincoln Giants. And after he finished playing baseball, he was a gardener for a couple white families in Catonsville. He would do their garden—cut lawns and grow vegetables for different people in Catonsville.

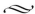

This was the Hall [trolley] station right here. There was a little house there that you could stand in to be out of the elements and wait for the trolley to come back and forth. We went into Baltimore quite a bit, and Ellicott City. My mother would go to a hairdresser in Ellicott City, she was on Main Street. She had a little house there and she would do your hair for two dollars or three dollars. And that was a rough process with the hot comb. Boy, would you get burnt—but your hair would stay up for two or three weeks, 'cause she used this real heavy grease on your hair and your hair would not go out, your curls would not fall. But you'd know you had to go back and get it washed and done all over again. By that time, the burns would be healed. It was rough.

Well, we had outhouses, too. I still have ours up on the hill. I refuse to knock it down, I don't care how much fun anybody makes of it. That's Oella—that's the signature of being in Oella.

I went to Westchester Elementary School, which was an integrated school at the time—the first year of integration. The first day was hell. My mother was a very determined woman. So I have a younger brother, he's five years younger than I am. He was going to the first grade and I was going to the sixth grade, so she held me in one hand and he in the other. And my aunt lived next door and she had two younger kids, my uncle's two kids. She wouldn't allow them to go to integrated school so she sent them to Banneker.

And there we were, the only two blacks the first day that we went there. And when we got to the door, there were two Secret Service agents there, it might have been the F.B.I. I mean, they looked like they were ten feet tall—scared the hell out of me. Well, Mother just walked on past them. They opened the door for us and we went on in, and somebody came out of the office—I can't remember who it was—and she told them what grade I was supposed to be in and what grade my brother was supposed to be in.

Then I walked to the sixth-grade door and the class was crowded with white kids, and the teacher said come on in. Everybody got silent. I said, oh God, I know they're gonna kill me. You know, you think all those thoughts. But everybody was just as nice as they could be.

Sixth grade, that was a perfect year. But when we went to junior high, I mean, we were called nigger, nigger, nigger every day—on the bus, mostly, not too much in school, throwing things at us and calling us names. My cousin Ann was the only one that was allowed to fight. My mother says, "If you fight, I'm gonna beat you when you get back home." So I said, I can't take two whippings so I might as well just take one from the kids and let Ann do the rest—and she did.

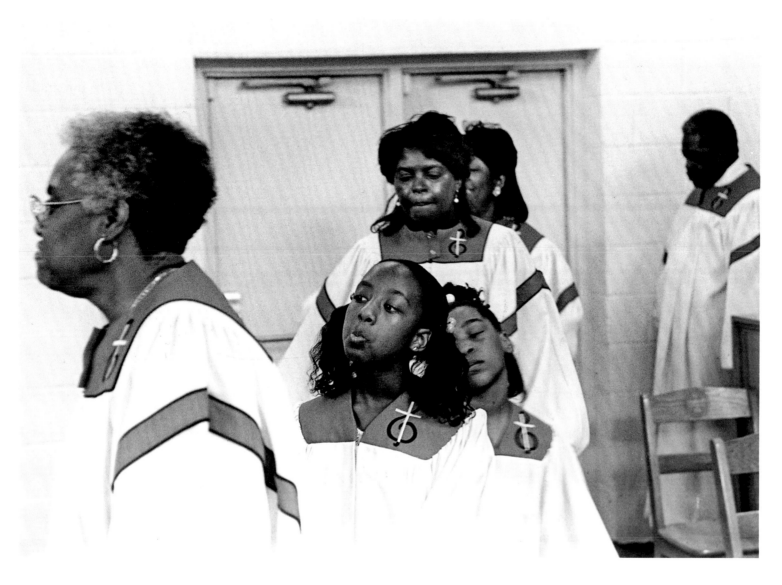

Members of the Morning Star Baptist Church choir, Catonsville, 2000.

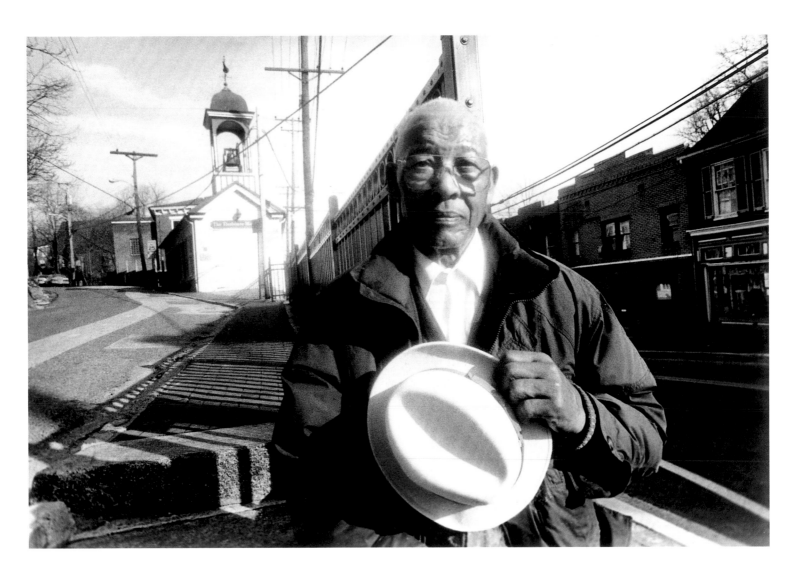

Leroy Cole below the Firehouse Museum, Ellicott City, 2003.

Leroy Cole

(b. October 18, c. 1917)

Factory worker and janitor

Well, the place down there called Oella, we colored people didn't go down there much. In them days, you know, they used to have this word they used for colored people, and so I went to the store a few times, but very seldom I went down there. They couldn't stop you from coming down through there, but if you did you'd have trouble, so I didn't go down there. In fact, nobody did. They stayed up on this side.

I heard of a colored fella down there working years ago and they got into something down there. I guess it was because they called him one of them names colored people didn't like and he got to fighting. They say he was knocking them right and left, but it was too many of them and he had to jump in the river in the cold wintertime, swim across to get away from them. And it was much deeper than it is now, and he swam to the other side, 'cause I heard my grandfather and them talk about it.

The colored people stayed to themselves and the white people stayed to themselves. They didn't associate in a big way like they do now. The families had any daughters that're grown pretty big, you know, you didn't talk to them too much. They didn't like you to talk to them too much. 'Cause I used to like white girls, but I never got out of the way with them or noth-

ing like that. Well, our parents would always tell you, "Now you stay to yourself now and don't you be out here fooling around. It's bad out here now. They don't like for you to fool with them white girls." Yeah, okay, so we didn't. Most of us didn't ever go with no white girl.

Well, I used to come to the store with them, walk up the road and talk to them and all. But you know, decent conversation, everyday happenings or something like that—"What'd you have for breakfast?" and "What'd you have for dinner?" Something like that. Outside of that, uh-uh. Yeah, it was that way clear until Kennedy got to be president. Then they got everybody together.

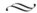

Blaine Hall, he was related to me on my father's side. He was a right nice-looking fella. I mean, he had good hair, and he was well liked by the white people in them days down here. Oh, everybody looked up to Blaine 'cause he was a ball player. He used to play on the Black Sox and then he had a place up there called the brickyard. In fact, I used to go to the ball games some—you know, Catonsville and Oella or Oella and Ellicott City—and they'd meet up there in the brickyard.

And Blaine, he used to school a lot of the white boys.

He used to teach them how to pitch, how to hit a ball and all that kind of stuff, and they liked him very well 'cause he knew a lot about baseball.

He used to be great for bunting the ball or placing it where he want when he's at bat, you know, so he could get on first base. Yeah, he was good at that. He was a good ball player, yeah. He used to go up there and play with them, years after he was off the Black Sox.

He hit a ball one time when he was playing and a train come through there. He knocked it clean over on the train so he walked the bases—made a home run walking. He just took his time and walked, and they couldn't put him out because the ball was on the train. It had to be *that* ball—it couldn't be no other ball, you know. Yeah, he knocked it clean over on the train.

When I stopped school, my father told me I could go for myself or stay home. I had to keep the home fire burning, and that was carrying wood. So I used to carry many a log of wood from way down halfway to Ellicott City in them woods down there, you know, up to the house where I used to live, right over there across from Joe Louis's.

Used to be an old white fella that used to carry wood on his shoulder from way down the streetcar track. The streetcar used to run right through down there. We'd meet each other—he'd be coming with the pieces of wood and I'd be going down the track. Them was rough days, walking them ties with a big load of wood.

We used to hunt rabbits and squirrels around here mostly. Some hunted deer, but I never did get deer hunting. I was always with the rabbits and squirrels. There were quite a few of them around in them days. When I was in my teens, sometime we'd go out and we'd have good luck, and again, the luck wouldn't be quite as good. And sometime no luck at all. You know, it's like everything else.

Partridges, you know, them birds used to stay together in a huddle and fly up, scare you to death almost, making that noise? They're funny. They gonna go on their way and bend their neck, looking back at you.

I managed to get one one time out of the drove. Maybe about fifteen or twenty of them in a drove, maybe, and I shot one—I *know* I shot one. And I went down through the woods and looked for him, I couldn't find him for nothing. I kept looking, and I just happen to see leaves was setting up a little bit high. I said, oh yeah, there he is.

He had turned over on his back and was holding up two whole leaves with both feet to camouflage hisself—but you had to look awful good to see him. Onliest way I found him, you know, seeing the leaves setting up a little too high. I said, oh yeah, something under here, gotta be him. Tell you what, I take it home and, oh my, that was a good piece of meat.

I never done any trapping, I didn't like that. I used to like to shoot the gun. I used to shoot in the squirrel nests, you know, lots of times they'd be in there. So it happened one squirrel, well one time, he come to the edge of the nest and his nose—I hit something, hit the leaves—his nose must've been bleeding. And I had shot up at him with the gun like that, you know, and it kicked, and I throwed this part of my thumb into my nose and *my* nose was bleeding, too. That was right funny. The squirrel's nose was bleeding and my nose, where the gun kicked me—and I didn't get the squirrel. The squirrel went back into the nest.

Yeah, I caught the train in Louisiana one time, say, "You in the white section now. Straight on back, there you'll see the sign saying 'Black.' That's where you go." "All right." So I went down and see a sign that said 'Black,' and then go in that part of the train.

A lot of white people say they thought the way they done to these blacks, say there's no sense to that, 'cause

you in the kitchens cooking and they eating from you as well. What's the difference out in the train? That's the way it was up there in Ellicott City, same way. Black people in the kitchen but yet you couldn't go in the restaurant.

Oh well, people's people, things happen. I never let it bother me. Of course in them days, if they did anything to me, they'd sure get a fight out of me—in *them* days. But now I'm different. You realize the end's coming, you gotta be getting ready for the end so you don't be fighting and going on. Like the Book says: "Smack you on this side of the face, turn the other side." That's what you supposed to do if you want to get that precious gift that's for you.

My buddy up there, he's Irish, he say, "The craziest damn thing, Leroy, I ever seen. This one can't go here, and this one can't go there, and can't associate—craziest thing I ever seen."

In fact, his mother and them—back in them days, before things became interracial—I'd go to their house and anytime they'd sit down and eat, I could sit at the table and eat with them if I had wanted to. But I was kind of bashful, you know, when I used to be around white people eating so I'd tell them no, make up excuse, you know, tell them, "No, I just ate" or something. "All right, you're welcome to it." But I never did eat a meal at his house. Yeah, lately, he has something up there, offer it to me, I eat it.

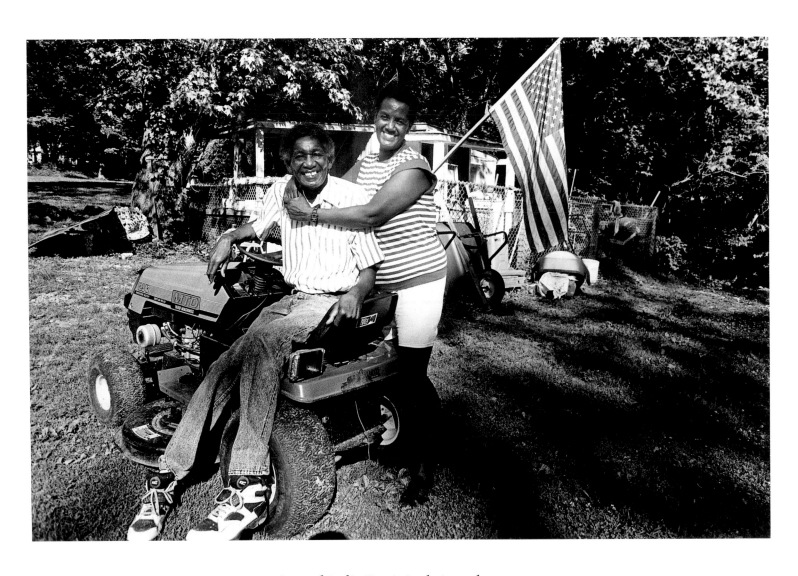

Joe and Lydia Harris in their yard, 1997.

Joseph "Joe Louis" Harris

(b. November 5, 1936)

Concrete finisher

Lydia Lincoln Harris

(b. July 28, 1940)

Collator for check printer, domestic, nanny

LYDIA: I was born right here in Oella. Yes, this was the black part of Oella, from the Country Corner Store on down. Mostly blacks live here—except the Treuths and the Boones, let me see, and then the Colfields. But mostly this was the black neighborhood.

And that section of Oella, you know, down there, that's where the mostly white people live at. We weren't even allowed down there 'cause we would get beaten. And if they came thisaway, the guys up thisaway would get them.

Right there where the body shop is? That was a roller rink. Vernon Bush owned that, but we couldn't skate in there. We used to go up there and buy the hotdogs and stuff, but we couldn't go inside. I mean, they would only sell that to us because we lived around here, but any other black person came around, they wouldn't, you know. But we all got along, I mean, wasn't no trouble or nothing like that most communities had.

And the church, Mt. Gilboa, the black church of the community—some of the older people, they went to school at that church up there. They attended school down in the bottom of the church. I know quite a few of them went to school there, like my mother and my uncles, that's where they went to school at, right up there in the bottom of that church.

They used to call this neighborhood Mt. Gilboa years ago, 'cause I have some letters that my uncle, when he was in the war, wrote back to my grandmother and it has "Mt. Gilboa, Maryland" on it.

LYDIA: We used to have to catch the streetcar right behind my house to go to school, Banneker, in Catonsville. And that school went from first to the twelfth grade. That's where we went to school at 'cause that Westchester School up there, that was for the white kids. So we had to catch the streetcar and go to Catonsville, walk in the cold winter—snow, ice—and we had to do that. But when they took the streetcar off, then the school buses ran through, picked us up.

Mostly we carried peanut butter and jelly. That's what we carried to lunch—when we did get lunch. Peanut butter and jelly or a syrup sandwich. You ever had a syrup sandwich? King Syrup. My sister used to make these homemade rolls and we'd put it on that. Yeah, that's what we had, yeah. We carried peanut butter and jelly sandwiches and syrup sandwiches. That's what we carried to school.

JOE: When we came home from school, we had to take our clothes off and hang them up. You ain't put-

ting those shoes on no more 'til you went to school the next day. You better *not* put them clothes on! And sometime you had to put paper in your shoes.

LYDIA: Yeah, 'cause there'd be holes in them, bottom of them. We used to have to put paper in the bottom of our shoes, too.

LYDIA: Wasn't no electricity, wasn't no running water, wasn't none of that, so we had a whole lot of chores—washing on the washboard, carry the water three and four times, and dump it. In the wintertime, hang the clothes up on the line in the snow. And chickens? Raised chickens. (I was scared of chickens, though, I didn't fool with them.) My grandmother and them had pigs—and they had the garden, you had to work in the garden.

They would cook the possum, the muskrats, and the groundhogs, they would cook all that stuff, now. And they had these hunting dogs, and go hunting. Then Thanksgiving, they would kill the pigs, you know. Every Thanksgiving they would kill these pigs, Thanksgiving morning.

Yeah, my cousin and them, they would go right in these woods around here and get the animals and the squirrel, and at night they would go coon hunting. And they would cook turtle soup, big pots of, you know, the big turtles? They used to catch them around here in the [river] branch or somewhere, put the vegetables in, make it like vegetable soup.

JOE: That's what you ate off. You didn't have no money to go to no stores. A&P or Giants weren't nowhere around here nohow, see. Folks had to go to Ellicott City to A&P.

LYDIA: Very few meats we ate, you know, like steaks and stuff. We never had none of that. We would have ground beef and we had chicken on Sundays. That was the dinner on Sundays—chicken. But mostly what we ate was vegetables 'cause we had them in the garden,

like cabbage and potatoes, nothing else with them. Or bean soup? Homemade bread, 'cause they made the homemade bread, you know, things like that. That's what we ate. We had no expensive food. And fish? We used to have fish. Eat squirrel. When the season come up, I'd have about ninety, 100 squirrels. Yeah, rabbits and squirrels, we had all that. That's what we ate.

And on Sundays, the grownups ate 'fore the kids did, always did, and you got what was left. And if there wasn't no chicken left, then you didn't get any. That's how they did that, yeah.

JOE: You heard that story 'bout the preacher ate better than anybody in the family?

LYDIA: Oh yeah, the pastor would come—

JOE: And then they eat all the chicken. And I didn't know a chicken had all them parts on it until I got about sixteen years old, 'cause I didn't know. We only got the neck, chicken feet. Used to take the chicken feet and light a fire outside and weenie roast them, and then you take the scale off them. That's what we'd do with the chicken. But I didn't know a chicken have no breast and thighs and legs and stuff. I thought it didn't have no more than necks, wings, and chicken feet.

Back when what's-his-name opened back here, sell chicken? And she asked me, she said, "Now, what you want? A breast?" Only thing I know is a woman's breast. I looked at her, I said, "Oh damn, I'm feeling pretty good now. She gonna give me her breast!" I reached over and looked—and she look like she's gonna smack me, she say, "What you want?!" I said, "Breast." But we didn't eat no upper part of chicken, you know, until I got older.

JOE: Paul's Market [in Ellicott City] used to get anything that you could eat—Paul's Market would have it in there. We used to get a lot of chickens down there and he have them in the crates. You pick out one you want, he'd kill it. Or you'd take it home or whatever

you want—*live.* He had the food out there and he fed a whole lot of blacks.

And Paul's Market, he'd treat you good. You go in there, treated you just like Jay up here in Oella. You'll never be hungry with Jay's store up there, 'cause I mean you can go in there and might not pay him this week or something like that, that ain't gonna stop you from eating. He will feed you. He'll do it right now. He's one of the goodest corner stores and there ain't no corner store around here no more like him—and ain't gonna be no more like Jay.

LYDIA: Kids, they always hung out at that store. Not the blacks—the white. Black kids, they never hung up that store. Most of the white kids hung, but we never hung up there because we weren't allowed to when we were kids. Our parents better not catch us up that store, they *better* not catch you hanging up that store. You get beat all the way down that road 'cause you don't belong up there. You go up there and get what you supposed to get and come back. You not supposed to be up there. And we didn't hang up there either. They would tear us up.

JOE: We lived on the Carrolls' place in Howard County—Doughoregan Manor. They owned like 100, 200 acres—Carrolls' was *big.* My mother used to work for Carroll, cook for them. My sister used to cook for them, and I used to cut grass for them.

See, Doughoregan Manor's the biggest farm in Howard County, and that's where we ate, hunt, fished, and everything down there in Howard County. You had a couple white families, but mostly all black—and a whole *lot* of them's up there, now, something like a plantation, 'cause you had your own church and everything. Wasn't the idea of slaves, but it was something close to it, you were close to it. But they would treat you good. I mean, it wasn't like down South. It was just like, you stay in your place and they stay in their place, see.

I went to St. Paul's in Ellicott City for seven years, from the first grade to the seventh. That big brick school there was the big white school. On the opposite side of the church was the black school. Yeah, they were white teachers because they were Catholic. You didn't have no black Catholic teachers.

The white classrooms were bigger and better. It wasn't as good as them because they had more white students in there, now. We would use the same books—*close* to the same books. You know, like some of these books so bad, they come to the black students, we had to get them. That was it.

Then I went to Cookesville, then Cookesville closed down and then I went to Tubman, and I came out of Tubman in tenth grade. All the surrounding areas up there used to go to Tubman. Used to have about eight buses.

But the first transportation was Miss Rachel Fuller in '42, the first transportation for us to go to school. She had a old Buick she used to ride us around, 'cause there wasn't no more than about thirteen of us. And she bought—well, they didn't call it a station wagon then, but it would haul fifteen people, had all four seats in it, and we used to ride in there from Ellicott City to Doughoregan Manor, back and forth. That's how we got back and forth to school.

LYDIA: Every morning, Grandma would give us cod liver oil in the wintertime. We had to take that stuff every day, cod liver. I hated it, but we had to take it. And then when we got sick, had to take kerosene and sugar, but not like they make this kerosene nowadays. But they used to give us that—kerosene and sugar.

JOE: You couldn't buy no cough syrup or nothing, you know, people made it.

LYDIA: And some kind of herb weed they used to hang up to dry? They would boil it for poison ivy, 'cause we used to get poisoned in the summertime.

JOE: You know, 'cause blacks didn't buy no medicine.

LYDIA: Went to the doctor—but when you was really, really sick.

JOE: Had them roots and everything they got in them woods.

LYDIA: Dig that sasparilla [sic] roots up for root beer. They get down there and get the root, and they wash it all off, and then they boil it like a tea. It was good. Used to give us that.

Grandma used to rub goose grease on us and tie a onion around your neck—bring the fever down or something, they used to say. It would do it, honest. She'd put it in one of her nylon stockings and my grandma would tie that onion around our neck if we got sick with a fever or something. And *sweat?* You had to sleep with all them blankets on you and wake up sweating. You would feel better in the morning. It's supposed to draw something out'n you. It did!

JOE: Old lady lived in Howard County, she didn't even go to school no more than I think about the third grade, and she would cure you just like if you go to Johns Hopkins right now. Called Miss Mary Liza. And she brought all the grandchildren here and all the rest of the children, and everybody around there. When they get in labor? She'll be there—snow, anything, she will be there.

She would make some stuff up there—roots and leaves and everything. You wouldn't want to take it, but you'd take it because you'd get your head smacked

off. But she just go around the neighborhood. Send for her anywhere, she'd go anywhere. She walked—and ride. You would see her coming down there on her horse. Not the buggy, though, one of them horses that haul a little short buggy. And my uncle bring her down the hill, give her breakfast. If she didn't get down there in the daytime, she walked.

Yeah, the medicine she gave, you didn't get too many sick. We didn't have no cancer or nothing like that. No, all she cooked was a couple of big bottles, you know, just like you might go in there and thought she was cooking soup or something, 'cause she'd be making something up that would cure you. And she would cure you. You just call Miss Mary Liza and she'd go around. Everybody know her.

JOE: When I came up I had it good, see, because five people working in my family, see? My father was working for the county, and my brother working for the county, and my sister was working for Carroll, my mother was working for Carroll. So, you know, I came up pretty good, 'cause when you go to work for any of them people, they paid you. When you go out there on the thrashing machine or hay, they feed you. And when I was a kid, I'd get out of school and go bale hay, but you got fed string beans and fatback. But that was *good.* Cabbage and fatback? So I was glad to go to work to eat. You go to work to eat. It was good, you know. For me, I had a good life when I was coming up.

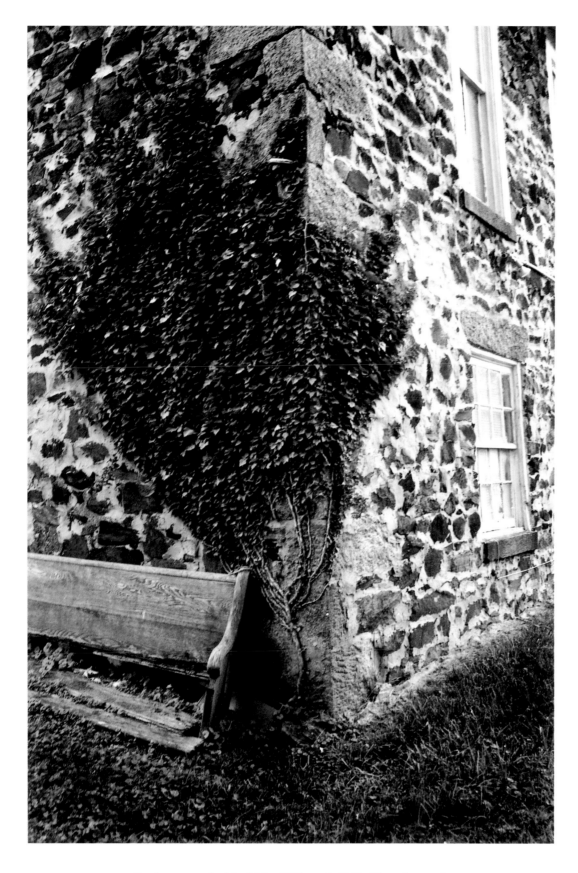

Broken pew behind Mt. Gilboa A.M.E. Church, 2008.

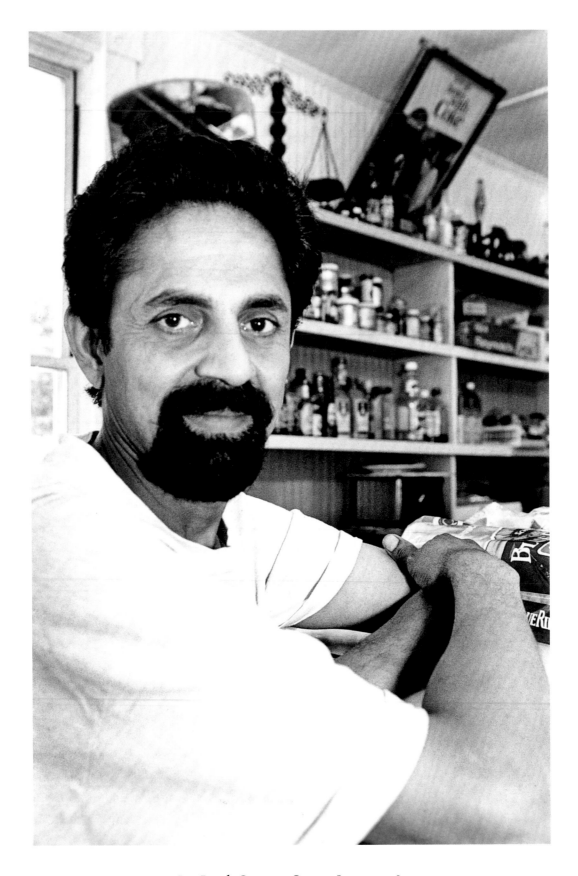

Jay Patel, Country Corner Store, 1998.

Jay Patel

(b. January 28, 1949)

Owner, Country Corner Store

The way I got this place, I was coming up the hill from Ellicott City one day with my real estate lady, they were showing me around. The most exciting thing was two-thirty in the afternoon, I believe it was on the sixth or seventh of June—summertime—and the kids were pumping water outside at a pump on the main roadside, and they were taking shower outside and their mommy was watching them. And I stopped the car and I said, "What's going on in this town? Why are they taking shower outside?" So, "We don't have no water and sewerage here, so this is how we do it for all these years."

Then I come up the hill and I find corner store. I say, okay, this is my kind of location. Reminds me of back home in India—nice people, surrounding country. And I didn't believe it the first time that there was such things that there is no water and sewerage in the United States.

We used to have our Christmas parties before the Dickeys' mill shut down, and they stopped doing Christmas parties in '71 or somewhere around there. For seventeen straight years, there was no Christmas parties for the kids in the neighborhood. When I came here, we started that back again, right up at the school, Westchester Annex. It was the old school, completely condemned, roof leaking, all the rooms were dirty, all the old plywood—lead paint, of course. They took everything out, and year by year they've been working so hard, and now it's like a modern school for the little kids. And that's what we wanted for the community center. That's one of the dreams that came true.

The first Christmas party we had here, I rented a helicopter at the same company I used to work in Baltimore and brought the Santa Claus from the chopper, and we landed at the school playground. There was no charge, nothing. You just come in and have fun, the spirit of Christmas the old-fashioned way. Everybody brings some cakes, you know? We make some sandwiches and drinks? There are little bags of toys? We've been doing it for fourteen years straight up right now, never missed a year—even the year I was shot.

I was shot right here in the head—in the mouth. Yeah, '92, our Christmas party was December nineteenth. On December eleventh was the day I picked up a lot of stuff for the kids. It was still sitting in my car. And day-to-day life, every time it happens, somebody likes to rob. And sure it did happen. And God was with me, and the neighborhood was with me, and I'm here, *back*.

I was back on the second day—Sunday, I was back to the store. We continued the same Christmas party right on the front porch and it was fun. But the whole neighborhood was with me, so I guess that God heard the prayers from them and send me back. Maybe I had to do something more in this town for them, that I'd been appointed to do it, maybe that's why I'm here again.

This is what makes the small corner store the neighborhood-oriented, family-type business. It's not mainly the business or the money concern here. People look after each other like a family to help each other, see? That makes me happy to be in this old town. I'm happy with them, they're happy with me, and we gonna continue doing like this. It's the old history. That's what we're trying to bring it back, and you can see it day to day, right?

We have a morning crew for the coffee and all, you know, the Treuth* and the construction crews in the neighborhood, plus break at ten. After they are gone, by eleven we have the senior citizens. They come here and sit down. That's my break time to cut the lunch meat and get ready for the lunchtime while they are sitting and talking, discussing about the morning news. It's like Congress—and that's what they say: "Come on, adjourn the Congress session. Everybody's here now, let's start!" And they start talking. Everybody's got their own ways of putting stuff—why the president was saying this, why this one's saying that—but it's just a matter of discussion and get it off from their brains. Nothing serious, you know. They argue with each other and all, but next day it comes different topic, different day, they're still friends.

And they adjourn their meeting after the lunch hour is gone. They say, "Okay, we'll see you tomorrow again." Then before they leave, they'll say, "What's the name of this town again?" "Oella!" *"O-K, oh-well,*

see-ya!" That's how they go, you know, it's funny. But some of them come back in the afternoon after two-thirty, three, after their nap, which is good. Makes my day go and makes them happy, somewhere to come and hang out—just like the little kids, every day.

We got a lot of them that keep coming and going—older ones, exchanging. There are new ones now replacing the one who is passed away. So it makes me feel going there is good. One person goes away, I think, oh, I'm gonna miss him. But then after two months I see someone else, [a] senior citizen, comes here and takes over the place. So in a way, it's good that it keeps continuing the same routine.

To me, it doesn't matter. They can sit, they read the newspaper, and they go have coffee. Most of them, I don't even have to charge them. They can have their coffee for free.

Then it's almost lunchtime. Lunchtime is over, I have my lunch. By that time the school bus comes at two-thirty, so kids—from then on until five, five-thirty, six—until the people start coming back home from the work. And then it picks up again, the business, for milk, whatever they short of.

We all were teenagers once and we did our part of hanging out—somewhere, some part of the world. Now we are grown up and we think that they should not hang around and they should not do this. In certain ways, right—in certain ways, no. For them to come and sit and discuss about the school projects, homework, boyfriend, girlfriend, or family problems—it's a way to take out their tensions. Certain things you cannot tell the family. You got to talk it over to the friends or someone else.

It's just like confessing in the church on Sunday morning to the priest, "I did this and I'm wrong and God please forgive me"—and the priest does. Here it's

*J. W. Treuth & Sons Wholesale Butchers.

the same thing in a different way. Of course, they're hanging in a corner store, but they're not damaging, or cussing, or throwing bottles, or doing something to anybody, so I don't see any reason why they cannot sit and talk. If my senior citizens can come and talk and sit down, they have the same privilege—as long as they listen.

If they don't have the money, we say okay. There's two ways to look on that issue. For example, kids to start with: Okay, they don't get their allowance until Friday. They want a drink, they're thirsty, it's summertime—ten cents, ice cream, popsicle. What is that gonna hurt me or them? The child is thirsty *now*. I think I prefer to give him that instead of stealing from me. They know that they've borrowed it from me. They remember that—one day they have the money, they'll give it to me.

We in the United States support all over the world a lot of other nations who are poor and don't have food, you know? I think I'm doing it for my neighborhood for a few cents here and there is not a big issue. They are still humans, you know?

And the senior citizens and the older people, they don't get their Social Security check until the end of the month. What happens when you run out of the money? You have sudden medical bills, or maybe gas, electric bill, or maybe heating system bill is gone up because it was too freezing cold. No money's coming out, the funding's not enough.

It's not my problem because of what they're going through, but then on the other side, it's my problem because they come to me and telling me, "Jay, can I have a loaf of bread and cheese?" We are talking only what—*food!* I think yes, it's okay. I'm sure they bring it back. Ninety percent of them always come back and takes care of the bills. There are people coming back after three years and still remembers and pays me back. There are kids and criminals who goes in jail. They remember, they come back out of the jail, and the first thing they do is come and pay me. And I have full trust in these people. It's the way of teaching them what I have learned through my life from all over the world.

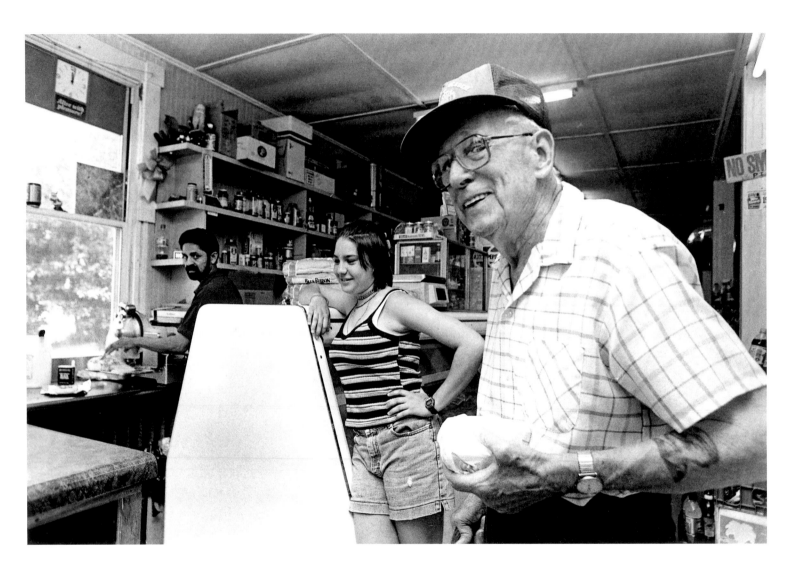

Jay Patel serving customer George Tucker and an unidentified girl,
Country Corner Store, 1997.

Kids eating hotdogs in the back room, Country Corner Store, 1998.

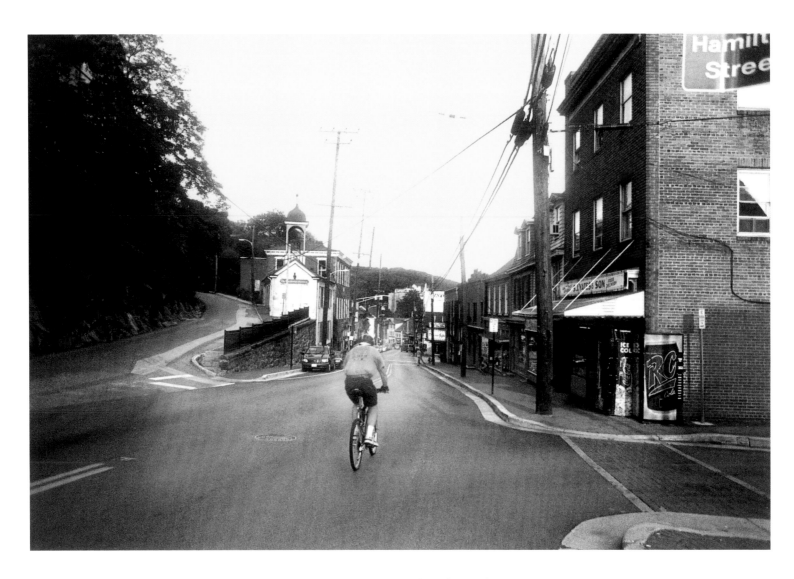

Cyclist, Main Street at Church Road, 2004.

ELLICOTT CITY

When it comes to disasters, you might say that Ellicott City has a flair for the dramatic. The place has seen floods and fires of biblical magnitude. It nearly died of insolvency and neglect after World War II. But no matter the damages, Ellicott City always rises from the ruins.

Actually, it rises—period. Wedged into a tight valley, the old mill town mounts the flanking ridges like an alpine village. *Ellicott City, you know, up there in the mountains,* you may still hear them say around the Patapsco. Narrow lanes switchback up the hillsides, threading through woods and rock and time. The natural landscape enfolds the built environment—row house and mansion, barn and bungalow, culvert and cobble, rail and mill. In seasons when the trees are bare, Ellicott City reveals her secrets and her contradictions, from classical ruins that crown the highest hill to the dam way down deep in the gorge. All mark passages and epochs in a story that began more than two centuries ago.

In the 1770s, the Ellicott brothers—Joseph, Andrew, John, and Nathaniel—Pennsylvania Quakers and millwrights, planted their family name and several gristmills on both sides of the river here, introducing large-scale merchant milling to the valley. Savvy businessmen with a keen sense of the region's economic potential, they bought and cleared land to farm wheat and harnessed the Patapsco to power the millwheels that ground the grain, first at Ellicott's Lower Mills (located at the lower end of present-day Ellicott City and across the river on the east—Baltimore County—shore) and then at the Upper Mills at Hollofield. They also built a network of farm roads to and from Ellicott's Mills that became the Baltimore and Fredericktown Turnpike Road and eventually connected to the first federally funded National Road (US 40). Their

flour industry and other endeavors took root, drawing more industry and sowing the seeds of a city.

But not without a major setback. In 1809, fire destroyed the lower mill and most of the surrounding log-built structures. The village was rebuilt, as was the mill, this time in brick and stone supplied by Patapsco granite quarries—and this time concentrated on the west, now Howard County, side of the river. Within a few years, people settled in, businesses began to fill the squat stone buildings along Main Street, and Ellicott's Mills became a going concern, an enterprising and accessible river town and the seat of Howard County. In 1867, the county granted Ellicott's Mills a city charter and renamed it Ellicott City.

Perfectly situated in the westbound path of road and rail, Ellicott's Mills was cut by the old National Road and, in 1830, made the first terminus of the Baltimore and Ohio Railroad (marking the end of the country's first thirteen miles of commercial track). The original stone depot, the oldest surviving train station in America, still anchors Main Street down at the river's edge. As for the highway, now a strippy bypass better known as US 40, it gradually diverted business and drained the life from the town's heart, just as highways have done to so many other towns and main streets. But, unlike so many others, this is one street that reinvented itself and revived.

Ellicott City's main street, serpentine and steeply graded, climbs higgledy-piggledy from the river—a challenging route for the Number 9 streetcar that used to run between here and downtown Baltimore. One side of the street abuts a twenty-foot wall of granite, from which protrudes an occasional unruly outcrop, as if to assert the preeminence and pervasiveness of the rock. Along the other side flows the Tiber (glorified in local parlance as the Tiber River), a mercurial feeder stream to the Patapsco that, until the mid-1960s, received Main Street's raw sewage.

Once the hub of town life and the crossroads for its comings and goings, Main Street delivered pretty much whatever you needed—whether groceries, gossip, a haircut, or a funeral. Now the town has stretched beyond its old borders and life has moved off the street and behind closed doors. You have to go elsewhere for a shoe repair or a barbershop. These days, Main Street caters mainly to tourists who come for the antiques, restaurants, and brimming specialty shops.

Change is the trade-off for survival. But on days when the wind is right, the pungent scent of fertilizer from a nearby farm settles over the town, as it has perhaps since the Ellicotts' time. And the past, ever present, seeps through on walls and pediments where old names in faded paint ghost the new.

Higher up the escarpment, above Main Street, crevice-like alleyways offer

slivered views down to the street below—a partial shop window, a cobbled lane, a sidewalk still life of hand-caned chairs, a peeling bench, a passerby moving across your field of vision like an actor in a brief take.

Framed by buckled walls of weathered brick and stone, these fleeting glimpses give you the essence of place beyond time, Ellicott City—as it is, as it was.

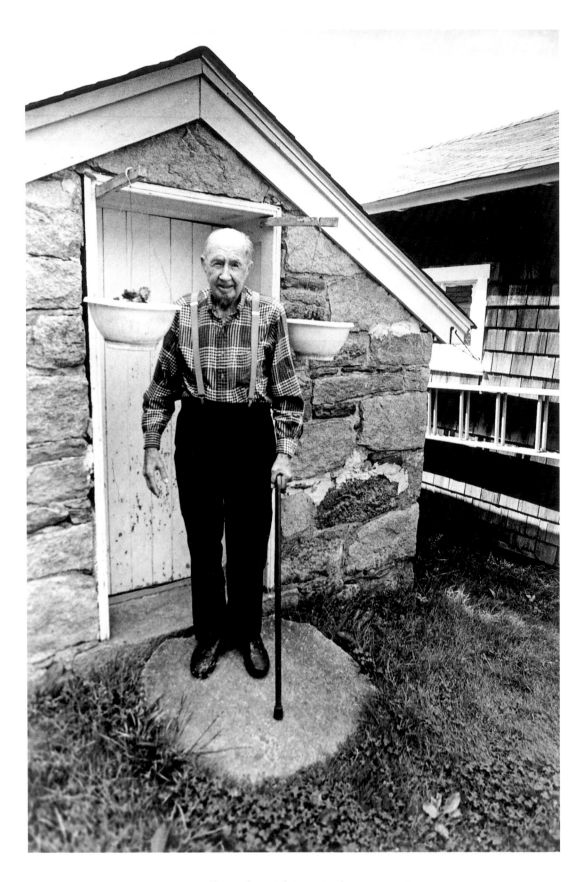

Russell Moxley at his springhouse, 1998.

Edgar "Russell" Moxley, Sr.

(b. June 30, 1906)

Chief of police, Ellicott City and Howard County

My father had four farms. We had a thousand acres one time and we worked it by mules and horses them days. But what I want to tell you is about myself. I went to school when I was five years old, little school up here on the hill—Jonestown School at that time, then they changed it to Rockland. We had seven grades. I went to first grade and second grade to Jonestown School, then I went from third to the sixth grade to Ellicott City, then I went back up here to the seventh grade. Reason I did that was I didn't like the teacher, one who was teaching seventh grade down there. That's my education—seventh grade.

Everybody mostly worked on a farm them days. When you got fourteen years old, you could leave school. We worked on the farm in summertime, and when cutting corn and things, you had to harvest them in the fall of the year. You didn't get to school until October. Then in the spring of the year, you didn't stay in school 'til June—you stayed in school 'til about April.

I was sixteen on June the thirtieth—I went to work for a coal yard in Ellicott City. I worked for the coal yard for ten years for twelve dollars a week, sixty hours a week. If you know where the parking lot is, goes up to Oella? That's where the coal yard was and there was a row of houses I lived in there before I got married.

I lived here when I first got married. There was a log cabin and my wife didn't want to live here, said it was too far out in the country. Wasn't no electric—coal lamps. So we rented a house in Ellicott City and then we tore the log cabin down and I built this house in 1928. I had eight acres when I built this house here. We got it from our father, see, he give us the ground and the old house was here.

I had an uncle was a captain in Baltimore City police, I had a uncle was a police in Catonsville. And how come I get into policing? I don't know why I did. But in 1925—we got married in September and it wasn't long after—I knew the chief [Julius Wosch] over in Ellicott City. I was living over across there, across the bridge. He said, "I got to go up to Glenwood, got somebody up there." He charged him with assault. I don't know what was his charge, I didn't know nothing about it then. So I went and he took my car and went all the way to Glenwood—that's about fifteen mile—and him

and I brought this man back. He picked him up there in a bar and brought him back. He give me a dollar—used my car and everything.

See, we never had police uniforms furnished until 1952. You had to buy your own uniform, you had to buy your own gun, you had to run your own car. You didn't get nothing for it, only your salary. First year I got twelve hundred dollars.

Then in 1939, we moved over to the police station there—police office was downstairs and we lived upstairs. My wife had to answer the phone from six until twelve at night—and she didn't get no pay. We didn't have no radio or nothing. She'd light the light out on the porch. If anybody comes in, she had to come down and talk to them. And if she gets any calls who wanted me, she'd light the light on the porch that she wanted me, and when I come up the street I would see what she wanted. We didn't get no radio until 1952 when I organized the Howard County police department.

Over here where Normandy shopping center is, it was a gas station on that side of the road—this was in 1952. We had four or five police working then in different areas and we always checked the filling stations along the road. And this other policeman and I pulled up to this filling station and I saw the man in the car. And when I saw him in the car, I saw the gun—he stuck it down his leg. When I started to back away, he pulled that gun out and shot right straight. I'll tell you, it pretty near went over my head, but he shot at me four or five times, didn't hit me. I shot at him, but he left the car and run. He killed a police out in Cleveland, Ohio. We didn't know he was wanted for anything. We was just checking it out to see what he's doing there, 'cause he's breaking into these filling stations and things like that on the road.

Well, Catonsville had their own radios and they got a call that this man was wanted for this shooting. But we didn't know it 'cause we didn't have no radio con-

tact with anybody, wasn't no radio in the car then. And he come over from Baltimore County. And it was four or five days before they got this fella, had helicopters and everything. That was the first manhunt ever in Howard County.

The usual calls was fights—assault, women fighting, drunks on the street or anywheres, someone complain about noise. See, people lived all along Main Street on apartments over top. They'd all complain about noise and drunks hollering and carrying on. You had to go down and, oh yeah, it wasn't no snap. You did it by yourself.

Everybody from Howard County'd come into Ellicott City on Saturday night. They come from Oella, they come from Alberton, they all congregated in Ellicott City on Saturday night. You couldn't walk down the street, were so many people on it. (You had two banks, four undertakers, and six saloons—I mean 'fore Prohibition.) I would arrest thirty-five people by myself on Saturday night for being drunk and disorderly on the street.

You got a couple, you know, used to cut each other and fight each other, but we'd put them in jail. If he didn't go with us, I'd use a club on him—blackjack. Well, what they call a billy club, but I made this one myself. I had a piece of two-by-four about that long with a handle and many of them I hit up the side of the head. We never took them to no doctor, we just took them to jail. Didn't make no difference to me, it was up to the jail warden—and the jail warden wouldn't keep the door open. So we'd get in with them, you had to rap on his door and wait for him to come down and open it.

They had about eight or nine cells, but they'd put them all in this big drunk tank—and they'd get in a fight and we'd put the hose on them. And we didn't have no trouble after you put the hose on them. But it was the same crowd pretty near every week—get

drunk and somebody would come up and get them out on five dollars, ten dollars bail. Next week, it'd be the same thing.

It was just a certain gang that come into Ellicott City. You see them hanging around, you know, we called it the Bloody Bucket. If you go through Ellicott City, it's across the bridge when you're going into Oella, it's the place on the right. They'd get drunk over there and come over here. Well, that's them days. But now he's got a nice place over there.

Mostly they come in here, in my time, during what we call the logging—cutting all these forests and things like that. Lumberjacks, we called them. Then during the war, they all come up from the mountains down in Tennessee and them places. Man, they was rough people. They used to drink that moonshine down there and get up here and drink this moonshine up here, see? They made it. Plenty of it around then in Howard County during Prohibition time.

Howard County had a local option, if you want to call it—dry. And Ellicott City was wet before Prohibition. They had stills in these woods and places on these old farms. A lot of these farmers had the stills and they'd haul it into the city. But you didn't have to go to anywheres to buy it, you could buy it anywheres. These old fellas just knowed their customers. They'd carry it around in the old coat pocket. They'd fill these half-pint bottles up and put them in their pocket. They had their regular customers.

You couldn't raid no still. They'd run when someone was gonna raid the still. You only had certain territory that you could go to. If you was the police in Ellicott City, you couldn't arrest anybody in Howard County unless you was a constable or a deputy sheriff. I remember the day when state police wouldn't've been allowed to make an arrest in Howard County on a automobile charge. These old politicians them days run everything.

≈

I was chief from 1952 until 1959 and politics changed. In '58 they passed a ordinance that they couldn't get rid of any police unless they brought criminal charges against them. In 1955 or '56, they charged me with electioneering too close to the polls and they fined me fifty dollars. But it wasn't no criminal charge.

When the new county commissioners took over in 1958, they elected one of them our side and two of the other side. So it was two against me and they tried to get rid of me. They sent a letter, said I wasn't gonna be appointed anymore. So my attorney took it to the court, won the case in Court of Appeals. County took it to the Court of Appeals, won the case, and they come back and said they wasn't gonna appoint me, 'cause it didn't say that you could appoint the chief. Everybody else was appointed except the chief—and they had the right to appoint the local chief.

So I left for a whole year. We appealed and we won it down in Court of Appeals. The judge said, "They got to put you back to work." But they didn't have to put me back to work as chief. I'd already had all these years in, so the judge said, "Put him back to work as a policeman for the same amount of money as the chief was getting." Same 5,500 dollars a year at that time.

After they tried to get rid of me, the Republicans took over and swept the whole county. Howard County was Democratic at that time. They never had a Republican county commissioner until 1962—and all three of them was Republican. I was Democrat. See, they wouldn't put me back as chief because I'd already agreed to go back as highest paid and take the job as a police patrolman.

I worked with four chiefs from 1959 until '72. And that was when I helped to get the pension system for all the county employees. They didn't have no pension system until 1962. You just worked, that was it. And I worked 'til I retired. The most I've ever made—I retired in '72—and only made 9,500 dollars as a policeman. Oh, you had to be political. Them days you didn't get nothing if you wasn't political.

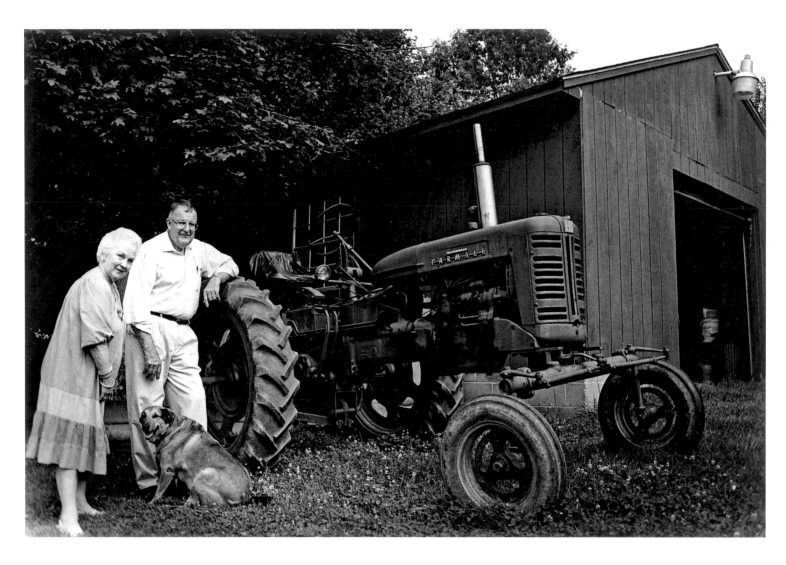

*Doris Thompson and husband, Phil, on the site of her great-grandparents'
farm off US 40, 1999.*

Doris Stromberg Thompson
(b. July 28, 1924)

Editor, Howard County Times; vice chair, County Planning Commission

This was a farming county—dairy farms, cattle farms, grain farms—and Ellicott City was where the farm owners and the farm workers went. In the late '50s, you would see lines of trucks coming in from the farm, going over to the mill. And sometimes it'd be backed all the way up Main Street, going over to unload their season's crop.

When I was growing up, Ellicott City was a very vibrant community. It was almost like a little United Nations. We had the Jews, we had Italians, we had Greeks, Irish, you know, all right there. We didn't know any Republicans but this one girl who was in our class at St. Paul's.

I should tell you about what the town was *really* like when I was growing up. The town was just full of beer joints. And these places, they had no indoor plumbing for their customers, so you got an assortment of odors. But the one where Ellicott's Country Store is, the man raised fighting cocks and he kept them in that building. And on a hot day, I used to make a detour and go on the other side of the street so I didn't have to walk past it. It was *terrible*.

Then down where the depot is, there was what we called the Lower Greek's. The Upper Greek's was about half a block up the street. And there was a little wood-en sidewalk across the Tiber for pedestrians, and on the other side, on your left, there was another one called Tommy's Saloon—same thing, no indoor plumbing.

And all the kids walking to school—'cause the Ellicott City elementary and high school were up on a hill, and the Catholic school—you got so used to seeing men standing out back and diddling around the drums and things. It was just part of growing up in Ellicott City.

I would take a shortcut home and go past the old jail. It was called Willow Grove. And now can you believe this? They would allow the prisoners to sit outside on a nice, sunny day—just sit out there, the prisoners. And one of them called out, "Hey, little girl, come here a minute." So I said, "Yes sir," and went over. He said, "Would you go down the street and buy me a pack of" whatever kind of cigarettes he wanted, and gave me money. And I said, "Yes sir, I'll go." So I went down, I got him his cigarettes, and took them back to him. But we were not brought up to be afraid of all that because people who were in the jails in those days were not hardened criminals like they are today.

Now my father was a German-Irish Catholic, but he got the job as the editor of the *Baltimore Jewish Times.*

And while he was there, he learned that the job as editor of the *Ellicott City Times* (we later changed its name to the *Howard County Times*) was open, and he applied for that and they hired him.

He moved back to Ellicott City and then he looked up my mother, whose first husband had died with the flu epidemic (he was a catcher with the old Baltimore Orioles) and they were married. He gradually bought all the outstanding stock in the company that owned the *Times* at that time and became the sole owner. In fact, the *Times* office used to be where the big outcropping of rock is. Then the next building my father had built in 1926.

In the meantime, he'd started a paper in Catonsville and he'd started one over in Reisterstown, Randallstown. And when he died in 1952, we had six papers in the family chain. And when we sold in 1973, we had fifteen.

My mother had a rather abrasive personality, shall we say, but she had a heart as big as all outdoors. If she knew somebody was really hard up (it was before there were any government-sponsored social programs), Mother would call them or get in touch with the person, tell them to go down to Yates grocery and get what they need, and tell him to put it on our bill. Then the way we paid for it was the Yates' took out ads in the *Times* and we bought groceries from them. At the end of the year they had a tallying up. Some years they owed us money, some years we owed them money. You just charged each other.

Our seventh grade, our last year at Sisters of Notre Dame, we were assigned a new principal. From the side view she looked just like a tortoise—and her disposition was just as bad as her face.

She had some procession that we were in and we were told we had to wear long, white stockings. And my mother said, "Damn if I'm gonna buy you any long, white stockings. You won't wear them but one time. That's just a waste of money." So she bought me knee-highs. I said, "Well, Mother, Sister said she was going around on the school ground before we went in the procession and pull up some of our skirts to see if we had on long stockings or not." She said, "That's fine, Doris. If she does it to you, you pull up hers and see if she still has on long drawers."

We had a grocer on Main Street who, well, people liked him or you didn't like him. He had a very strong character, shall we say. And, the sidewalks were all different widths because each property owner owned the sidewalk. He was responsible for removing the snow and all this other stuff. So you had different surfaces: you had concrete, and you had brick, and you had, well, just anything that you could think of. And if you didn't park your car over as tight to the curb as you could get it, the streetcar couldn't get by.

I was on my way home, and this grocer had been into Baltimore—I guess to the wholesale market or something—and he was unloading his truck. And he'd just parked and the streetcar couldn't possibly get by. So the motorman kept banging and banging and banging, and the grocer came out and he gave him what for. And finally (I didn't hear what the motorman said) but the grocer said, "You come down here and say that!" And the motorman handed the control to the conductor, and the conductor said, "Oh my God," he said, "He won the light heavyweight championship of Baltimore last night." And with that, the grocer was out on the sidewalk. I'll bet you there was no more trouble with anything in front of his place of business.

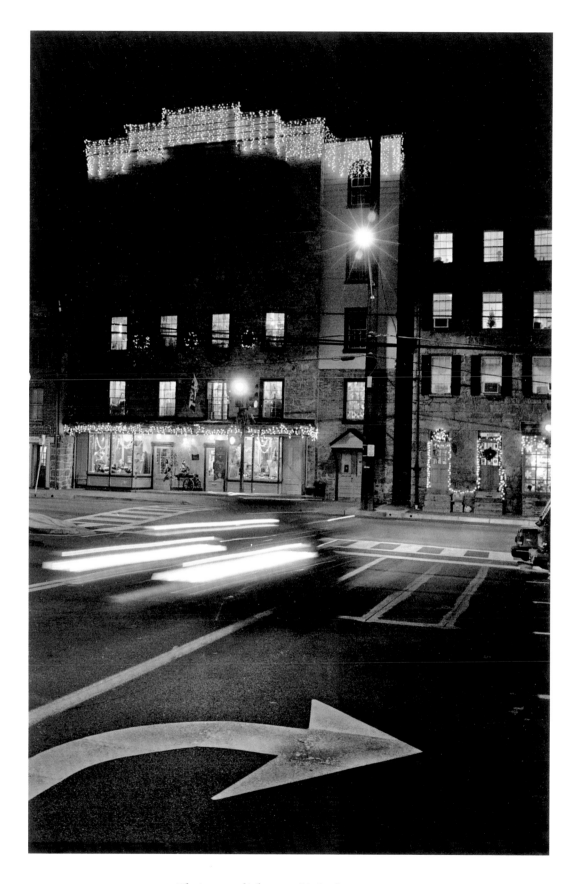

Christmas lights on Main Street, 2007.

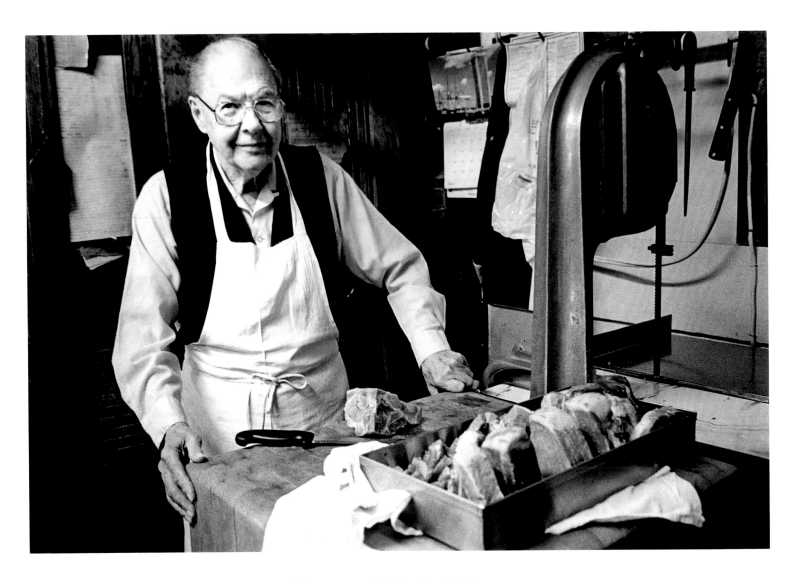

Bladen Yates at his butcher block, 1997.

S. Bladen Yates

(b. June 3, 1918)

Owner, Yates Market

My father and grandfather before me, my great-grandfather before me, they all run stores—grocery stores—and I followed in their footsteps. My great-grandfather had the store up the street. His name was Robert Yates, he came from Wales. And my grandfather's name was Samuel Yates and my father's name was Samuel Yates, and mine is Samuel Bladen, so they called me Bladen to keep from having too many Sams.

Always was a grocery store, or a general store, whatever you want to call it those days. Sold everything from soup to nuts. They always delivered, and I guess like all farmers, they ran wagons around—started with horse and wagons. They were more like truck farmers: they raised crops and sold them, all through that side of my family. They brought it to the store later, then delivered it from here.

There were several livery stables, and the one was right behind us, it burned down a few years ago. And where the post office is, that was a large livery stable where they kept horses, and wagons, and fire engine, blacksmith. That whole block there was one big building.

Matter of fact, we had a stable—or my grandfather did, just a couple streets up, and we kept two horses in there and two or three wagons. And they got around

to adding a truck and eventually no horse and wagon at all.

We had a driver, colored fella, and I guess he was the main one that delivered. So we put him on a horse and wagon and he'd go down the street delivering. He goes up by the railroad track to deliver, all the houses up there. Here comes the train, horse and wagon took off—and our driver, he was petrified. And eventually, my father had to go down to the track and get the horse and wagon and bring it back. So that was one story.

And then World War II, shortage of gas, we bought the two horses back for a while, just temporary. We ran deliveries for a little while to help out the gas shortage—and it was quite a novelty at that time.

I lived upstairs. My father put me to work early, maybe weighing potatoes or sweeping the floor or fixing some vegetables or whatever. Then when I got a little older, if I wasn't busy here, they'd send me up on the farm and make me work on the farm—dig potatoes, pick beans, and bring them down to the store.

We'd stay open 'til nine, eleven o'clock, especially on a weekend. Nine o'clock was early anytime, and then Fridays and Saturdays was usually eleven or twelve.

Well, the other fellas would be out on dates or having a big time and I'd have to work, I can remember that. So if I wanted to go out on a date, I had to wait 'til I got off. I guess I must've managed 'cause I got married.

I helped my grandfather and my father, and then I went next door and opened up a little hardware store there in '38. And my wife and I run that and I would just go back and forth.

When I had to put most of my time in over here, my wife ran that pretty much on her own then, and she did furniture and caning and sort of cut back on the heavy hardware. It fit in with the town, though, because it was going antique, you know, and regular stores were fading out. I would say Ellicott City is antique now—I mean all the shops are antique shops. In those days, you had drugstores and dry goods stores and hardware stores and more grocery stores. You don't have that type stores today here. So she sort of fit in with the times as she changed over there.

We took pride in what we had. We always figured we had the best in meat and tried to fix it up better—and delivery service. That was the big thing: take a truck and go all around the county. We had several trucks and certain days we'd go to a certain part of the county. And some places, like close by, we'd go every day.

We would buy stuff. Farmers always sent back potatoes or chickens, eggs, you know, whatever they raised. We'd usually come back with a load—we went with a load and come back with a load.

We bought a lot that way. We didn't have to go to town [Baltimore] to get vegetables as a rule, but we did go to town to get things that weren't raised here, fruit and things like that. And of course canned goods was the big item then and everybody bought cans of merchandise, and we'd always get our order from used to be called the wholesale market down on Market Place, strictly wholesale. They would bring us a order at least once a week and we'd go down to the fish market and get fish and crabs.

Well, we'd go to somebody's house—and we'd just go in and put the meat in the refrigerator or wherever. We'd pretty well know where to put their things. Most people paid by the month. We'd send them a bill the end of the month and that's about the way it worked, really. Wasn't anything to go to somebody's house and the door was setting wide open. Just go right on in and put the groceries in, that's all. You wouldn't do that today, not very likely.

Most people called every week, you know. We've always had a pretty good phone business. I guess ninety percent of the business was on the phones. If people didn't come in, they just called us.

And in those days, you picked the phone up and you told the operator what your number was. (I think you had better service than what you get today.) But we had a telephone operator, 'cause they had a little place here in Ellicott City, and if we were busy on the phone, lot of times she would take the order. And then when we weren't busy, she'd call and give us the order. (That would've been in the '30s, I guess.) And this is the truth!

I can remember the police chief, if he caught somebody down at the other end of the town doing something, he'd just send them up to jail. (The jail's right up on the hill here.) So he would send them up the street. Then he'd call me on the phone, 'cause he knew I was here, and he'd say, "Bladen, so-and-so's coming up the street. See that he goes on up to jail." So I'd wait and watch when he'd make that turn. Then he'd either call me back or I'd call him and I'd say, "Well, they're on their way up to the jail." He'd go up that Church Road there and go on up to the jail. So, that wouldn't happen today either, would it?

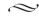

Yeah, it was Samuel J. Yates and Son then. That was my grandfather and my father. And we used that name until after my father died and the lawyer talked me into just making it Yates Market 'cause nobody knew what S. J. Yates and Son stood for, I guess. Yeah, I often think why I ever changed it, but it didn't say "groceries" or it didn't say "market," you know, just the man's name—which meant a lot for a long while. But over the years, a name don't mean, you know, individual person's name doesn't mean that much.

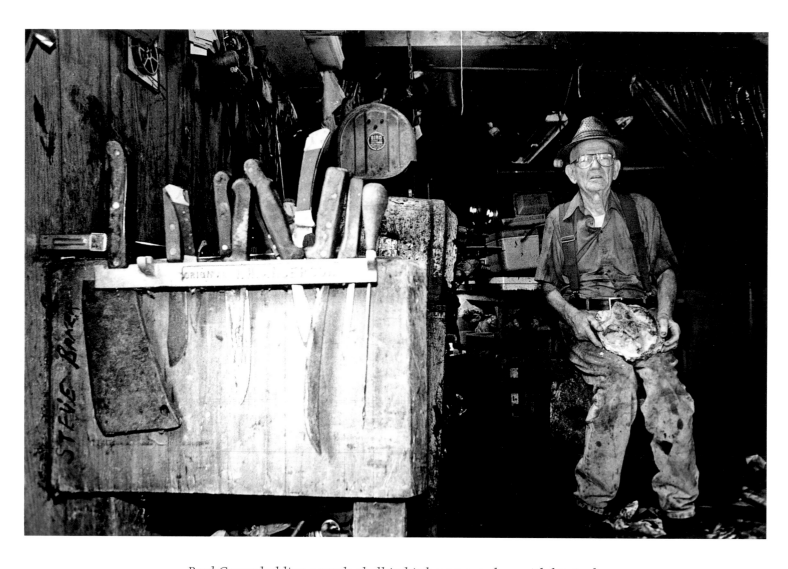

Paul Corun holding a turtle shell in his basement shop with his tools for butchering and dressing game, 1998.

William "Paul" Corun
(b. January 2, 1917)

Owner, Paul's Market

I was born behind the post office, which originally was a old livery stable and Wall's filling station. There was a row of like six homes in back of the post office and I was born in one of the six houses there. I can still remember it was very picturesque. There was a grapevine that run down to the Tiber River and the privies, the outhouses, straddled the branch of the river. It was a beautiful sight. You'd hardly know it was there 'cause the grapevines covered it up. And each house had a walkway to their own private outhouse.

At thirteen years old I went to work at the American Store 'cause I couldn't afford to go to high school. Had to get out and help raise the rest of the family 'cause my father only had one lung from working at the Daniels cotton mill and he couldn't work a regular job. So my father would take care of the old pot-bellied stove at the firehouse. As a matter of fact, he even drove the garbage cart with the old horse.

At day, he'd keep the fires and then, of course, on the side he was a bootlegger. He had the bootleggers to bring him the whiskey in the half-a-pints and put dried peaches in to color it. Then after it's all finished, he would take the top to the half-a-pint bottle and fill it

up and light it. You could tell by the color of the flame the goodness of the whiskey.

Pop would inform them when he wanted another five gallon of whiskey. But there'd never be a customer come to the house. Pop'd meet them on the street or meet them in the old fire department. He would have a place in the third floor cut away under the bed—put a rug over it.

As a matter of fact, the son of the chief of police of Baltimore County was Pop's supplier. As time went by, Pop was joking, he said it'd got one time so many bootleggers, they almost had to wear buttons so they wouldn't be selling to each other. You got the money, he's got the whiskey—in fruit jars, they were old fruit jars. Used to joke about fruit-jar drinkers? Well, what they were drinking was whiskey out of the fruit jars.

Hickenbottom Funeral Home, that's an old landmark. And him and I got to be friends over the years. He was older than I was and he practically treated me like a son. Him and his wife never had children and I would help him retrieve bodies and fill in for pallbearer and one thing another.

He'd come over to the store and he would say to my

boss, "Jim, I want to borrow Paul for maybe twenty minutes, half an hour." So I'd take my coat and apron off and I'd go with Hickenbottom, and him and I would go out and retrieve the bodies that died during the night or whatever. And then I'd come back and work in the store the rest of the time.

He invited me into the laboratory. See, we called it a laboratory where they did the actual embalming. And of course, me, being thirteen, was so squeamish and they would scare the devil out of me. They'd hide in caskets and moan and groan. As I got older I got tough, so then he would show me the autopsies. I witnessed almost everything. And of course, the blood and the offal went right into the [Tiber] branch.

To make matters more interesting, I took up taxidermy [through a correspondence course] and I did taxidermy work for twenty years. Hickenbottom the undertaker, see, he sent for the course.

<center>～</center>

I worked at Jimmy Brown's market on Main Street for, oh, like eight or nine years, and of course I got drafted. Then he was gonna turn the store over to me after I got out of the service, and two weeks after I got in the army he sold the store.

When I got out, people by the name of Sykes bought the store. They bought it for their son, and he didn't like the grocery business because it was too long of hours and too hard a work, so they turned the store over to me—lock, stock, and barrel. The only thing I had to pay for was the stock and fixtures. No mortgage, no interest, no nothing. And that was the result of being a loyal worker.

<center>～</center>

We had a thirty-foot awning—red, white, and blue—and, of course, we had the sign, Paul's Market. And we'd have a Coke machine on the outside. Business got so good we had a Coke *and* a Pepsi so we had two machines.

We specialized in fruit baskets, and live rabbits and live chickens, anything you could get in a cage. We'd put it out on the stand in front of the store and we could sell it. Whatever the farmer would bring in, I'd put it there and we would sell it. Or we'd slaughter them and sell them fresh killed.

So we built up quite a reputation. I'd jokingly say to them, if I could get an elephant in a cage big enough, I could sell it. So one day a guy, he had a monkey, and he come down, says to me, "Paul," he says, "I know you can't sell this monkey, but I gotta get rid of it." I said, "Okay, I got a heavy cage at home and I'll bring it down and we'll see."

All he wanted was seventeen dollars for it, so I think the first day I had about four offers. There were people saying, "Save it for me." I said uh-uh, I ain't saving nothing for nobody. Give me the money, you take the monkey.

So a really well-known man in Howard County (has a riding stable on Ilchester Road), he bought it and he kept it, I don't know, for years. It was a squirrel monkey, a small one—and he didn't like men. Any man tried to pick him up, he'd bite him. But any woman could pick him up and do anything with him. So, of course, Dick's wife had to do all the taking care of it.

<center>～</center>

Easter come along, we'd sell raccoons and possums. I'd practically give them away. We processed them for the people and then they would pick them up when they were finished or we'd freezer-wrap them. Two days a week, Tuesday and Wednesday, we devoted to freezer-wrapping. Monday's clean-up day, Tuesday and Wednesday was freezer day, Thursday you got ready for the weekend, and then, of course, your regular routine. We had all modern equipment. I had a Frigidaire ice-maker in the back that produced the ice.

As a matter of fact, this fella (he's a French chef in Washington), he'd get me to save all the blood from the rabbits in a quart jar and then put it in the ice-

maker, keep it chilled. And every week he would pick up at least a quart of rabbit blood and then he would put that in the gravy. I don't know how many years that he dealt with us.

And the odd part about it, when he'd come he would have new girlfriends with him every time—waitresses and all, you know. He would talk about, "Oh, they've gotta see this." So he would come, and the Lord knows how many girlfriends he'd have that would drive him (he was a elderly man), but he enjoyed it. 'Course, we did, too.

I would have contractors that would dig ditches and things like that, people that were building homes and one thing or another. They would run into these animals and they'd either bring them to me alive or dressed. And when I'd open the store up in the morn-ing, I'd look on top of this Coke machine. The guys would have cages and they would put these things up on top where people couldn't see them riding by. So when I'd come for work, I'd see what was my day's work ahead of me. Then they'd come around—and of course I'd pay them for the turtles.

I got one in the freezer down there now that I caught in the branch over here. The turtles we would dress for the people and then charge them for dressing it. Had a regular business going.

There's seven different kinds of meat in a turtle. I can open a turtle and I can show you—like chicken, veal, lamb, beef, pork, there's seven different kinds. If it's a young turtle, you can parboil it and fry it, and if it's a big turtle, you make soup. So I break them down and cut them in quarters. The kids would take the shells and I'd put straps on them and they'd have helmets and everything.

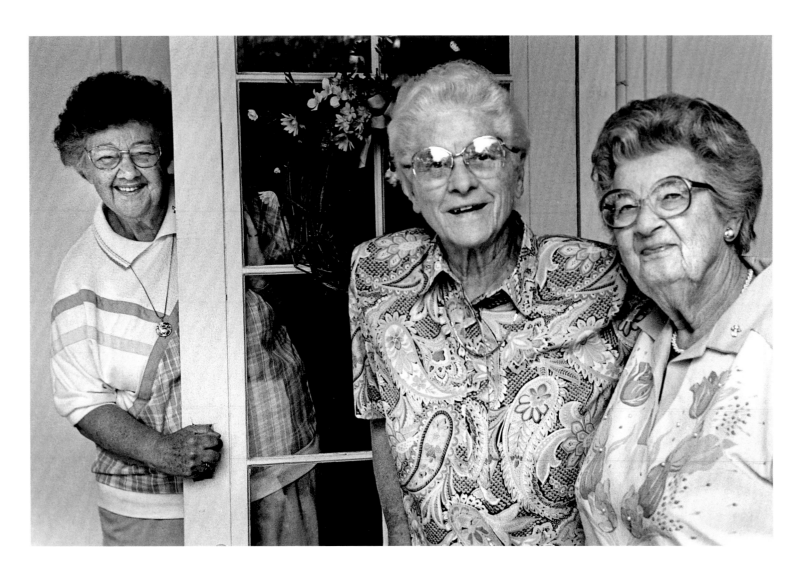

Wilhelmina Oldfield (center) at home with friends and housemates,
Mary "Betty" Lang (left) and Eleanor Dries (right), 1999.

Wilhelmina Oldfield

(b. July 17, 1913)

Howard County teacher, truant officer, principal, elementary school supervisor

When I went to sign my contract with the superintendent, he said he was sending me to Hell's Corner—which is really High Ridge Elementary School. And he said, "You may need a club this big." I can see him now put his arm out, he said, "You're very athletic. You may need a club as big as your arm!" And I thought, what am I getting into?

Well, he meant that there were going to be boys. See, they didn't pass you unless you passed that standardized test, so if you were in the seventh grade and you didn't pass, you just came back and did it over again. They milked cows before they came to school, they did farm work. They were big fellas, they weren't the little kids like you might see around later. One boy often took a nap in the morning on me, and it disturbed me at first until I was told how early he was up in the morning milking cows and doing farm work before he came to school. So you can understand that he might be pretty tuckered out.

The first thing that happened to me that was not very pleasant was that the sixth and seventh graders thought that they could get away with some things. And of course, in those early '30s, spitballs were well known. So I had a barrage of spitballs one day. And I said to the other teacher, who had more experience than I did, what do you do?

So this is what we came up with: I kept them after school, gave each of them a sheet of paper, and had them make spitballs. I'd go around, and if it didn't look like a good one, it went in the waste can. They got to the point they were so dry, they couldn't make a spitball. And it went to a hundred. Well, they never made a hundred, but I never had any more trouble with spitballs.

Some of these little country schools were one-teacher schools. A teacher who rode with me, I'd meet her at the B & O Railroad. She'd come from Daniels (it was then Alberton) and I would drop her off at what was called the Scaggsville School, which is where the Johns Hopkins applied physics lab is now, and then I would go on to my school. She had grades one through seven. Now she might have a grade with no one in it, you know, it would happen that way. But I was lucky to have four, five, six, and seven.

We had no time for after-school activities with the students because they walked home. Some of them

walked almost to Laurel—I think that would've been three or four miles.

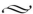

The first year that I taught we had a little outbreak of scarlatina [scarlet fever]. Sometimes when you have a very contagious disease, they don't let anyone in or out. It was around Christmastime and there was a lot of illness. Miss Proctor, who had grades one, two, and three—she and I got together at Christmastime. We wanted to give the children an orange, a nice size orange, and a half a pound of good hard candy. Can you believe that was a real treat in those days? And there were so many absent that we got in the car and went around and delivered so our youngsters would have that treat.

I was asked during the war to be what originally had been called the truant officer—who also supervised the black schools. We had two assignments. You had the whole county. (Now they call it pupil personnel, they don't call it truant officer.) I only did it two years, but it was so heartbreaking to me I could not have stayed in that position, because there was an influx of people from Appalachia and there was a different standard of living from where they came.

I went to one home down in the Elkridge area and I said to the mother, "Why isn't this child in school?" And she said, "I didn't have a poke for his lunch." And I had never heard this term before, and I thought for a while, and I said, "You mean you don't have a single paper bag?"—just taking a chance. And that's what it was. She didn't have something to wrap his lunch. That was her excuse. But they just weren't used to going to school. And to come into a group where you were expected to go to school, I imagine, was a little bit of a cultural shock for them. Eventually I think it all worked out, but it took time.

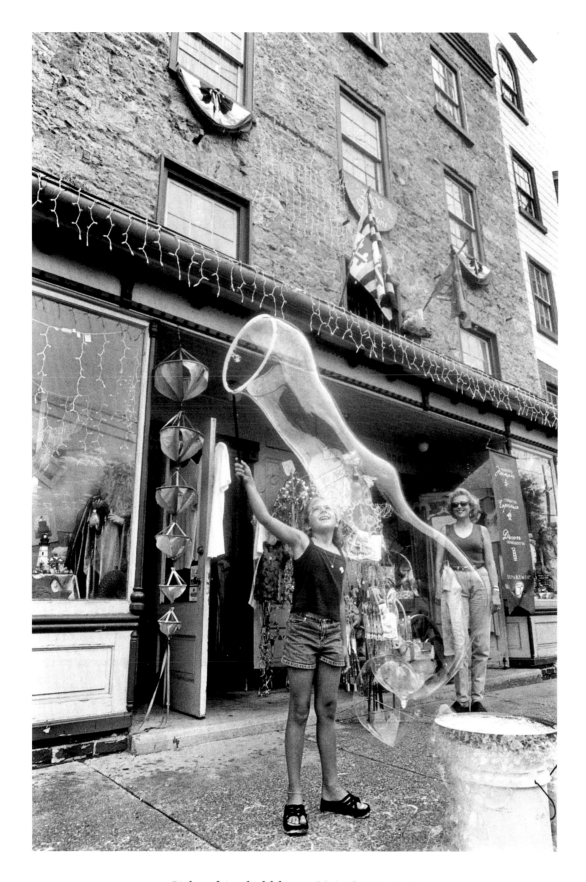

Girl making bubbles on Main Street, 1999.

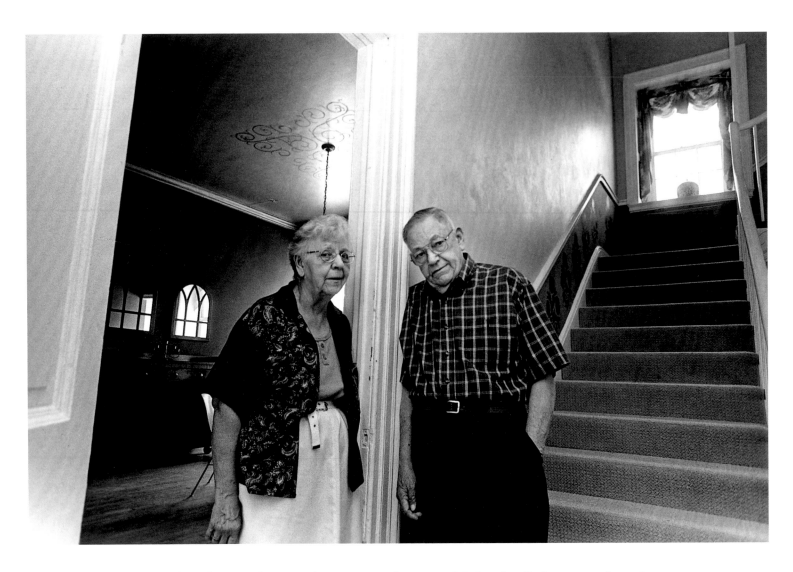

Frank and Lois Baker at Hebron House, the original Baker family homestead, 1998.

Franklin "Frank" Baker

(born August 21, 1913)

Dairy farmer

Well, I was born in Whitesburg, Tennessee. My father had a farm in Tennessee, and the neighbor and him—oh, two or three neighbors—got together and they wanted to get away from Tennessee, so they traveled around Alabama and different places. And one neighbor went to Alabama, and the other went somewhere out west, and my father come here and bought this place.

When my father come up here, he brought the cows along—Jersey cows we had. Brought them up here, and two mules and two horses, and we had them for years after we come here. The house is right back there—Hebron House, we called it, and that was the home place. We had 460 acres. Well, we were here from 1920 to 1938 before we got electricity.

We had a dairy farm until '52 and we had milk routes from about '29. My oldest brother was running the route. Delivered door to door and to stores. I was on milk route twenty years, from '32 to '52. I don't guess I missed three, four days in the whole twenty years—and seven days a week then it was delivering milk. You had to be up early in the morning and leave here about three-thirty, four. Sometimes you wouldn't get back 'til dark, all day long it was.

In the morning you would get up (that's before we had electricity), you'd get your lantern—you had your nice clean globe on, your lantern full of oil. Everybody would go down to the barn. In the wintertime, the cows was in the barn, and you go in and clean up all around them, you know, wash them off, and then sit down and milk them. Strain the milk into a can and then bring it up to the dairy and cool it. That was morning and night, seven days a week.

We had a icehouse and we got ice in the wintertime off the ponds, see. Put it in the icehouse and put straw over it, and every day you'd go out, move the straw, and dig down and get your ice. We had ice year-round like that, see, because it was down in the ground. Oh, I guess it was thirty feet down in there. And we'd get that ice out to put on the milk to keep it cold 'til we got electricity. After we got electricity, well, we had an icebox, you know, nice refrigerator to put it in, see. But we wasn't very big until we got electricity.

We had a horse and wagons for a couple years, but then after trucks come, why we had trucks and kept the trucks running and all during the war. If that wasn't something, wartime, you know, hard to get

parts. Well, we were lucky. We were getting tires from Montgomery Ward. Then the fella called up the day before Pearl Harbor and said they were gonna take stock of everything and to come in. We went in, got a whole truckload of tires, and then we would have them retreaded.

Oh, winter, that was something else. See, didn't have any tractors or anything. We had what we called a A-frame. It was about this high with braces across here, and we hooked the horses to it and drug them, and that would spread the snow out. But it would drift and then you'd have to go back over it again. We'd have to take everybody out and shovel it out to get out to the road. And then on the roads, they didn't have any snowplows. You just run over it and packed it down and wore it out. Oh, I was stuck all the time. Had to put chains on and take chains off and put chains on.

Dunloggin Farm over here, there's a fella had bought up, oh, I guess he probably had a thousand acres in there and it was timber. After he finished the timber, he started this dairy farm and called it Dunloggin and he started a herd.

Well, he had all kinds of money and he hired this fella, I don't know where he was from, but he was herd manager and he went and bought cows. Well, that breed of Holstein cows that he raised, there's still people around the country got Dunloggin breed, you know, cows from that Dunloggin Dairy. So it really started right here.

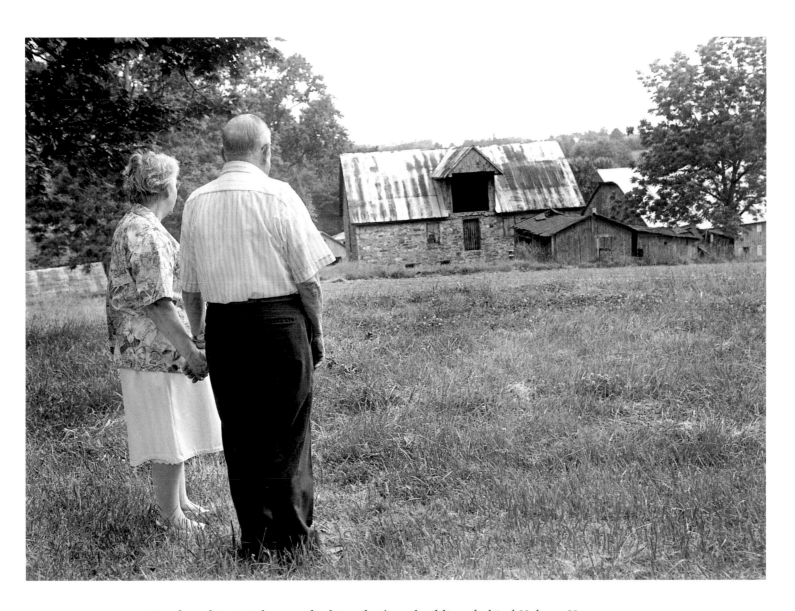

Frank and Lois Baker overlooking the farm buildings behind Hebron House, 2000.

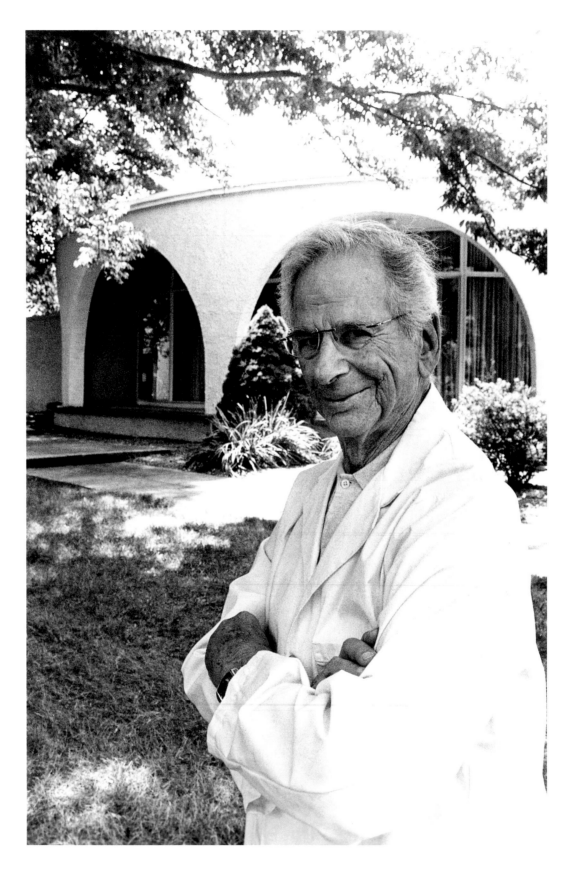

Dr. Irving Taylor on the grounds of Sheppard Pratt at Ellicott City,
formerly Taylor Manor psychiatric facility, 2005.

Dr. Irving Taylor

(b. February 25, 1919)

Psychiatrist and medical director, Taylor Manor Hospital;
assistant professor, Johns Hopkins School of Medicine

My grandfather's name was Toller. The immigration official said how do you spell it? And my grandfather didn't know how to spell it in English so the immigration official put down what *he* could spell. And I'm sure when my grandfather said Toller it probably sounded like Taylor, because he didn't speak English at that time. He came from Russia in the 1880s to Baltimore—and he was a tailor in Russia.

My father grew up in East Baltimore and left the sixth grade to sell newspapers and help his family. He went to the Pennsylvania College of Optometry without ever going to high school and he became a doctor of optometry. He also studied engraving, watch making, and jewelry making. And then in 1912, he borrowed five hundred dollars from his father—found out there was a small jewelry store here in Ellicott City for sale by a family named Rosenfeld.

Ellicott City is built on granite and it's in a stream valley, so it could never be an ordinary town with streets that go off perpendicular to Main Street. The streets had to go off at an angle in order to go up the hills. And the stores on one side of Main Street were up against the granite hill. On the other side of the street, some of them were built over the stream. And that stream was called the Tiber River, which flowed into the Patapsco. So Ellicott City had a Tiber River and seven hills like Rome.

My future mother, Rose Caplan, lived across the street from my father's store. She was a Peabody student and also taught the piano. And in those days, the windows were open in the summertime and he heard her playing the piano and that fascinated him. Eventually they met and then married in 1916.

Well, I was born February the 25th, 1919. And all of my life was spent in Ellicott City—in the *second* store my father had. He rented the first store and then he moved two doors up, rented another place. Stayed there for a few years and then built a place across the street. Then the store that has the Taylor sign on it now was built in 1924. So I started working there at the age of five and I lived over that store through elementary and high school and college.

Main Street was our playground. Oh, we climbed the rock all the time. In the summertime, it absorbed the

heat and it kept the heat even later in the evening. And when I was growing up, Main Street was paved with Belgian blocks. Belgian blocks were big solid blocks of granite, about three times the size of a brick—and thicker. There was a water pump in front of Caplan's store with a horse trough and the farmers would come to town and hook their horses up there—and the horse would get a drink and they'd go shopping in Caplan's.

There were three other dry goods or clothing stores beside my grandmother's and all the clothing stores were kind of in competition. The Caplans were a classy store—they were the most *modern* store, for a little town. They had Hart Shaffner and Marx suits, Florsheim shoes, Manhattan shirts, Stetson hats, Hanes socks and underwear, and this was first-rate merchandise.

My uncle Sam Caplan later ran my grandmother's store. And he was kind of Mr. Ellicott City, Mr. Howard County. He knew the farmers, he knew all the other businessmen—because, you know, when people come in the store, you talk, you hear stories.

Of course, I never bought anything until I got married because my grandmother and uncle never charged me for anything. Uncle Sam made me a tailor-made suit from an English-American tailoring company in Baltimore. I picked it out from a little swatch of fabric. And I took my wife out in that suit—my first date when I wasn't in hospital clothes—and she said it looked like a Christmas tree. It looked funny made up, you know, all the colors in it.

∼

My father was not content with just being an optometrist and a jeweler. In the third store, he incorporated musical instruments—guitars, violins, mandolins— and records, which were very big then. When we outgrew that store, we still sold records, but in 1924 or '25, radio came in. I remember we sold Atwater Kent and Fada. Until we got an outside aerial, we had to carry the sets up to the third floor, because the first two floors of our store had metal ceilings and you couldn't get any radio waves through those. So then when we put up an antenna, we could have the sets on the first floor of the store. They were battery-operated, of course, and had three dials. You had to get all three dials tuned in to get your station.

But in the more modern store, we had four booths: one was the optometry booth, which could be darkened completely. The other two were soundproof listening booths where people could go in and listen to records and it wouldn't upset the rest of the customers in the store. And the fourth was an open booth that was our business office. Otherwise, the store was wide open and the jewelry counters were on one side, furniture was in the middle, radios were across the front of the store, washing machines on another side.

And, of course, people would come in and sit on the furniture—and we lived upstairs, so my mother would come down. She always had a little pocketbook with her and she would put it under a cushion of a particular sofa and forget where she put it. So we would be looking under the cushions—we had maybe a dozen sofas around there. She wouldn't pick the same sofa all the time, because she didn't want to leave her pocketbook exposed in the store, so we were always finding her pocketbook.

∼

Our apartment was on the third floor and we had a kitchen on the second floor, along with furniture and a rug department, a big rug rack, and other things. The kitchen was on the second floor so we didn't have to run so far, because while we were eating in the kitchen, one of us would sit on the steps and watch the store. Customers weren't that frequent. When a customer came in, you would run down the steps or you'd call your father or mother and they would go and wait on them. But I started waiting on the store when I was five years old. I'd stand on a stool behind the jewelry counter and greet customers.

I maybe had one Saturday night off a month, sometimes not, 'cause Friday and Saturday nights were our biggest nights. The mills paid off on Friday, and they would come in Friday night and we'd cash their check, and they'd pay fifty cents or a dollar on the account. Some accounts we went to their homes and collected; others, they liked to come in the store. It was kind of a little social thing for them. They came in and they talked a little bit and paid on their account. We got to know everybody personally. Then Saturday night, the farmers would come in or the mill workers. So Friday and Saturday we were open 'til eleven, twelve o'clock at night.

And Sunday my father took off and we went to Baltimore, to Lombard Street, and bought kosher foods. My mother would ask the butcher every week, "Is this meat fresh?" And every week he would tell her, "Absolutely, Mrs. Taylor, this is the freshest meat you can get." Or we would take chickens—which my grandmother had raised in her backyard or we bought from a farmer—in to the *shokhet.**

My mother kept kosher—two sets of dishes, two sets of towels, everything. But my father—because he and my Uncle Sam were two of the founders of the Ellicott City Rotary Club, they never missed a meeting—they ate whatever they had there.

You had to work on the Sabbath. My father did the best he could under the circumstances. We would all get together for Passover, at my grandmother's usually, and we went to Baltimore for Rosh Hashanah and Yom Kippur. My father wanted my brother Harold and I to have a Jewish education, so he hired a teacher to come out three times a week on a streetcar. Maurice Shockett rode the streetcar three times a week and gave us a Hebrew lesson for an hour and a half or two. And after I was bar mitzvaed I continued on until my brother was bar mitzvaed. Usually they had to send the maid out to find us—we were playing ball or something. We

*An individual who performs the ritual slaughter of animals according to kosher requirements.

weren't too particular about keeping the appointment.

When I went to school, elementary and high school students were all in the same building. And at no time were there more than a half a dozen Jewish kids of the four hundred students in that building. In fact, in the last couple of years, my brother and I were the only two.

I was surprised there was so little prejudice against me as a Jew because I went to school during the Depression and, you know, people were really pretty hard up at that time. In the county, since they were mostly farmers, they weren't starving like they were in the city. There were no soup lines out here. But when you're in the jewelry business and you had your gold on display in the window, people knew you had something—and it was surprising.

But my father would examine somebody's eyes, they couldn't pay for the glasses, so we got maybe cream every week for a couple of months, or eggs, or chickens, or whatever in exchange. Taylor's had a good reputation because, although we had a good many credit customers, when the mills shut down in the Depression, we never repossessed any of the merchandise like the big department stores did in Baltimore. They repossessed; we said, look, you're good people, the mills will reopen one day. And they did. We had some people would come in and pay us a nickel a month or come and say, "I know I owe you money and when I get a job, I'll pay you." And they became our very good customers forever.

People would come out to Ellicott City and my father would sell them a ten-dollar wedding band, and if they were Jewish, they would get married in my grandmother's store. Usually they'd bring a rabbi out with them. If they weren't Jewish, I took them to the preacher up on Church Road to get married. So second to Elkton,

we were the marriage capital of Maryland. I don't know why, but it was easy to get married here, easy and convenient—courthouse, Taylor's store, the preacher.

My father had a good reputation in the community. He was a civic servant and he was a member of the original volunteer fire department—and he was the founder of the public library system here. He built this movie theater on Main Street. At that time, in the '30s, it was a modern movie theater. There was another theater down the street, the Earl, which I had gone to as a kid. Then he formed a partnership with another fella who had no money, but who knew the movie business and knew how to sell popcorn and candy. They started a small movie in Middle River, one in Sykesville, and one in Eldersburg, and then they later bought out the second movie in Ellicott City. At one time, they had five little movies.

When I went to medical school, I lived at Taylor Manor Hospital, which was then called Patapsco Manor Hospital. It was originally called Patapsco Manor Sanitarium and was started by Dr. White, a Canadian physician, in 1907.

Dr. White had run a twelve-bed sanitarium—it was always a mental institution. He died in 1938 and in 1939 it went up for sale. My father found out about this and he said let's go up and take a look at it. And the next day we bought it. So, I left my house—the apartment over the store—and moved into a patient room here. I lived at the hospital and I would mow the lawn and rake the leaves and do other things. I literally knew this place from the ground up.

So in 1940, a year after we bought the hospital, we got as a medical director a Hopkins professor, Dr. Leslie Hohman. It was his idea to name the hospital after Philippe Pinel, who took the mentally ill out of prisons in 1791 in France and put them in an asylum. So from 1940 to 1954, we were called Pinel Clinic.

And in 1949, I became medical director of our hos-

pital. (I was thirty years old.) I didn't want to put the name Taylor on it, but after we built the new office building here in '54, they convinced me to call it Taylor Manor. My son Bruce took over in 1979.

Two-thirds of our patients for many years have been adolescent because we established the first major adolescent program in the country in a private psychiatric hospital. We didn't mix adults and adolescents together, which other hospitals did at that time, so we were innovative in that respect.

And we evolved our own cottage plan. See, most of our patients who came in before the adolescents were psychotic, so they all started out in the closed building on the first floor. As we got to know them and they could be trusted with more privileges, they went to the second floor, which is kind of a convalescent locked floor. Then they graduated from there to an open cottage where they could go in and out of the building anytime they wanted. And then from there they went home. So it worked very well, unlike going to another hospital where you went to a room and that was your room until you left. This way, the patient was promoted through the system and you got better, you could take more privileges.

After managed care came in the late '80s, we lost money for a number of years and I wanted to sell or close the hospital. Everything we'd built up for fifty years was going down the tubes. Bruce was here and he said, "I like what I'm doing and I want to keep it up." So in 2002 we sold the operation to Sheppard Pratt, but we kept the buildings and land. I'll tell you, the good thing has been they took over ninety-five percent of our staff, and Bruce still works at the hospital.

I think the two worst things that happened to Ellicott City were they took the streetcars off—and [US] Route 40. Then shopping malls grew up and Ellicott City just kind of went downhill, a lot of empty shops. That's how I got started with my father and Uncle Sam buy-

ing places in Ellicott City—by accident. Those shops right as you come into town from the lower end were vacant. I said, people coming to our hospital, they pass these stores, the windows are decrepit looking. Let's find out who owns them and wash the windows and put some kind of display in them so it looks like somebody's alive here.

Well, those five old granite buildings that used to be part of the hotel that had burned—people came out on the original trains to stay there—went up for auction. So we bought them. And then we formed Historic Ellicott Properties. And whenever anything would come up in Ellicott City, we bought it. My father and Sam Caplan and I were Historic Ellicott Properties and we fixed up so many places it's amazing.

Many people in the area don't realize that the Taylors had nothing to do with that store for over sixty years now, because it has our name on the front. The store signs will stay there because they've been deemed historic value. The warehouse around the corner, Taylor's warehouse, where I spent a lot of time with rugs and mattresses and bedsprings and whatnot, now has a restaurant in the bottom. Who would think?

There are so many things we could talk about Ellicott City. It was an interesting town. We're never done because it's a bottomless barrel. When you live to be eighty-six, there are so many stories. You have to be careful because you can turn people off telling the stories. So many things happen that remind you of something—and that's how the stories come up, they remind you of something. One of the problems when you get older—you remember these ancient things, but you can't remember what you did yesterday.

Well, listen, I may live now in Baltimore County, but my home is in Ellicott City. I've spent all my life here. I mean, I only went to bed in Baltimore County. It's in my heart in some way, I can't tell you—it's home.

Gertrude Caplan with her nurse and portraits of her and husband,
Sam Caplan, 1998.

Gertrude Caplan

(born May 19, 1909)

Owner, Caplan's Department Store

My mother-in-law lived one year after we were married and then, when she passed away, I took the business over more or less. I did the buying, selling—I did every bit of everything in that store.

Well, when I saw the old-fashioned windows and things, I found the window trimmer who trimmed them. I had him come out once a month. And I don't know whether it sat well with my husband, Sam, the way we fixed the place up, but I made up my mind that we were going to modernize a little bit. Many a time I went over his head, many a time.

Upstairs, there was two rooms full of mannequins. They were all no good, no good at all. They had broken feet and broken hands, all kinds of disrupted mannequins. I dumped every bit of the stuff that was there.

Sam seemed to drop the department store when he took up real estate. He took on the real estate and I was running the store. That was the sort of division between the two of us: I took the store and Sam took over the property.

Enalee Bounds at Ellicott's Country Store, 1998.

Enalee Bounds

*Owner, Ellicott's Country Store**

My mother called me one day and said, "I really would like to open an antique shop." I was always interested in country stores because I felt that they were part of history. So I said, "Well, the only way I would consider it is if you did something along with it, like a country store." So she said, "Well, I have found a place in Ellicott City."

And at that time, Ellicott City was sort of drab. Almost every building was painted white with black trim, a lot of the stores were boarded up. As you can imagine, the streets gave off lots of dirt and dust. Well, I guess it intrigued me because of the history and the location—the winding roads, and the fact that there could never be any modernization, 'cause you have the rock on one side and the river on the other. So I mean, how much can they change it? I mean, it's built on solid rock.

So we rented this first floor only, we started out with the first floor. And my mother put in all of her antiques and we put in some money—not a lot, believe me. A thousand dollars, I think. Only had a few things on every shelf. And that's how we opened.

It's funny, I didn't realize at the time that we were probably real pioneers in the field and probably had a lot of nerve. But it was fun and then we gradually met lots of people who encouraged us.

Mr. Caplan, he owned most of the buildings in town at that time. And if I would go and get a lot of furniture, and I didn't have room to store it, so I would say, "Mr. Caplan, I've got a fabulous opportunity to get some beautiful antiques."

At one time we had stuff that came out of a palace, and I said, "Would you like me to decorate your windows?" So he said, "Sure, you can do anything you want." I said, "I think it will help you rent them faster if they look nice." So we did. He would let me have a couple windows and I would fill them up with furniture and decorate them, and that helped a little. It spruced up the town a little bit, I think.

Well, when we first came, the gentlemen who were in town, I understand that they took bets on how long these two ladies would last. Some gave us a week, some gave us a month—and they're all gone and we're still here. If they don't know women!

*Ms. Bounds would not share her date of birth.

Senator Jim Clark at Clarkland Farms, Clarksville Pike, 2000.

Senator James "Jim" Clark, Jr.

(b. December 19, 1918),

Former Maryland state senator and farmer

Well, I was born to politics, I suppose. People in our family were always interested in politics. And I knew at a very early age that I wanted to be the senator from Howard County.

Both sides of my family have been in Howard County a long, long time. Mother's family came when the Ellicotts came to Ellicott City in 1772, because we're direct descendants of the Ellicotts on my mother's side. On my father's side, my forebears came here in 1797 and they settled near Clarksville. That's where Clarksville got its name. And the Clarks were always farmers. They did other things from time to time, but they always farmed in addition to whatever else they did.

We were so Democratic that if you won the primary, you were considered elected—and that didn't always prove to be true. We were so Democratic that Abraham Lincoln ran for president in 1860—only got one vote in what's now Howard County. And in 1864, he didn't do a whole lot better.

But you had to face facts: Howard County was a slaveholding county, as was a big part of Maryland.

There were some big plantations—some of the biggest in Maryland, I guess—but there were also a lot of free farmers who weren't slaveholders. But the Dorsey family had slaves and they had a lot of land, and the Carrolls. And there were a lot of people that had a few slaves—not great holdings, but they had some.

In the 1920s, my father was running for state's attorney in a close election. He needed every vote he could get. He had two maiden aunts and they were quite elderly, and he went over to see them. One was named Aunt Martha and the other one was named Aunt Annie. And he said, "How would y'all like to vote? Y'all have the vote now, I think you should vote." And Aunt Martha said, "No, I've been getting along fine without voting all these years and I don't think I'll start now." Aunt Annie says, "James, I think I'd like to vote."

So he took her down on Election Day and gave her a sample ballot. And then she came out of voting, and he got her in the car and he said, "Aunt Annie, how'd you like to vote?" She said, "James, I really liked it. And to make sure they counted my vote, I signed my ballot." And, of course, that nullified the ballot, so after

all that he didn't get a vote. But he won the election anyhow—narrowly, I think.

My father was state's attorney, ran a couple times in the '20s. He wanted to run for the state Senate but he figured it would cost him too much money, and he had his family obligations so he decided not to do it. And I think that's about the time I decided when I grew up I was gonna try to be the senator.

Well, 'course, the senator in the old setup in Maryland, when you had one senator per county, was very powerful because you couldn't pass any local law without his approval. And you couldn't get any appointment through Annapolis without his approval, so he was a really powerful individual. And as soon as anybody got in the Senate, then another group of people would start figuring out how they're gonna get rid of that person and get somebody else in. So when you got the power, there's always somebody wants to get you out of there and take over.

And that was true all over Maryland, I guess, because the same system existed: The senator had to approve all the appointments, you know, advise and consent of the Senate. And the governor—even the governor wasn't powerful enough to override the senators.

I was the only white senator that cosponsored the Fair Housing Bill in the early '60s and that caused me some problems politically, but none that I couldn't overcome. It didn't become law at that time. Verda Welcome was the only black senator we had—and she was a woman. Of course, it fell on her to introduce the Fair Housing Bill, and she wanted somebody to help her sponsor it. She said, "I gotta have at least one white sponsor and I think you're the one that ought to do it." And I said, "All right, Verda, I'll think about it over the weekend. I'll let you know Monday."

I came home and talked it over with my wife, and we decided that it was the right thing to do, and I went back and told her that I would do it. So her name and mine are on the bill, and we got it passed through the Senate, but the House didn't pass it. But we came back later and it became law. That meant a black could buy a house wherever one was for sale—that wasn't true before.

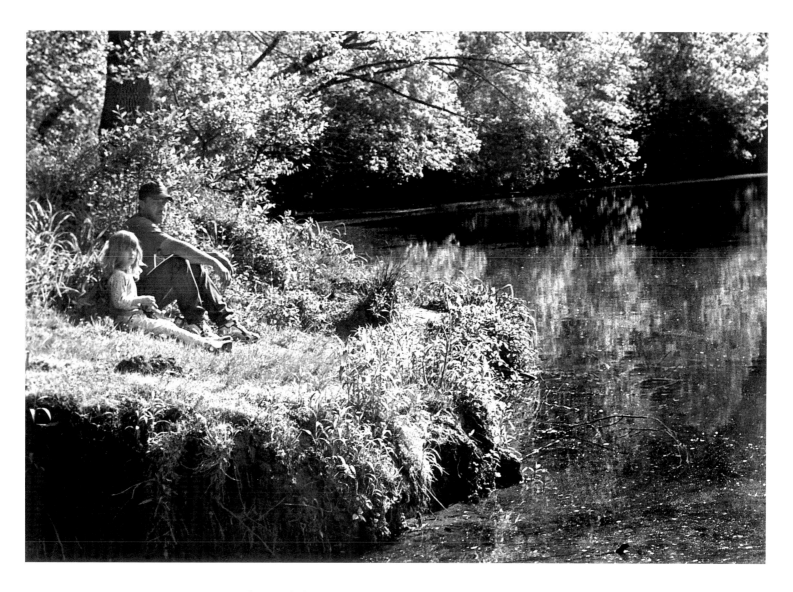

Father and daughter on the banks of the Patapsco, 2002.

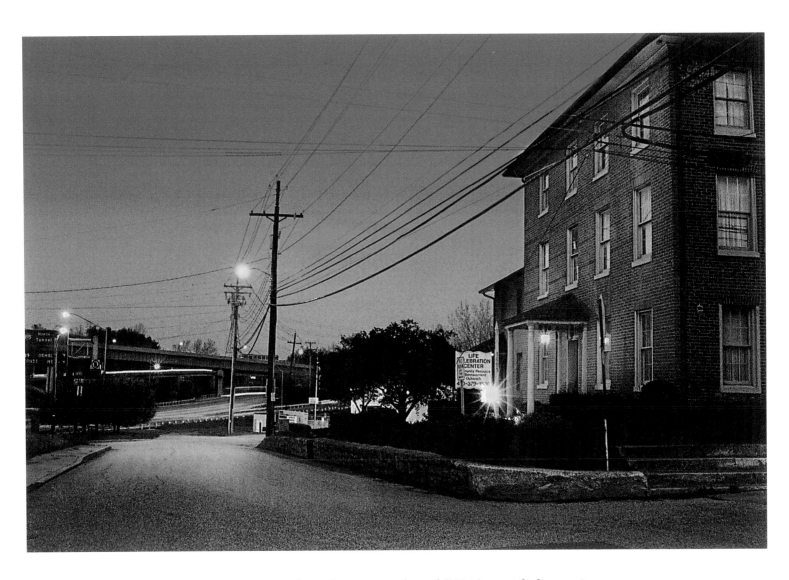

Main Street and Washington Boulevard (US 1) at twilight, 1998.

ELKRIDGE

Some places are harder than others to find. Elkridge is one of those places. Split in two by US [Route] 1 and sliced by an interstate and an expressway, the town hangs on a core strip of fast-food franchises, gas marts, shopping centers, and housing developments, a prefab proxy for its retired main street. More about movement than destination, the strip funnels you past Elkridge but doesn't take you there, doesn't even tell you where you are. Amid this generic sprawl, the only signs of authentic local life are the biker bar, a couple of vintage motels, and a few brick shells of faded businesses.

Back in the 18th century, though, Elk Ridge Landing, as it was called, was a going concern. A bustling seaport second only to Annapolis, the Landing was also the gateway to the Patapsco Valley. Tobacco put the place on the map, literally, just below where the lowest falls of the Patapsco met a deep and slow channel to the Chesapeake Bay, ideal for shallow-draft shipping vessels. When you reached the Landing, you had gone about as far as you could go by river. Here at the crossroads of water and land, a network of crude roads converged. Farmers rolled hogsheads of tobacco down these roads to the docks, where boats and barges waited to carry the cargo downriver to the harbor for shipment overseas.

At its peak during the mid-1700s, Elk Ridge Landing reaped big profits from its import-export trade and its iron works. The place prospered and its merchants and planters got rich. They built grand homes and filled them with imported furniture and china, linens and silks, all off ships that anchored right here at their doorstep.

But by the end of the century, its channel silted up and its glory stolen by Baltimore, its furnace on the wane and tobacco on the outs, the town went to

sleep. Revived in the mid- to late-1800s by the flurry of business that arrived with the Baltimore and Ohio Railroad, Elkridge was eventually bypassed by the new express trains, and later by the wide, fast roads.

Fix your eyes on the strip before you and you'll miss the place. But shift your focus to the peripheral view and you just might catch a glimpse of the old Elkridge in your sideview mirror. Off the strip, Elkridge reveals itself in layers, in moments. Pace and scale abruptly downshift as textures come into relief. A train slowly approaches, passes, and retreats. The bell tolls from the tower of St. Augustine's. Smoke curls from a fire department barbecue. A flag drapes a porch. Streets narrow, houses age, trees mature. Old-cut roads put down long before the highways, and resting on beds of crushed oyster shell, meander over the hills. And storied landmarks, like the railroad, assume the mantle of monuments.

Trains still pull through town on north-south tracks laid by the B & O, bisecting Main Street and forging a boundary between "upper" and "lower" Elkridge. In fact, no matter where you stand, the sight and sound of a train seems inevitable, as though one train were circling continuously around and through the town like a giant electric train set—now emerging from a tunnel, now crossing a bridge, now running along the river—suffusing the place with a distinctive soundscape: the percussive rhythm of engine and axles, the scrape of metal turning on metal, the squeal-hiss of brakes, punctuated by an intermittent melancholy whistle.

At the corner of Main and Brumbaugh, the latter named after the town's legendary doctor, stands his preserved two-story house, where generations came for cures and treatments. Nearby, tucked under the trees like an old country kirk, is the squat stone Grace Episcopal Church, its shaded cemetery harboring a who's who of Lawyers Hill bluebloods—Morris, Murray, Turner, Worthington, and generations of other Elkridge clans. Although the old families are gone, their manicured Victorian estates still sprawl up on "the Hill," across the river from Relay, while, down below and across the tracks, rows of shotgun houses and tiny bungalows front more humble lanes.

You can still find remnants of the town's original African-American community on and around Race Road, named not for the skin color of its residents but for the old millrace that ran from Deep Run to the Elk Ridge Furnace down at the Landing. Both the furnace and the race are gone, but the river—mostly silted up and not much wider than a good-sized creek here—still lures fishermen even though the gudgeon stopped running decades ago. Above the banks

where Elkridge meets Relay, the blackened but solid Thomas Viaduct still arcs across the Patapsco gorge. Once filled with water, it is now mostly a terrestrial floodplain of tangled understory and spindly riparian forest.

Change is the prevailing force here, and contrast—between old and new, insider and outsider—is the dynamic. In the midst of rooted neighborhoods and once open spaces, treeless new developments flaunt the borrowed and bastardized names of real Elkridge places—the Gables, Lawyers Hill Apartments—as if to create an illusion of continuity, an instant connection.

There are contrasts here, too, that reflect epochal changes—changes that measure gains, not losses. Perhaps the most dramatic contrast happens down by the river at the edge of Patapsco Valley State Park. There, at a certain point of optical convergence, the graceful, Roman-arched stone viaduct aligns with the lithe and sweeping concrete curves of the interstate. In this place and moment, past meets present, classical meets modern, and the means that have connected us over time—river, rail, and highway—find confluence.

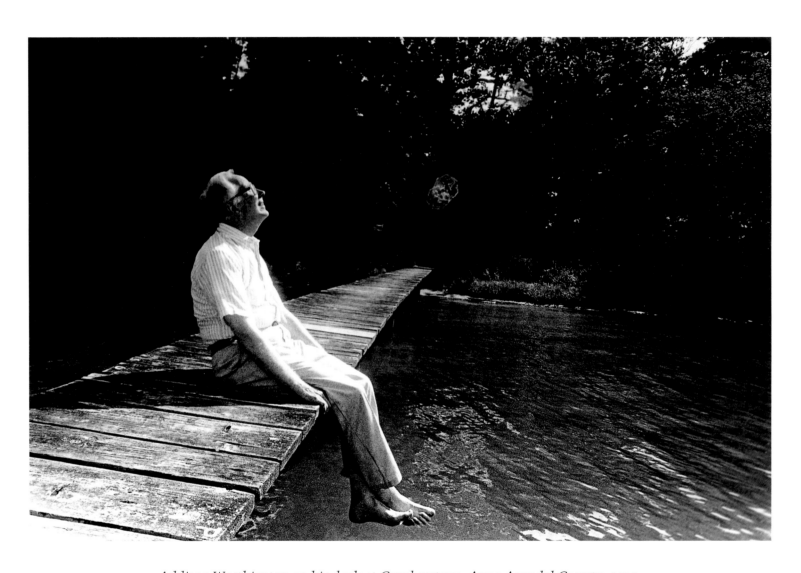

Addison Worthington on his dock at Cumberstone, Anne Arundel County, 2000.

Addison Worthington

(b. February 9, 1931)

Engineer; training supervisor and manager, Westinghouse and Chesapeake Instruments

The village was where the Baltimore-Washington highway went through, which was a two-lane rutted road originally, and where there were some stores later, gas stations and things like that. It was also, when I was there, where the school was.

It's interesting, the relationship between Lawyers Hill and Elkridge proper. Initially, Elkridge was the village and the mansion was Belmont, in the old English sense where the lord would live in the mansion and all the peasants would live in the village, and the village people would be hired to do work on the place.

The reason for Lawyers Hill's existence was, in the 1830s the first railroad was built by the B & O up the Patapsco River to a junction called Relay Station. A few years later, they decided to extend the rail line to Washington, so they built a bridge across the Patapsco at Relay, and they built a road from the Howard County side up the ridge and that was called Lawyers Hill.

The reason it was called Lawyers Hill was the early builders there were mostly lawyers. They were all basically Dorseys or Murrays. That's a common thread through most of the families of the area from the time of the Civil War.

All these people who came out to Lawyers Hill when the railroad brought them out, just before the Civil War, did not necessarily know each other. For instance, the Steads were an unknown. I mean, this was *terrible*, a Washingtonian moving into Lawyers Hill. But generally, if they were Baltimoreans, they probably knew each other to some extent, and they heard about Lawyers Hill—it's a nice place, there are good house sites available—so they moved.

Many of them were connected long before Lawyers Hill, even if they weren't connected by blood. Baltimore still has a very tight society. And, well, you've probably read some of Ann Tyler's books. That's Baltimore society. She's got it pegged. Like *The Accidental Tourist*, there's a typical family that's kind of dysfunctional and kind of odd. A lot of Baltimore society is pretty bad, I think. There's so much attention paid to social position and who your ancestors were, but that's been going on in Baltimore since the beginning.

But the people at Lawyers Hill, a lot of them looked down on the people of Elkridge, even into my time. The people in Elkridge also felt this and I think a lot of them resented it, felt that the Lawyers Hill people thought they were superior.

Everybody I was introduced to as a child was always "Cousin this" or "Cousin that" or "Uncle this" or "Aunt that." And generally they were. There was a lot of intermarriage, or just people who met people, at Lawyers Hill. My parents were third cousins.

At my time there weren't many kids who were full-time residents of Lawyers Hill. Leonard Bjorkman went through grades one through six with me, and then he went to Boys Latin because his parents felt he wasn't getting a very good education, which was correct. I stuck it out through grade seven.

Most of the kids in elementary school were farmers' children. Howard County was a farm county and many of them didn't get beyond seventh grade until they were at least sixteen, and they would all go work on the farm. When I finished seventh grade, my parents decided to send me away to a better school, so I went to a high school in Virginia. I went there because my father and uncle and six of their cousins went there, all at once.

~

Leonard Bjorkman, Dickie Dunlop, and I were all going to Elkridge Elementary School. Well, all three mothers were very strong in the P.T.A. because they figured this was a poor school, "We've got to go in and shape it up." They were all from different perspectives: my mother from the perspective of education, Mrs. Bjorkman from the perspective of religion, and Mrs. Dunlop from the perspective of class. These were the "lower-class" kids, and Mrs. Dunlop referred to the children as the "hill kiddies" and the "village kiddies"—we were the hill kiddies and they were the village kiddies.

Well, as children, *we* didn't feel this, I mean, we got along great with our classmates. Some of them we fought with, but it was not because of a class distinction at all.

~

I was not conscious how I was felt about by anybody there, unless it was a direct confrontation with some kid. That was usually over a baseball bat or something like that. As far as I knew, the Catholics had another school and we never had anything to do with them. The blacks, they went somewhere, we don't know where they went. We didn't see them when we were in school.

There were, of course, a lot of houses that had been servants' houses that were still lived in by blacks. Each main house seemed to have one and generally the blacks had lived in them. Sometimes they were employed by the big house owners, but sometimes not—they'd work somewhere else.

But the only blacks I had contact with were the older ones, the old family retainers, of which there were quite a few. My parents, they couldn't afford them, but a lot of the families had servants because they had houses, and they'd say, "Okay, you can live in our house if we can have one of your children work for us." It was in lieu of rent. It wasn't quite slavery—it was kind of on the edge of it.

As a child, it was usual to address blacks by their first name. I don't remember ever calling, or being expected to call, a black as *Mr.* so and so. And generally, they would call my parents, if they didn't know them well, Mr. or Mrs. Worthington. If they knew them well, it would be Miss Rosalie or Mr. Addie. And on some occasions, I was Master Addie.

~

My uncle was a game-chicken fighter and apparently well-known in those circles. He had a village of chicken coops, each one with a game rooster in it, and he would take great care of them. He was constantly training them and exercising them and feeding them special diets—and fighting them. They had the fights all over the country.

I didn't go to chicken fights often, but I did go to one with my uncle near Washington. Brooke Johns', I think

was the name of it, Brooke Johns' barn. This would have been in the '50s. Mr. Johns had a big barn where the chicken fights were held.

When we got there, there was a huge crowd of people, lots of cars, and inside was a sunken pit, the cockpit, with bleachers all around. It looked like a professional boxing ring and the chickens were fought in the ring. The bets were made and the chickens would go out and fly at each other a couple of times, and one of them would drop down dead, and that was it.

Then money would change hands. Occasionally a chicken would leave the ring in a hurry—which was, I think, maybe the origin of the term "being chicken." He would chicken out.

In any case, at one point my uncle had fought several chickens and won. (He always won, it seems to me.) We went out, took the winning chickens, which he kept in burlap bags, out to his car, and got some more chickens to bring in. And we saw this line of headlights coming across the field, so my uncle suggested we not go back into the barn but sort of take a walk—which we did, leaving the chickens in the car.

When we came back we discovered that where the chicken fighting had been going on, there was a barn dance taking place, with a flat level floor and a band. Some cops were standing around and police cars and so on, scratching their heads wondering what to do. It seems that lookouts had been posted for the police and there'd been a raid.

But of course, they found no evidence, and they hadn't looked in my uncle's car and found bags of chickens. And the chickens, fortunately, when they're in a bag, don't crow. None of the chickens acknowledged themselves. And then the cops went away, and the floor of the barn sort of folded down and exposed the seats, and they went back to it.

My uncle had a farm later in his life and his main crop was chickens—not the chickens themselves but their eggs, for breeding purposes. When my wife and I used to stay at his farm, he would go away for the

evening, Saturday evening, and we'd know he'd gone to a chicken fight.

On one occasion, he came back about three in the morning and we heard this celebration going on in the kitchen, he and my aunt. We got down there and he was throwing money around the room, just great packets of money, thousands of dollars. He had won the Eastern United States Championship and apparently it was worth a good bit. And the farm prospered for several years after that before it was all spent.

Another neighbor, [who] was named Daniel Murray, he became state's attorney for Howard County. My uncle, who was Daniel Murray Worthington, of course was the chicken fighter. And Daniel Murray got in a bad position where he had to organize a raid of my uncle's chicken fight and caught him—or the police did.

So the headline in the *Ellicott City Times* was "Daniel Murray Imprisons Daniel Murray Worthington." They threw the chicken fighters in the jail for the night—and also the chickens. The cops, not being very smart, threw all the chickens in one cell as a place to keep them, and of course the next morning they were all dead. They'd killed each other.

There was a store, we called it the Pink Store because it was pink. It was Sewell's store for a while and Mr. Sewell had one arm. His missing arm was kind of interesting, especially to children. He would sort of flap it. I don't know whether it was intentional or just something he did. But while he was flapping it, he was writing up your totals on the brown bag—and raising the prices a little bit or cutting a little bit off the meat so he didn't give you as much meat as you were supposed to get. And nobody trusted him.

I don't know how much that distrust was valid, except that during the war, of course, we had meat rationing among other things. And Mrs. Howard Bruce, who

was superior to anybody around, was going to have a party and she wanted to get steak for the party—and she wanted lots and lots of steak. So she went to Mr. Sewell, who was delighted to sell lots and lots of steak. Of course, he supposedly asked her for her ration cards but she didn't give them to him.

At the time, there was a plainclothesman in the store who was there for the purpose of checking on Mr. Sewell and, of course, nabbed Mrs. Bruce. And Mrs. Bruce being Mrs. Bruce did not suffer any consequences as a result, maybe a slap on the wrist. Poor Mr. Sewell, I think he went to jail for a while.

My grandmother lived in a house that was called The Cottage. The reason it was called The Cottage was because my great-grandparents bought it when they were married in the 1850s. There had been a cottage there and a little sixteen-acre farm. The little cottage became a big house; the little farm got half of it chopped off for the interstate highway and an access road.

But whenever an old lady of the family would be widowed, she would move in with my great-grandparents, usually their sister or brother or something like that, so the house grew. They built a house around the little house. And then, because it was desirable to have the kitchen separate from the house—mainly for fire reasons, so if the kitchen burned down it might not catch the main house—there was a kitchen wing added. And there were rooms added over the kitchen for servants. The cook lived in and the butler lived in.

She had a black family living on the place that did a lot of the work for her. A man by the name of Jim Fields was the father of the family, his wife was Nellie, and I believe they had fourteen children. Jim became the minister of what was known as the Purple Church, which is on Montgomery Road. It was a black church painted purple.

Jim had a great deal of influence on me. I would follow him around like a dog. If he hitched up the horse to the wagon to collect hay, I would get in the wagon. And when I was very small, I would just get in the way, but later I would help. He lived in a little cottage which my grandmother gave him, free, at the bottom of the place. It probably had been a slave cabin originally, or at least a servant's cabin.

Jim would, fairly early in the morning, stop by the spring which was downhill from the main house, and he'd carry a bucket of spring water up to the house and it would sit in a place next to the kitchen—every day we always had fresh spring water. Jim would then get his orders what to do today, and at the end of the day he would report to my grandmother what he had done, and pick up the empty bucket and take it back down for the next day.

Nellie, his wife, would work when she wasn't too pregnant, doing laundry and things like housecleaning and occasionally cooking.

Jim asked my grandmother if she could use his son Robert in the house and she made a deal with him: Robert would come live in the house, live over the kitchen, and would learn to be a butler and a manservant and so on, which he did.

And Robert was a really very intelligent person, very nice to me as a much younger child, and a good student of my grandmother. As a matter of fact, Robert was drafted in World War II, and when he went in, because of his experience, he was made a general's aide, or general's servant I guess, and progressed through the army quite well. I think he retired as a major.

My mother was very active in Planned Parenthood way back then. She opened up a clinic in Ellicott City, but nobody would rent to her. She finally rented from a Jewish family who owned Caplan's Department Store, they rented her the upstairs. And so I first became aware of the Jewish people being discriminated against.

My mother was very aware of it. She was very liberal in politics and things got pretty bitter. Later, she was

attacked by the local Catholic priest and was reported, to whoever you report people to, as a Jew, an atheist, and a Communist. I don't know which was worse as far as he was concerned, but the combination was terrible. So my mother was actually investigated for a while. I mean, it all blew over. People knew it was absurd, because she didn't happen to be Jewish and she was definitely not a Catholic or a Communist. Well, she *was* an atheist, but 'so what' was her approach.

The real end to Lawyers Hill was I-95. That killed it as far as we were concerned. It cut us off from our neighbors and totally disrupted the neighborhood, drove a number of families out. The last old resident to live in Lawyers Hill was either my Uncle Teddy Morris or Edward Stead. The Hill, as we put it, was gone.

You won't hear that now if you talk to the people from the Old Lawyers Hill Road who consider themselves, many of them, oldtimers. But they were generally there after we were. There are very few, if any, who were connected with the older families. And it's not just lineage, but also association of my parents, my grandparents, my great-grandparents, with the neighbors.

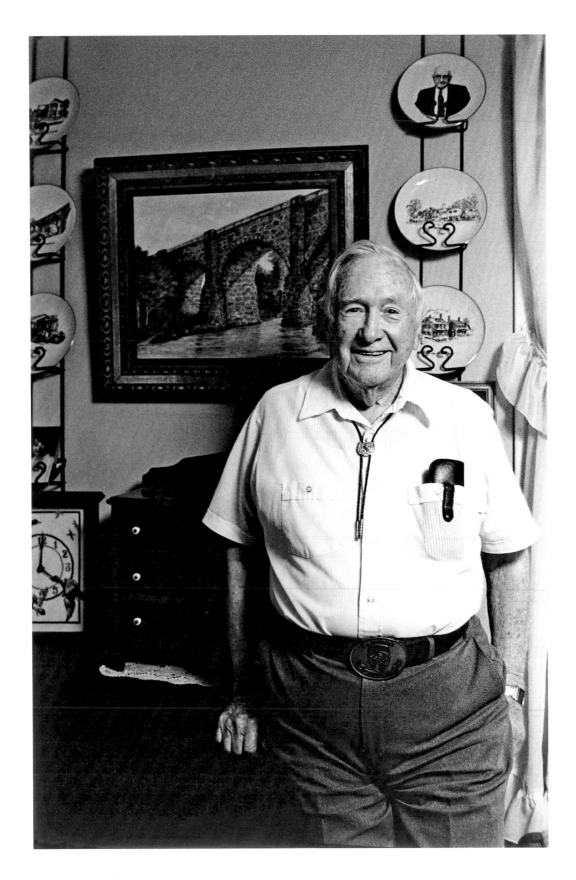

Willie Amberman with his painting of the Thomas Viaduct, 2000.

William John "Willie" Amberman
(b. July 5, 1909)

Chief clerk, Medical Division, Maryland State Police

I was in the sixth grade or something like that and then we moved to Elkridge. And when I say country, I mean *country*, because to go to the bathroom, you lit a lantern and went outside to an outhouse, which my father built before we moved there, thank goodness.

We lived in what they call West Elkridge, which was near a little town called Harwood. The train was very popular. We were closer to Harwood than we were to Elkridge Station. In fact, Elkridge Station was pretty large. Now Harwood was nothing but a lean-to just to keep you out of the rain.

And if you wanted to go in town at night, for instance, you had to take a flashlight along with you to flag the train down. If that engineer didn't see a fire or a candle or something like that waving up and down, he didn't stop. He just kept right on going and you missed the train, 'cause he didn't back up.

I don't know what date we moved, but I know it was in August of 1921. I remember it very vividly because I was just a kid, twelve years old, and going to a brand new school in September, the day after Labor Day.

And because I had something wrong with my scalp, my father and mother were advised to have my head shaved prior to moving to the country, which they did.

So I went to school with a shaved head in a brand new school. And I didn't know one soul. So I was immediately monikered the Baldhead Eagle.

The high school was nothing more than one half of a house that had been converted into a classroom. I attended there for two years and then, due to financial conditions, I had to help out at home, so I had to quit school and help out on a twenty-five-acre farm. 'Cause my father still maintained his blacksmith shop and wheelwright shop, you might call it, which was building wagons, repairing wheels, putting new spokes in wheels, etcetera. I helped my father in the blacksmith shop so that I started learning the trade, too. I learned everything except nailing the shoe on the horse. My father thought that was too risky a situation, possibility of laming the horse, so he nailed all the shoes on. I would prepare the shoe, fit it, weld it, make it, and prepare the hoof of the horse before he arrived home, and then he would nail the shoe on.

Well, there were all kinds of horses. My father shod everything that was into the shop. For instance, I don't know whether you recall the horse's name, Billy Barton, who was a steeplechase horse? Well, my father used to shoe him. He was owned by a very prominent

man in Howard County. I never touched him 'cause he was too frisky and I was afraid of being kicked.

We had show horses coming in, and then they didn't want to bring the horses to the shop a whole lot 'cause they had to ride them too far. So then he fixed up a forge and the whole blacksmith outfit on the back end of his truck so he would be a traveling blacksmith. That's what he did the latter part of his life.

I got up about three-thirty, four in the morning because I had three cows to milk. We always had about 800 to 1,000 chickens, and we had two horses and a mule. We didn't call him a mule, we called him a jack-ass. His name was Jack and he could tell the time, because you'd get Jack out in the field and you'd have one more row to cultivate, and you'd turn him into that row to cultivate it. And if it was noontime, he would turn around and look at you, and you'd say, "Come on, Jack, only one more row." He wouldn't do it. He would turn the cultivator around and head for the barn—you, cultivator, everything, would go to the barn. I think he could tell time 'cause he wanted to eat, he wouldn't finish it. They say 'as stubborn as a mule'? They're right. He was a wonderful worker, but come twelve noon, he wouldn't finish it.

Yeah, we had hogs one year and then after that we didn't have any more. They got loose a couple times, and believe me, chasing hogs is no picnic. I had to chase them, and we had to round them up and get them back in the pen. Hogs are funny, though. They're very intelligent animals because they knew exactly where they got out of the pen. And when I rounded them up, which was, oh, I guess eighth of a mile away, and started them back—it was about twenty or twenty-five of them—they all knew exactly where they got out and went right back through it into the pen.

Dr. Brumbaugh, he looked like a country doctor—short, medium-build—and drove a Model T Ford. He not only had office calls, but he also made house calls to anyone. I don't care who you were, what race you were or anything, he made house calls—and any time of the day or night.

For instance, we had a couple bootleggers in Elkridge, and one bootlegger by the name of James had a still in the little stream that runs back of our place. And in those days, if you turned them in, you got fifty dollars from the authorities. So his wife would turn him in occasionally, see, to collect the fifty dollars.

Well, he would serve his time and then come back and beat her up, and she would come down to my mother's place all beat up, crying. So my mother would call Brumbaugh. He would come up—and our lane was so muddy that he was afraid of being stuck in it, so he would ask that I meet him at the end of the lane with the lantern and then walk him in. So that's what I would do: I would light the lantern and meet him at the end of the road. He'd park his little Ford and we'd walk in and he would take care of Mrs. James. And then Mom would keep her, oh, maybe two or three nights, and then he'd come back maybe the next night or so to see her and then she was okay.

And then by that time, why James, he would have forgiven her, and come back down and say, "Why don't you come back home, honey?" So she would move back in with him—until the next time that she would turn him in. And that happened regularly.

Hecht was another one. In fact, I used to cut hay on Hecht's place, so I knew where his still was. It was down in the woods and along a stream—had to have water.

I saw more money on his table than I ever saw in my life. They were bringing money in bushel baskets. (This was about 1923 or 1924.) I went into the kitchen to get a drink of water and here's six men sitting around the kitchen table, and another man then came

in with a bushel basket filled with bills—twenties, fifties, hundreds. And he dumped them on the center of the table. It had to be thousands of dollars.

They would sell their bootleg stuff in Washington. They were gentlemen personified, they were all dressed up, you know, ties and business suits? And they were counting the money—I suppose dividing it up among themselves.

I know my father delivered some. In fact, the sheriff sat on a case of booze coming in town one time when he flagged my father down. My father had this old Ford and the case of booze was sitting there with a blanket over it. That was the only seat available, so the sheriff sat on the booze.

They stored it in our house on occasions, because they brought an awful lot down there one time. And it was pure white, which is good moonshine. It had to be colored, you know, because you can't sell white moonshine. So you know how they color it? Burnt sugar, which is harmless. A teaspoonful of burnt sugar will color a half a gallon jar, and it all came in half-gallon jars.

I used to do it. It gave me something to do in the evening, sure, just coloring the booze. It was only on this one occasion that I recall, and we must have had about, oh, I guess maybe fifty or sixty cases. Each case held six half-gallon jars and I had all that to color with burnt sugar.

While I was furloughed from the B & O Railroad, I did a huckster route for about six months. I made more money than I ever made in my life. I would go down to the wholesale market about three in the morning, buy produce, and then bring it home. And then I run it Saturdays and Wednesdays, it would only take me about four hours. And I remember most of the time I would make between forty dollars and fifty dollars for that half a day—which in those days in the 1930s was a real pocketful of money.

I would stop and then display my stuff on the hood of the car. It was a touring car so everything was open on the back end. A good bit of it we grew so that was sort of clear money. And I would just drive down the street and stop, and then I'd go to another street and stop 'til I finished unloading all my stuff.

But I found out this: The housewives did not want to shell lima beans then, 'cause they would ask me, are they shelled? I said no. Well, they didn't want them. So the next time when I come by there, I said I got shelled lima beans. "Oh, we'll take a pint" or "We'll take a quart," and of course you made money on that. So when I bought lima beans, I shelled them all the night before. They brought, oh, four times the price of unshelled, so you made out good.

<hr/>

We sold milk, just in a tin gallon pail. They'd usually want a half a gallon of milk or something like that, and most of the time they got three-quarters of a gallon because my mother would fill it up.

The fact is, that's how I met my wife. I was the milkman—this was on a Sunday evening. Church meetings started around seven and the church was about two miles away, and I had to walk. So my father says, "I got the Caveys' milk ready. Would you stop by and deliver it on your way to church?" I says sure, so I did.

Well, the end result was, I never went to church that day 'cause when I got up there, I rapped on the door. See, 'cause Mrs. Cavey, the mother, usually answered the door, but instead of that, here's this beautiful girl answered the door. And I says, "You must be Marian." (I had heard about her.) And she says, "And you must be William." I says, "You're so right." So she says, "Well, come on in." So I went in, she says, "Mom and Pop had to go in town, but they'll be back very shortly. Won't you stay a while?" I says, "Yes, I don't mind if I do."

So I stayed the entire evening, even when Pop and Mom came back. And from there on, why, we went to

church together. She was Presbyterian, I was a Methodist. So, guess where I wound up? I soon became a Presbyterian.

I was about twenty-one at that time and we went together three years, and then we got married when I was twenty-four—she was thirty-one. She was older than I, and everybody says absolutely it will not work. My mother and father were dead set against it, her mother and father were against it—it would not work. Well it didn't—only for forty-six years. We were married forty-six years, wonderful years.

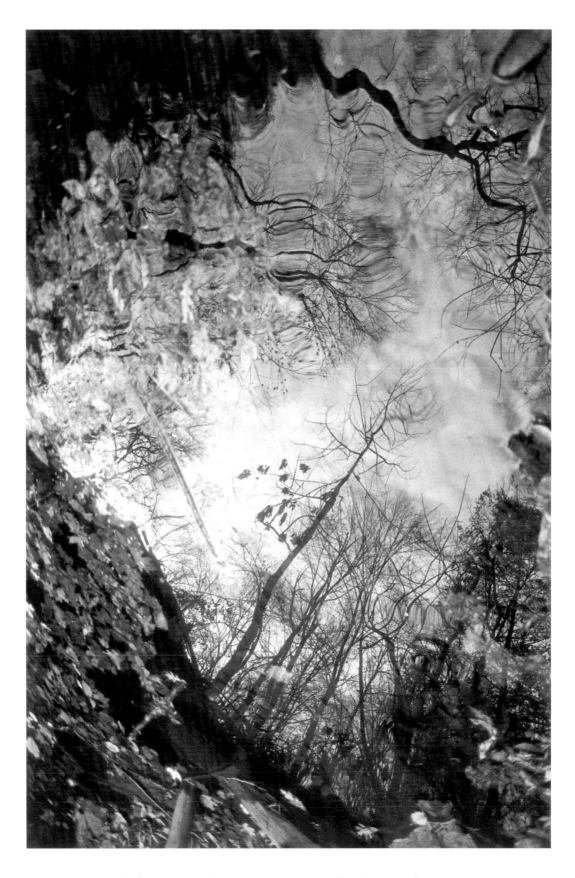

Reflections in the river, Patapsco Valley State Park, 2002.

*Jack Baker with a brass engine bell from the Belmont estate
on Lawyers Hill, 1999.*

John F. "Jack" Baker

(b. March 9, 1923)

Automotive serviceman

I lived out on Number 1 highway at what they call the Dead Man's Curve—the Devil's Elbow, they called it. That was on Route [US] 1 where my father opened up a garage and a gas station in 1929. (I was basically raised in the automobile business. That's how come I got to know automobiles.) It was a terrible curve that came around the Number 1 highway, almost opposite Harwood between Dorsey and Elkridge, and so many people got killed on it.

The bootleggers used to haul whiskey over that highway. Revenue agents used to chase them, and if they run off and run down through the woods, then they got killed. My mother told me those stories about how the revenue agents would chase the whiskey haulers on the Route 1 highway through there. It must have happened in about '25 or '26.

See, a lot of people out in the country made whiskey in those days. My father made a little bit, too. He had a still. Yeah, I found out about that later. Well, he made his own mash boxes, set up his own steam boiler, and never sold any locally that I ever knew of. He took it to Washington and sold it. He had to go to Washington because he worked over there during the '20s, he

was doing construction work. Well, when he had some whiskey, he would sell it. It wasn't a big steady thing. I think a lot of the locals all kind of done it.

Well, the big-time gangsters run Route 1. My mother said she could see the blasts of the shotguns shooting at one another going by, 'cause the cars that the bootleggers had, I seen them myself. I'm four or five years old and I could see men standing out talking in front of the garage or the gas station along the highway and looking at the bullet marks on the back.

You see, what they do, the gas tank was in the back of those old cars, and the revenue agents would shoot at the gas tank, naturally. You could see bullet marks on that sheet of steel that they had hanging down in the back to keep the bullets from going into the gas tank. They would stop by there and buy some gas or something. That was about '29, which was when my father opened up the gas station. We run Baker's Garage there 1929 until about 1950.

I used to see them pull off the side of the road and take their five-gallon cans of whiskey and put them from this car to that car. They were like a changing station, and there was one there, right at the old Dead

Man's Curve. That was a changing house where they used to change loads. I'd pick up from you or you pick up from me, something like that.

The old-time cars, they had plate-glass windshields and plate-glass side glasses—if they had side glasses. A lot of them were just open cars, and when those cars hit a tree or run over down in a bank or in a gully, people got slaughtered in these automobiles.

My oldest brother got into the wrecker business and we stayed in the wrecker business on Route 1 up until 1997. My brother towed the first cars off the road—Model T's. He towed them off the highway with a iron-wheeled Fortune tractor, little farm-style thing. Pulled off the side of the road and fixed the man's kingpins or bushings or tie-rod and get him going again.

They really didn't have any ambulances until early parts of the '30s. Savage, I think, was one of the first ones that had an ambulance, and Arbutus. I took people that were hurt to the hospital in the car. The police and myself would put them in there and I'd take them in to St. Agnes Hospital, which is the closest place. And then my brother would tow the guy's wrecked automobile in and it would sit there for a couple of days until somebody come out.

And I was just a kid, man, sixteen years old, you know, you see people's knees hit the dashboard. Their head would hit through the windshield. And there just wasn't nobody else there. People would stop, and the doctors would come along the road and they'd run over to help. But that wrecker business, I'm telling you, was something on that highway.

The state police did a lot on Number 1 highway because there wasn't any local Howard County police. They only had a sheriff and a deputy sheriff. That was the only law enforcement Elkridge had—Harry W. Bosse. He had a green Chevrolet and they called him the Green Hornet. We were kids going to school and the Green Hornet'd be down there directing traffic or something.

It was a mixed gas station in those days. You sold six or seven different types of gas—Gulf, Texaco, Amoco, General, a mix. All these pumps you had and you had to pump them up by hand. You pump it up, you got almost three gallons; you pump it up to ten, let it down to seven. You knew your arithmetic when you went to school if you pumped that hand pump up.

Not only that, you had to have muscle to pump that thing, too. I was out there eight, ten years old pumping them pumps up. My father would say, "Go out there and pump all them pumps up!" And then I'd come home from school and he'd say, "Make me a sign to put out there: 'Gasoline six for a dollar! Oil fifteen cents a quart!' " So, I liked to do printing and I always changed the signs for him. Make a homemade sign, wasn't no such thing as big fancy signs like you got now.

And back in those days, it was all loose motor oil. They didn't have it in these plastic cans that you buy today. Case oil came out in the early part of the '30s, but prior to that everything was bulk. The oil jars had a long, pointed metal top on it, and it was a quarter or half a gallon jars what you put in the man's car—had a little metal cap, a little funnel. Then you went back to the barrel and you filled it up again and put it out front so the next customer could get it. A lot of people only got three gallon of gas and a quart of oil for sixty-five cents. I mean, you just didn't have a whole lot of money, either, you know what I mean?

Automobiles broke down a lot. A man couldn't go from Baltimore to Frederick on this little highway. Oldtimers will tell you, say, "We couldn't go there without having four or five flat tires." And most everybody, they had to carry one spare, and some of them carried

as much as four. They had two in the fender wells and two on the back with some big leather straps on them, 'cause the tire business wasn't what it is today.

Other things—the drive shaft would fall out in the highway, connecting rods would burn out people's automobiles. We had cars that wouldn't start when it was cold. When I was sixteen, seventeen years old, I was out towing people from Hanover Road, Lawyers Hill, all over back of Elkridge—in the morning, going out with a big bumper on a wrecker and getting a push to get them started so they could go to work. You got three dollars to go out and give a guy a push and get him started. Nowadays, I guess it cost you fifty dollars to get a tow job.

People didn't have antifreeze in their cars back in those days either. 'Cause when the doctor came in to deliver my sister, his Model T—the motor block froze up and cracked, so they had to take the two horses and tow it back down to Elkridge and put another engine in it. But they'd forgot to drain the water out of it. People had to drain the water out of their engine, then take a tea kettle and go out and put some more warm water back in the engine before they cranked it up to go back home. Today we live with all these nice modern things and we don't realize how tough it was back in those days.

I tell you, people would leave their cars along the road and hitchhike with somebody else—and never come back to get them. We pulled them down in the field and scrap them after they stay there two or three years and the blackberry bushes grow over top of them. Same way with a lot of the wrecked cars. See, people didn't have any insurance hardly. 'Course, what did automobiles cost in the '30s? You buy a nice Ford or Chevrolet for 600 dollars.

The Number 1 highway, yeah, that was the main thoroughfare from Maine to Key West. Chester-Bridgeport ferry used to put out a little map, used to give it to people. They'd say, "How do I get north? I'm going to New York, I'm out of North Carolina," "I'm out of Georgia," or something. You'd say, "Well, you got to go up to Belair, Route 1 north of Baltimore, and continue up that way." You had to give people all those directions. They had no place, nobody to tell them anything.

People used to stop at a gas station those days, they wanted a transmission check, they wanted a rear-end check for the grease level, they wanted the air checked in the tires, they needed water for the radiator, all this kind of stuff. You had signs out there on the highway, "Free Air!" You could give people free air, see.

A lot of places didn't even have no bathrooms, and we had nice bathrooms at ours. With my father being in the building business, he had fixed it real nice. Had big brass Corbin locks on the doors, not padlocks, I mean nice thumb locks. He had nice flush toilets, one on each side—a nice American Standard toilet and wash basin and all in there. See, a man's got a little independent gas station, he's trying to keep it real nice and clean and all—nice cement driveway and curbing, and grass growing around there. Oh, he had it all fixed real nice.

With the trucks that were traveling the highway from North Carolina, Georgia, places like that, they had to hit that market at New York—and those trucks had to run. And they weren't the big tractors and trailers that we got today. I mean, the wheel bearings were going out on trucks, they'd blow out tires.

And the biggest thing you had was Western Union in Baltimore and public telephone. They'd call their boss back down in North Carolina—had a load of beans on board, trying to hit the New York market with it—and the local banker would get on the telephone and say,

"Can you fix that? My name's John Doe. I'm the president of this bank here in New Bern, North Carolina," or Charlotte, North Carolina, or somewhere in Georgia. "Get that man on the road. We've not only lent him the money to buy the truck with, we lent him the money to put the crops in the ground." There'd be a kid sixteen, eighteen years old driving that truck to New York. "Get him fixed and call me and your money will be right at Western Union." They have a little Western Union in that little town down there, see. When they call me and say, "The money's in here at Western Union," I'd say to the guy, "Hit the road—go!" Then he'd usually stop on the way back and say, "Man, I made it up there and back!"

Then they'd have wrecks out there on the highway. They'd turn loads of produce over and run down those ravines. That was something. Now they have a *backup* on I-95, it's on the TV.

The Bonus Marchers came and went on Number 1 highway when they went to Washington. You know what that was? In 1929 or '30, all the veterans that came back, Washington promised them a bonus. Those people walked from Philadelphia to New York to Washington, D.C., along the highway. And I can tell you it was streams of them, walking.

I was a kid and I stood out on the side of the road and I watched them come by. A man would be going along with his wife walking behind him and a coaster wagon with all their belongings on there—pots and pans, and some food, and clothes. They were going to Washington, they didn't have any money. Things were tight, the Depression was on. I think they were supposed to give them the bonus, oh, about 1934 or something,

but they wanted it sooner because they were broke, so that's why they come along the highway.

My father had in the front of the gas station—he had like it is today, you know, where you go and you could get cakes, and Gibsons' baked beans, and Nabisco crackers, and wafers, and fig bars. I seen my father take whole bunches of stuff off the shelf and give it to them. He felt sorry for them. It was sad times, I'm telling you.

And from then on, even though things got better under Roosevelt's administration, people didn't take any checks. If you didn't have cash money, don't talk to me. Credit cards weren't even in existence. Only credit anybody had was at a country store where they wrote everything down in a notebook, and you came in and paid at the end of the week or something. You always had a big book. Mr. Jones would stop and get gas, and he'd stop on payday and pay you. Yeah, everybody did that—not *everybody,* you only trusted local people. And they were good people, I mean, they just had to work for a living.

I know one man that worked at the B & O Railroad. That was probably '38 or '39 he retired. He'd been an engineer and his eyes had gotten bad and he retired from the B & O. He walked over and paid my father the last thing he had on the tick book, they called them. It was like three dollars or nine dollars or something. And my father said, "I'll tell you, there's an honest man," he said. "He paid those bills every week for all those years, and here he is retired and he's coming over and he's paying his last bill." He was walking down the road—and somebody hit and killed him. He didn't see good is what it was, and he was walking home one night and somebody hit and killed him.

Daniel's biker bar, Washington Boulevard, 2001.

Helen Voris mowing the lawn at the Elk Ridge Assembly Room, built in 1871 as a meeting place for neighbors divided over the Civil War, Lawyers Hill, 1999.

Helen Presley Voris

(b. August 22, 1917)

Teacher

Back in those days, before Route 1, it was a very definite division between above the tracks and below the tracks. Below the tracks were many commercial establishments. People lived there above their stores.

There were at least five grocery stores. We dealt with Sieling's, who ran a meat market and grocery store. There was also Mr. Petrlik, who ran a cobbler shop at first and then went into groceries. There was Sam Earp, who ran the post office and a grocery store on the side. Then there was Jarvis, who ran the store at the corner of Main Street and Railroad Avenue. Farther on down there was Sybert's General Store, which carried everything, and across from Sybert's there was Tilghman's.

My brother owned the corner store down here, Presley's, which is now Commercial Tire. He took it over from the Laynors and they had subdivided it with an A&P store, a little hardware store in the middle, and the soda fountain at the far end. And Stuart leased it when none of the Laynors wanted to run it, and then eventually he bought it.

Well, he worked very hard at it. During the war, he had a Goodyear agency, he had a Shell station, and for a while he had a barbershop on the corner. And so it was one of those things that this happened and then that happened, and so eventually he was selling what he could—tires, gas, and he put a laundromat in. It was also a bus stop, although my father ran the Greyhound ticket office across the street.

Then above the tracks, you see, the Episcopal parish house and Episcopal church were located, the Methodist parsonage, the doctors (Dr. Brumbaugh was practicing then). The drugstore was one of the few drugstores in quite a wide area.

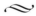

After World War II, a whole group of "new" people came in to Lawyers Hill. We were among the new people, of course. Those few original residents that were still here were used to a different sort of way of life. I mean, their children went to private schools. School buses did not run on Lawyers Hill Road until the new people came in.

And, I mean, as far as membership in the Hall [Elk Ridge Assembly Room], you could be blackballed. The Millers lived there for ten years before they were invited to join, and I think probably then they were invited to join because they needed their land. You just didn't belong to the right set, you know? Somebody from the old guard could say, "Oh, well, you know, I think that

would not really be up to our standards." We were sort of puzzled about what their standards *were.*

Now my brother at that time, he made deliveries to Lawyers Hill. He said, "You know," he said, "when I deliver their goods, I go to the back door. But when their checks bounce, I go to the front door."

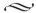

Dr. Brumbaugh, he went out on Thursday nights, so my oldest sister answered his phone. Then the job passed to my brother, then to my mother, then to me. And you got you were familiar with who was going to have a baby because those were the only people that you were supposed to call the doctor at home for. And I mean, if you had a baby on Thursday night, you were on Mrs. Brumbaugh's bad list for the rest of your life, because you weren't supposed to have a baby on Thursday night. That was *her* night.

There was a vacant lot next to our big old house there on Main Street, and my brother was five years older than I, and I used to hang out with his gang, so we'd play ball there. I remember we used cow pies for bases some of the time. There was a little boy named Craig Berryman who was about my age and we would compete. My ambition was to get ahead of Craig and his ambition was to be chosen ahead of me. So they would throw just as hard as they possibly could and I learned to be a pretty good baseball player. I was always pleased when they'd say, "We'll take Helen, you get Craig." But I was a tomboy. I never played with dolls very much.

We hated Ellicott City. We called them the Alley Cats—we'd go up to "Alley Cat City." Well, they were bigger than we were, see, and Ellicott City had this stone high school and we were still in the shingle building down here on Old Washington Road.

So at Rally Day we'd have this competition for the teams. We would hire a bus and go up to Ellicott City—and they hated to see Elkridge coming. And we would have the support of all the one-room schools. Lisbon and Clarksville would always root for Elkridge instead of Ellicott City because Ellicott City could put two teams in the field to our one, which meant that even if they lost the first place, they could take second and third place and get points that way.

When I was a senior in high school, we took every first place and won the meet. That was an occasion for great rejoicing. But as you can imagine, the *Ellicott City Times* did not put a banner headline saying, "Elkridge Wins the Meet!"

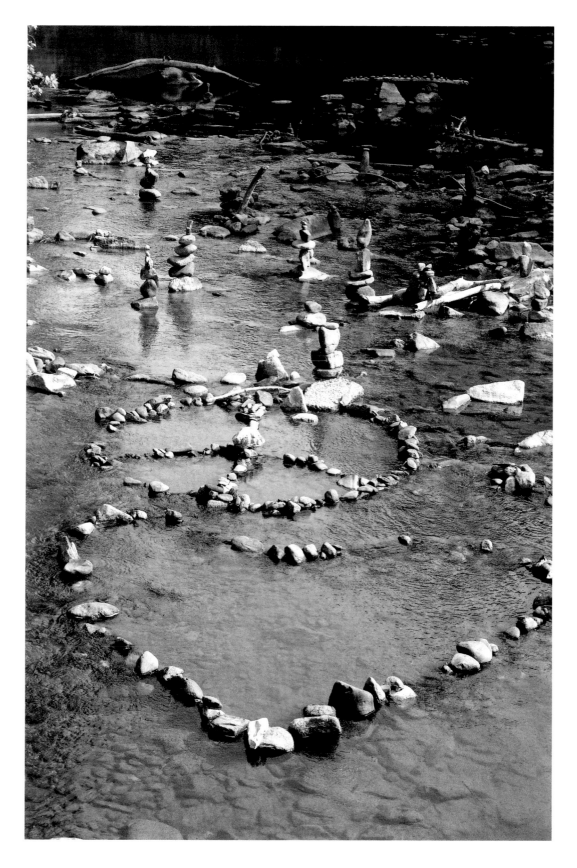

River art, 2008.

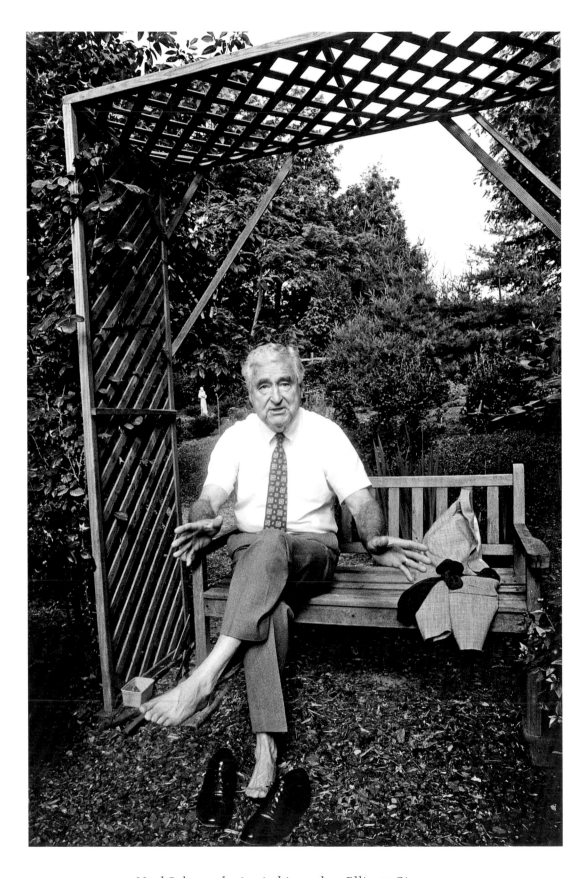

Neal Sybert relaxing in his garden, Ellicott City, 1999.

Neal Sybert

(b. June 4, 1928)

State's Attorney and Circuit Court judge

My grandfather's name was Pius Alphonsus Sybert. And in 1895 (he lived in Altoona, Pennsylvania), he developed tuberculosis and the doctor told him to go south. And he got to Elkridge, that's as far south. He bought a big store down there, and he and his wife had eleven children. Well, the whole building is where he and my grandmother and all of the eleven children lived. I remember it very well, 'cause the boys lived on this side right here and the girls lived over here, and there was a big porch you could sit out there.

It was a big old general store and he had everything you could think of. He had an icebox that was probably bigger than this room here. And once a week, he'd buy something like ten halves of steers and about twenty pigs, and he and one of his sons who worked with him would butcher all of them. He'd hang all ten of them up there, and twenty pigs—and some sheep 'cause they want lamb. They'd bone and roll them and all that kind of stuff.

Now, the chickens Grandpop had out in the back-yard. And if you ordered a chicken, you'd come back an hour later, 'cause he would have to cut the chicken's head off and then dip it in some hot water and take the feathers out and all that. That's the way all the stores were back then.

And he ran that until 1942 or '43, when they put in rationing for sugar and coffee and all. He then was eighty-one years old and he didn't want to fool with the rationing so he finally sold his store in 1944. And my Uncle Donald, who was vice president of Sears Roebuck, bought it and turned the whole big building into an apartment house, and it's still there on Main Street.

Down on the corner of Furnace Avenue and Main Street, a man named John F. O'Malley lived there. And he was *the* politician of Howard County, he was *the* boss. He literally picked everybody to run and all this kind of stuff. Yeah, he was a little short, fat man, and John O'Malley ran Howard County for about thirty years.

They were very conservative back then, you know, and of course after Prohibition, then everybody who wanted a liquor license would go to John F. O'Malley and he could get it for them 'cause he knew the liquor board—he was one of the ones that had the governor appoint the liquor board.

My father, his name was Cornelius Ferdinand Sybert, was the state's attorney of Howard County. In '46, he ran for the House of Delegates and got elected. The minute he walked in the House of Delegates in Annapolis, he got elected speaker of the House of Delegates. And in 1950, he ran for senator and he got elected senator. And then in 1954, he ran for attorney general and got elected. In 1958 he ran again.

And then 1961, he was thinking about running for governor and the then governor offered him a position on the Court of Appeals, which is our highest court in the state of Maryland. He wasn't going to take it, but my mother and I talked him into taking it 'cause we figured that we didn't have that kind of money for him to run for governor. He probably would've gotten elected. Millard Tawes, who was the governor then, offered him this job on the Court of Appeals. That's 'cause he was afraid Dad was going to run against him in '62.

There was a family down there named Petrlik and they lived right up Main Street from my grandfather's store.

And the Petrliks had about ten or twelve kids, same as my grandfather. Right behind Petrliks' house on Main Street was where the cop lived—"Snickle" Norris, that's what they called him, lived there by himself. And he would pay the kids a nickel for every dead mouse or every dead rat they would find or kill or anything else, and of course this was big money back then.

And Al Petrlik found a dead mouse and took it around one time and knocked on Officer Norris' door, and Mr. Norris gave him a nickel for the dead mouse. And Albert came up and was standing in his kitchen and he sees the officer come out his back door, go to the garbage dump, and drop the mouse in there.

So Al would go down, pick up that dead mouse at night and save it—and the next day, knock on the door and get another nickel for that mouse. And he did it about eight or ten times until the mouse started to smell. And Officer Norris caught on to this and finally got Albert and spanked him for cheating him and all.

Farmhouse and horse trailer, 2001.

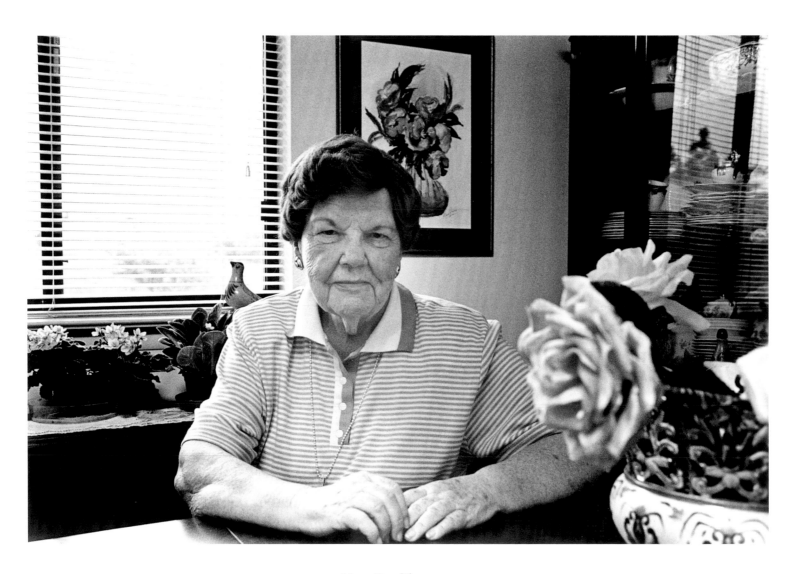

Mary Petrlik, 1999.

Mary Petrlik

(b. April 20, 1919)

Accountant

My father had wonderful meats and he delivered to the Lawyers Hill people who were wealthy aristocrats that had their orders delivered—and they had big bills at the end of the month. I remember going with him when he delivered some of these orders. You'd go in the kitchen and the cooks, they would all know you and everything, and they would give you a piece of gingerbread or whatever, and of course we loved to go.

Well, they had standing orders and then they had special orders. And I remember that they loved olives. And I didn't like olives, but I thought they were such unusual people and such lovely people, and I thought, if they liked olives, I'm going to make myself like olives. So I ate the olives until I really developed a taste for them. They were big green olives with the seed in it.

They'd order a lot of delicacies—they had a lot of parties and things, you know. They were just terrific people. I've never met people like that in my life. They had their own private cooks and butlers and chauffeurs. They'd come down to the store with a chauffeur-driven limousine and I just thought they were absolutely marvelous. I made up my mind, I was going for the finer things in life.

My mother and father were born in Prague, Czechoslovakia. They didn't know one another until they came to this country. And they both belonged to St. Wenceslaus Church, which was in northeast Baltimore, a Czech settlement, and they met at a church picnic. So they got married and they were living in Baltimore, but my mother got typhoid fever so the doctor suggested that she move out to the country.

So my father came to Elkridge and started a shoe store because he could make shoes. He was a real shoemaker, learned it in the old country. And then he also later opened up a grocery store. It was Elkridge Shoe Store and Elkridge Grocery Store—Petrlik's. It was like a double house in a way, the two fronts of the house was a store, and all the rest of the rooms were taken for our residency.

But the grocery store, the best part about that was my father had about thirty assortments of cookies in individual boxes, like a staircase of cookies. It was really fantastic. And when he wasn't looking too much, we just helped ourselves to cookies.

~

I remember there was one store next to us, Sieling, and he didn't like us. I mean, there was a lot of resentment

of being Catholic and also of being foreigners, 'cause I was called a foreigner and I was called a "Catlicker" and all that kind of stuff, but I never paid any attention to it.

Well, he was really ornery. And the county wanted to put a road in between the two places, from Washington Boulevard into Main Street, and he didn't want them to put that road there. My father didn't object to that road being there at all. As a matter of fact, my father was *glad* because he would be a little distance more away from Sieling.

Anyhow, it was done. They moved our big house and they built this terrific foundation for us. We had this big cement cellar, you know, real thick walls and everything, so that was a gratis that we got out of that. And my brother, he said he remembered my mother on the back porch just scrubbing clothes while they were moving the house.

[Officer] Mike Norris, oh my God, he was a character. Well, he lived right on our property. The little house that he lived in is still there. And he never locked anybody up. He used to come over to my father's store and buy different things, and my mother used to deliver his dinner to him—one of us kids would take his dinner to him. And he never paid us for that dinner, I mean, it was just him living alone and everything. So he would give us maybe a nickel or something for taking it over.

My brother George, he never worked in the store. He played baseball—and he was with the Baltimore Orioles one year. Elkridge had a sandlot team and that's where everybody went Sunday, that was our entertainment. My father, he was quite a character. And he was

so thrilled about his son playing baseball (and he was a good player), he would go over to the ball game (and he had an accent) and he'd holler, "Georgie, Georgie, chicken for supper! Hit a home run!" People used to wait for my father to say that—"Chicken for supper!" Isn't that a riot?

George was drafted and he was in the army for four to five years, He was one of the first people to go. And when he went in the service, I mean, it's amazing how close people were back in those days. We knew his train was gonna come through Elkridge. (I don't know where he was headed, but he went overseas.) And it was a whole crowd at the Elkridge station just to wave to him as he went by on the train. I'll never forget that

Back then everybody didn't have a phone and our phone was used a lot by people who had to make a call. They would come in the store and use the phone. And we always thought we were lucky 'cause we had a phone—but we had a phone because my father needed it for business. It wasn't really a social phone for us, you know, it was in the store.

And my one sister, I think she was trying to make an impression with this one boyfriend she had. I had been in a play and I had taken the part of a pickaninny—this was in parochial school with the nuns. It was about the Civil War and this little pickaninny delivering food for her father or something like that. So my sister, she says, "Mary, I'm expecting a call. When you answer that call," she says, "you talk like a little colored girl. I want him to think we have a maid." Isn't that terrible? The only people I knew that had maids were those people that was on Lawyers Hill. They had maids, they had chauffeurs, they had the whole works.

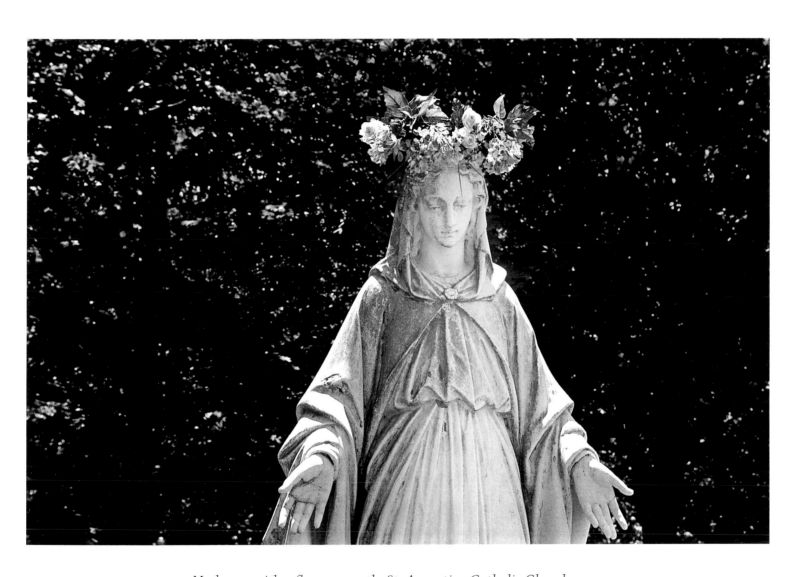

Madonna with a flower wreath, St. Augustine Catholic Church, 2001.

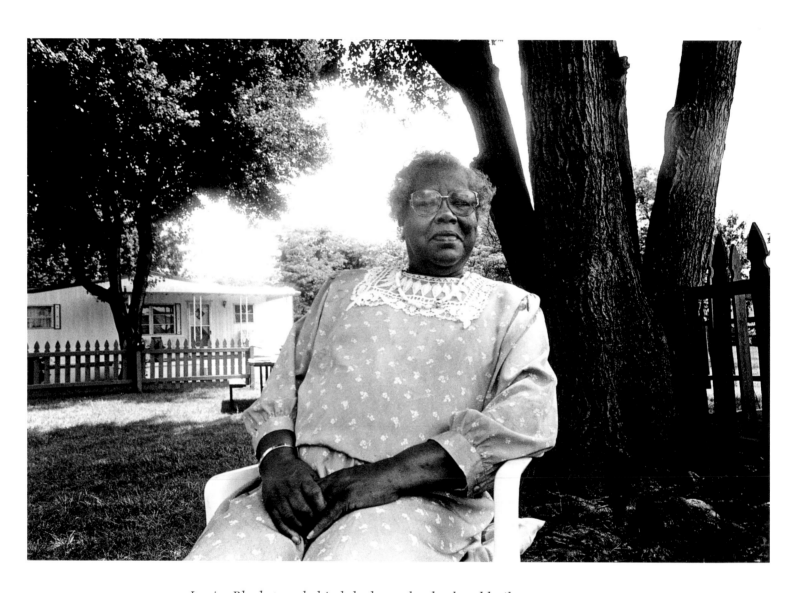

Louise Blackstone behind the house her husband built, c. 1939, 2000.

Emma "Louise" Fields Blackstone

(b. November 23, 1916)

Domestic worker

I was born about two blocks back down in the woods from where I'm living now. I was born right here, in other words. I'm from the Fields family that owned property adjoining the Ducketts, the family that owned this strip of land.

My uncle raised me and he worked on a farm down on Lawyers Hill. In those days they had what you call the big house and the farmhouse, and the little house is where the farmhands lived. And all of your vegetables and meats for the winter and all was gathered from this farm. And I don't know, but I don't think they got much salary.

I can remember as a little girl that my mother would be working up at the bigger house on Lawyers Hill, Forbes' house. And we used to have insurance men in those days, and my aunt would send me up to get the money for my mother's insurance. Wasn't like it is today, you mail it in. You knew your insurance man. He came to the house to collect the insurance, and I used to have to run up to get the money for my mother—ten cent a policy for life insurance. Wasn't no such thing as health insurance, but it was that life insurance, they always made sure they paid that. It was a very, very important thing in those days to be able to bury your dead. And that few little pennies that they got hold

of, they always made sure that they had these insurances.

But we were only allowed to go up to the door and stand while they brought the money to you. We couldn't come in the big house, we had to stand outside. And we'd get this money and run back down the hill. I can remember that as a little girl.

Yeah, we lived in the little house, as I said. See, they had what you call, for "the help," they had a little house down below and this great big mansion up on the hill. And my uncle worked the farm. My mother and my aunt, they cooked and cleaned up at the big house, 'cause those people in those days didn't do anything for themselves. Everything was done for them by the black help. And that's the way we lived. They took care of the house up there and he did the farming, and that's the way we lived.

We had a nice house and we never knew we were poor. We didn't have a whole lot of materials in it, but we always had plenty of love, and was always well fed and well taken care of. I don't know how they managed to keep us in shoes and all of that sort of thing, but I never remembered being real poor. We were just

happier then. I often tell my children that I don't have no regrets for the time that I came up in, as far as my family was concerned. Now I've got sense enough to know that they weren't fair, but at that time I was perfectly happy.

We didn't have no swimming pool, but we certainly had a beautiful swimming hole right down there, with nice trees. And the water was purer than the water is today because Mother Nature kept it flowing and we never had any stagnant water.

You killed your hogs in the winter and smoked them in the smokehouse right out in the yard. We had wood stoves. I imagine they must've had oil or gas up there in the big house, but we didn't. We had a stove and plenty of wood. You had to get the wood in—and the water. 'Cause see, we had to carry our water, yes indeed. We had a pump right there in the yard.

The place was nice. It wasn't slavery-like, but had a slavery mentality, if you let it, you know. Well see, everybody was the same, so we didn't notice it the way we done since we been bigger. Get older, we know. But it was slave mentality.

But we children never worked in the fields, my uncle never allowed that. We had no time. That schooling was *it*. You had to go to school and you had to go to church.

Sunday, they still had to feed up in the morning, but they'd get up early enough to do that. They didn't do any farming on Sunday 'cause we always went to church. From the time I can remember, I was in church. We had to go to Sunday school and then stay until the next service and all through. If it was service all day, you stayed all day, and if it was an evening service, we went back. That was our life. Yeah, we always got a beautiful religious upbringing.

The same little church down here, Gaines Church, I've been there for eighty-two years. It was just right down the field where we lived, yes indeed. We were so tickled to be going, we didn't mind walking like kids do now.

~

We would have Sunday dinners, and I tell my children about it now. Oh, we'd have everything, every vegetable that you could mention, because we growed them there in the garden—string beans, lima beans, cabbage. In the fall, it was kale, collards, all that kind of thing. Nothing grew them but horse manure. They'd take the manure from the horses, put it around the plants. No such thing as this chemicals that they use nowadays.

That's why they had big, strong, healthy children. We never went to a hospital. (There was no hospital that I know of for it.) You had to really have something bad to go to hospital. When you had measles and chickenpox, the doctor come—Dr. Williams. (He was before Dr. Brumbaugh.)

See, I was never in a hospital to stay until I was seventy-five. No indeed, we had that doctor come to the house and he'd stir up his little glass of medicine, put it in the middle of the table. Now they got safety-top bottles and all that for the medicine? They'd set that glass on the table, put a postcard or something over it, and laid the spoon that they gave it to you with right on top of that. And that sat there until it was used. And a whole bunch of kids running around didn't touch it, you didn't *touch* that. You can raise children to mind. We never touched anything we weren't supposed to touch. That glass could've sat there with that medicine in it and had no top on it, but we knew better than to touch it. Yes, indeed.

Everything was a home cure. When that doctor came, put that pink medicine, that was either measles or chickenpox or something like that. But for bee stings and cuts and all that, they had their own remedies. For bee stings, it was seven different weeds out there and they'd take them and rub them together, and put salt on them, put them in a rag, tie it 'round wherever the bee sting. Because in those days, when a bee stung you,

you swell way up. You put that on, by the next morning it'd be all gone.

If a cut was bleeding real hard, they'd squeeze it and tie it real tight. Well, Cousin Rosie used a cobweb, but I never did that. We did know this lady that did one time, reached up and got that cobweb at the corner, and it stopped it. That little boy, he was cut bad, too.

But for fever for babies, we used onions and salt and put that onion on his little stomach, bring the fever right down, 'cause I've used that remedy with all of mine. Now in those days they had cloth diapers. No one heard of the Pampers. You take one of your cloth diapers and slice the onion, put that onion on, and tie it around him. Now he'd be smelly, would smell your bed all up—but it would cure the fever.

Oh, stomachaches, we had all kind of remedies, but I never gave my babies anything but Castoria for stomachaches. In my day, they put a little turpentine on sugar. That's what they did for me. Well, they never considered whether you liked it or not, you know, they put it in your mouth and you ate it.

Yeah, warm salt water, that was for sore throat. And for toothache, dip a little bit of the Pain King was the name of the medicine. Put a little bit of Pain King on the end of rolled cotton, stuffed it down, and *oooh.* These children, as soon as they say "My tooth hurt!" Oh, get the car, let's take them to the dentist.

I can't remember going to the dentist at all until I was real grown. We never used to be talking about no dentist. No, that tooth just stayed in there and they did the best they could for it. I went to the dentist when I got big enough to take myself. Then it was, "Take them all out and give me a plate!"

≈

You know that old dilapidated building over here right by the church? That's where we went to school—one-room schoolhouse. For eight years I went there, graduated in eighth grade, and then after that, that's another story. And there was no such thing as passing unless

you did pass in those days, you know what I mean? They didn't mind holding you back. I've seen them full-grown still held back in the first grade if you didn't learn. And we went from the first to the eighth grade there.

They had a wood stove. We had all the throw-away books from the white schools, half the leaves missing. But we were smart. We could visualize what was missing, we put that in ourselves. So that's the kind of books we had.

The teachers were very, very strict. Only had one teacher for eight grades, that one teacher, yes sir. And you kept quiet, and each one done whatever he was supposed to do. Was no interruptions whatsoever 'cause they had something for you in those days. They didn't fool with you. They'd take you out in the vestibule and put that stick onto you, and then send a note home to your parents and tell them what they put on you. Oh yeah, you learned. When I went to school, you learned. We learned more in the third grade than the kids graduating nowadays.

We had three recesses a day—ten [o'clock], lunchtime, two. (And the day started at nine and ended at four.) We didn't have a whole lot of activities, we made our own activities. That's another thing that made us smart: We had to *create.* We couldn't afford to buy the toys, we *made* our own toys. They used to play a game that they hit a ball with a stick with a hook on the end of it. And my brother would come home from school, he'd spend half the night down in the woods finding the right kind of stick for to play the next day, and we played that. Oh, and I Spy, and ball. We never had a whole lot of fancy things, but we designed our own things, made our own playtime.

≈

In order to go to high school, we had to have somebody living in the city 'cause Howard County had no high school for black children. And in those days, our parents believed in education. They knew that that was

the step to higher living or higher perspective in this life. We knew when we got out of elementary school, somehow they were going to get us a higher education.

And the way we got ours, we happened to be lucky enough to have an aunt living in the city, so we went and lived with her for the nine months of school, and that's the way we got our education 'cause there was none here in Howard County. We'd come home on weekends and then they'd get us back. (We had cars by then, see, by then we'd left the farm and had cars.) But they'd bring you home, and then wash our clothes all up and pack our little suitcase, go back in.

'Cause see, we weren't even allowed to do that. We were supposed to be residents of Baltimore City in order to go to school in Baltimore. Baltimore County kids could go, 'cause we had couple of friends from the county was going to high school with us, but we couldn't. But we found a way to get there.

Do you know, we were the smartest. I remember a teacher picking us out, and we had better education than the city children did. Yeah, I didn't feel a bit out of place, far as my mind was concerned. I guess I just was that type then, you know. I resented them, but I didn't let them hold me back in no way. Oh, some kids had better clothes. 'cause some black kids, their parents always had good jobs, like with the railroad. And I tell you, one of the biggest was train porters. If their parents was porters on the train, well, they had big homes and the best of everything, yeah.

One time we was three churches and one minister. We had Gaines, St. Stephen's, Jonestown—three churches, all on a circuit. They called it Elkridge circuit. And like this Sunday, he'd go to our church in the morning, the next Sunday he'd do St. Stephen's in the morning. And each time the churches were full. There was more of us around then than it is now 'cause most of the younger generations have moved on into the city or whatever.

We'd have what you call a local minister and he'd conduct the service when the pastor was at another church. Sometimes one of the locals from St. Stephen's would come to us when he was at their church, then his local he'd send here, and that's the way they did it. It was beautiful.

We had what you call camp meeting. It was down in back of Gaines Church. Then they'd all three of the churches come together and churches from all around the area. Well, we had three services a day. And, oh, they have a great big tent, and in this tent they'd have all kinds of foods, great big pots of food. The people come in from different churches and they'd all gather around under this tent, and they had benches and sell this food. And I remember the big thing was the ice cream. Oh boy, we couldn't wait to get a saucer of ice cream.

We'd stay there all day and the kids play around, you know, until service time. When service time come, you'd have to all come in the church and they have a service. They did that like about four Sundays out of a year. We don't have camp meeting anymore. They're too sophisticated now.

I don't know whether they were talking to you about down the lower part of Elkridge, the stores and all. I can remember being sent there with a little list of what our parents wanted, and that's how they got the outside things, you know, the staples. It was Sybert's and Hartke's and Earp's—three different stores along Main Street, and each one of them, our parents would have charges with them.

And on these farms, they only got paid once a month. So during that month, they would send us kids down to the store with a little list of what they wanted, and then at the end of the month they would tally it up and they'd pay them.

But we wouldn't know whether we were getting a pound of something or an ounce because kids didn't know, you know? Whatever they packed up and give to us to take back home, that's what we carried. And they wouldn't really know how much they owed, but whatever he said, you know, that's what they paid him. Yeah, that's the way it's done. They didn't ever question them—they wouldn't *dare* question Mr. Hartke 'cause that was their living. They question him and he cut them off, where would they get their food?

See, they were handicapped, really. They didn't have the choices like we have now. If we have problems down at Super Fresh, we can go to Giant. See what I'm saying? See, that was the difference. So whatever they sent them, they accepted it.

And I can remember Mr. Sybert, he was the kindest old fellow, used to give us all a little bag of animal crackers, free. Oh, we thought he was the greatest man. All the way home, we'd be chewing on these animal crackers. We'd have to come from Main Street in Elkridge, up Lawyers Hill, 'cause that's where the farm was, and we used to love it. That was a privilege to be able to go to the store. Isn't that something? A privilege to walk that far. If I asked one of these children to walk that far, they'd think I lost my mind!

And maybe once or twice a year, they'd go into the city and buy clothes and stuff like that, but they didn't buy no Nikes every day.

Our parents cut our hair if we needed it cut. And the men cut their own hair, too. I don't remember going to the barbershop. My uncle might have 'cause he was very particular about how he looked for Sunday church. See, in those days, men learned how to do for one another 'cause they didn't have money to put out. I'm sure it was somebody around that could cut hair 'cause that's not really a hard job.

Elkridge was segregated, very much. No indeed, you better not go in there to get no haircut, no, mm-*mmm.* Now I know Wizard Lilly, if it'd been left to him, he would have cut your hair. But if he'd of cut your hair, then he wouldn't a had no more white customers, see? And he knew that. No, we couldn't go in there to get a haircut.

I mean *now*, I see that it's negative 'cause I'm grown and can think about it. It's how we worked, had to work so cheap, you know, for so long.

I worked when I was seventeen, right down on the corner of Lawyers Hill Road and Montgomery Road in the beautiful white house there on the corner. I worked there seven days a week: I cooked, I took care of two children, served three meals a day. I didn't do the washing and ironing, but I stayed there, I mean, all day, all night—and for six dollars a week. And I said to myself, now if those people had all that money to work somebody that many days, that wasn't even a dollar a day.

Those are the kind of negative things that I thought about. That was the norm—then. Yeah, that's all everybody was getting, what everybody was doing. That's all I've ever done was domestic work.

I didn't have kids of my own then, see, I was only seventeen. But I had completely all the responsibility for those children—feed them, bathe them, take them for walks. She didn't allow them in nobody else's house, but every day I had to take them for a walk and bring them back. And after I get them in, get them settled, then I had to start thinking about what was for dinner.

And I mean walking around a table, now. They're one of *those* kind, you know? You ever been around them kind of people? They had somebody serve the meal around the table? Oh yes, honey. All was on that table was the silver. The first trip in, I had to pass all the plates out, and then I'd come with the meat and go from person to person. Take that back in the kitchen and come with the next dish and serve that all around 'til it was finished. And that's how it was served. Oh, if they needed something, they had a bell.

She'd come out every morning and tell you what was for dinner. Oh, I prepared it, 'cause she was so stunned to know I was so young and knew how to cook so well, but I had been taught how to cook since twelve years old. Yeah, she'd tell me what to cook, but not *how* to cook it. Just ordinary things, but they had to be cooked just so, you know. The steaks were always broiled, they ate no fried food. And then just have two vegetables. And wasn't nothing for her to have a whole tableful of guests and no bread, they didn't bother with bread.

But it had to be done all fancy like that. It wasn't no more than what we'd slap in a pan and eat—but it wasn't the food. It was the way it had to be served—every night. They ate no other way.

I had another lady much older than me, she worked on Lawyers Hill. That's where the bigwigs was in them days, all the rich was on Lawyers Hill. And in them days, you couldn't be on there if you was too poor. They'd find some way to see that you didn't come on. They were just as prejudice against poor folk as they were against colored. And she said she couldn't even go in the kitchen. She had to go around and stand behind a screen to wait her chance. Yup, I resent that now—but that's what it was like then.

The children called me Louise. They didn't call me Nanny or nothing, we never got that. It was way later, years here, before I was called *Miss* Louise. In fact, my mother worked for this one family for thirty-nine years, 'cause my mother was old when she stopped working. She didn't do the housework, she was just a cook there where she was. But she was always Matilda to little teeny things on up—and my mother used to have to call *her* Miss.

They were bluebloods, sure enough, oh my goodness. They had a cook and a waitress; my mother was the cook and my aunt was the waitress.

You could play with the white kids at the big house—long as they were little. But as soon as they got so she was *Miss* something or other, made her a debutante, we would call it, she wasn't allowed to associate with us.

I remember not being allowed to come in the house where my mama was. (You heard of Carrolls, way up in the county? Carroll Manor and all of that?) I didn't like that, but honeychild, history repeats itself, you hear me?

It's been I guess about twelve years ago now, a white lady, Mrs. Clark, used to rent this same house where I used to go as a child (where I couldn't go in the door to pick up Mama's money). She was a friend of ours and she had a Christmas party. And I got in there, and oh, I cut a rug that Christmas. Old man Carroll, he's been pushing up daisies for a long time, and if he could have, he would have come back and run us out of there!

But we had a ball, a bunch of us. My sister-in-law worked for her—and she was one of these people that everybody was the same to her. Honey, I had a *ball* that night. And all I could think about is what he was grumbling about. I *know* he was somewheres grumbling, *"Get out of here!"* You have no idea what that done for me.

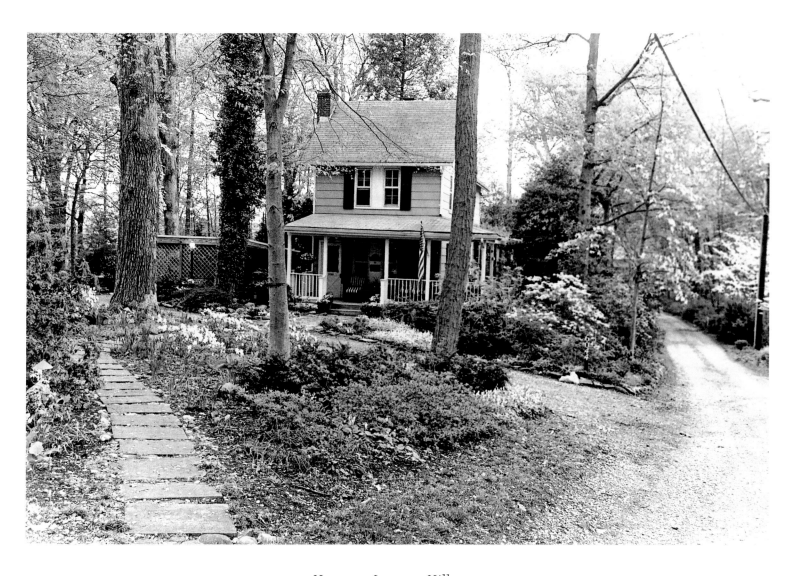

House on Lawyers Hill, 2002.

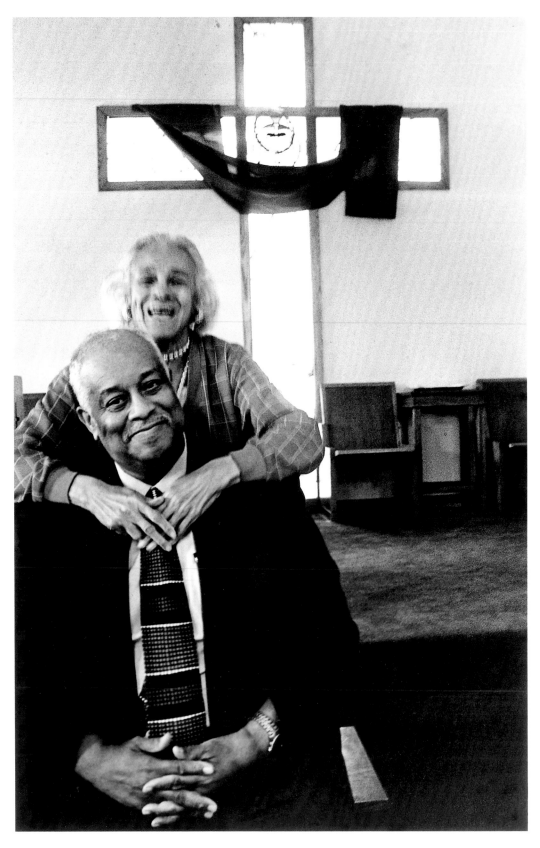

Reverend Monroe Simms and his aunt, Dorothy Taylor Richardson, in the First Baptist Church of Elkridge, 1999.

Reverend Monroe Simms

(b. January 23, 1935)

Pastor, First Baptist Church of Elkridge

Dorothy Taylor Richardson

(b. September 1, 1916)

Teacher and florist

DOROTHY: My mother was a domestic and they went over to Relay and St. Denis to work. And my father worked there on the railroad tracks and then on the weekends he'd cut hair, he was a barber. Right there in the kitchen, had his big chair and his towels and things like that.

REV. SIMMS: The women, they went and were maids. And my mother used to have Dr. Brumbaugh, some of the leading whites, would bring their clothes to the house. Sometimes they would have them already washed. If not, she would have to wash them and then iron them, because, like Dr. Brumbaugh, he did not want anyone to touch his shirts except my mother. And then when she got sick and she had to get someone else to do it, he was very unhappy 'cause he was so used to her starch and everything was just right.

So he would deliver the clothes that morning, maybe like on a Monday, and he would come back on Friday or have his wife to pick up the clothes. He wanted his clothes to be specially hand done instead of putting them in a laundry, he said they last longer.

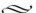

REV. SIMMS: He was the only doctor in this community. And there was a double standard in his procedures there, too. Number one is that when he wrote out his prescriptions, he wrote on the white prescriptions "Mr." or "Mrs." On the black prescriptions, it was always, you know, if your name is Monroe Simms, it was "Monroe Simms."

And plus, his general procedure was that he would prefer coming to your house. He charged you one dollar or two dollars for a whole visit, you see? He would prefer coming to your home than you coming to his office—but he did not deny you from coming to his office.

There was double procedures there in Elkridge. The procedure was that if you were white, you could come into the soda fountain area and drink out of a glass. If you were white and you wanted to take that soda out, you paid two to five cents for the cup. But when a black came in, they didn't drink out of the glasses, they drank out of the paper cups—free, whether five cents, two cents, whatever it is.

They didn't have a sign up there saying "Black" or "White," but see I worked there when I was ten years old and you knew that when you walked in and you wanted a soda, you would get a paper cup. If a white walked in there at the same time, you knew that she or he would get a glass to drink out of.

But blacks had a form of prejudice against each other. There were some blacks that could afford more than others, you see? And so, we talk about black and white prejudice, but this goes way back. People were prejudice about people's hair. If her hair was longer than yours—"She thinks she's *cute*." If you had a nice dress on, they might rip it off you. I mean, this was blacks for blacks, see? Yeah, they would call Dorothy's family the "cute Negroes that live on the hill."

DOROTHY: "The Taylors that lived on Taylor's Hill," 'cause we all went through school, you know, and had a car.

REV. SIMMS: "They think they're more important than anybody else." But the problem they have on Race Road is that there were a certain segment of homes that were up on the hill and there were some that was in the lower part. Those people always thought the people up on the hill thought they were better than everybody else 'cause they had cars, they were first ones to have television, and you know, all these things that makes life more easier and the luxuries of life. But they didn't realize those people up on the hill worked to try to make something of themselves.

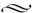

REV. SIMMS: Her father did work on the railroad tracks, but he was a big-time politician, too, in those days. He was considered one of the head men as far as blacks—as a Republican, you see? And he was considered the mayor of Race Road because he interceded in getting streetlights, and he had succeeded in getting a blacktop placed on Race Road, and a lot of little things. And he interceded in getting out the black voters to vote the Republican ticket.

When you lived in his household or lived around here, it was a life and death thing if you voted anything else except Republican. Because when I first started voting, I voted Republican when I was young until I got good common sense and got on my own. I'm not saying that Republicans is bad, but I'm saying at that

time it wasn't doing us any benefits, and so that's why I changed my affiliation from Republican to Democrat.

But when I did it, I could not breathe the word Democrat around him. And so his whole family had to vote Republican 'cause he had set it up. And we didn't have to worry about going to the voting polls; they would send cars (he was responsible in coordinating that) to come down and pick us up and take us to the polls.

The fact is that the Republicans here in Howard County had promised him so many incentives if he would get the blacks to vote Republican. So naturally, to see streetlights going up in a place that was totally dark, that was enough incentive to get people out. He could say to them, "Look what I have done for you," you know?

And then next thing, instead of riding down a dirt road, muddy when it rained and everything, he put blacktop down there. "Look what I have done for you through the Republican party." The Democrats at that time did not come in and say, "We'll do this for you, we'll do that for you, if you will vote for our ticket." And that's how that came about.

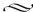

DOROTHY: We had what they call a henhouse outside. It was fenced in, you know, and that's where the chickens were raised.

REV. SIMMS: Early in the morning they went to the henhouse to gather the eggs, because we didn't go to the store at that time. Didn't have that kind of money to be buying eggs every day. When they got a certain size, they took them to a chopping block and took a hatchet and chopped their heads off, and then they put them in the water to take the feathers off, and that was the Sunday afternoon meal. And sometimes people became very envious of her family because they were able to have quite an abundance of chickens, and a lot of people came to their house on Sunday to eat dinner.

And when we got in the state of Depression, not only did you think about the chicken legs and the thighs

and breasts, so forth—you look at the chicken feet. And what they did, they would chop the chicken feet off and scale them down, and take potatoes and onions and celery, and then boil it and make what you call a chicken-feet soup. And it would just be a simple meal: water, some seasons and potatoes, and sometimes you'd chop up carrots. Take those chicken feet, throw them in there, and you put that on the table.

You might get a couple of them in your soup bowl and you just suck them up there, just like you take a chicken bone and suck it, you know. Sometimes during those times, if you had a chicken bone in your mouth, you were so proud and so happy to have it, boy, it'd be just like having a T-bone steak. I can really taste it right now.

DOROTHY: And the school that we went to up where Gaines Church is, that's where we went to school. We walked from where I lived, Race Road, up to Montgomery Road. Didn't have buses, we walked.

And the rest of my education, I caught the train up here and went to junior high school in Baltimore. I had relatives who lived in the city and I used their house number as my residence, and that's the way I went to junior high school and Douglass High School. There wasn't any high school nearby and that's how my sisters and whatnot got their education, we all rode the train.

And my biggest problem going to school was, I had long red hair and I had three plats—had one on each side and one up here—and every morning, I would have to sit there and wait 'til my mother got my plats in.

And then half the time I'd be going to catch the train, because I would be late, and sometimes the conductor would see me running and he'd wait for me to get there to get on the train. Because I went down to South Baltimore for junior high school, and I tell you, those years getting to school was something.

REV. SIMMS: This church was blown up in 1965 by three whites. They were working on the building and then they blew up the church, the original church. That was a church dated back to 1843, and this church was deeded to us by the Ellicott family—and this was a *white* family. This church also was used during the Civil War as a hospital, the original church. And we were told that they would deed the church to us as long as we kept this church a black Baptist church.

This church was used with some of the great famous blacks that visit here, such as Booker T. Washington. He came through here and spoke in this church, the original church. And then this was used as a part of the underground tunnel [Underground Railroad]. See, we have a railroad track on the other side and Mary Bethune, Harriet Tubman, all of those leading blacks at that time had used this church as a refuge center and also as a railroad tunnel, you know, during the time of the Civil War.

But the money that was used to rebuild this church was from the white community—from the white Episcopal church that let us use their church. Grace Episcopal Church opened their doors just like that, and we went in there, and we never broke service. This church burned down on Monday and we were back serving on Sunday.

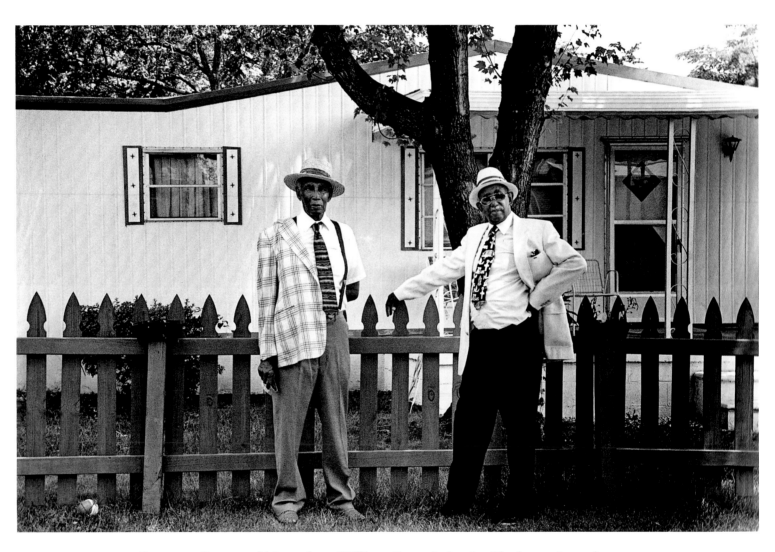

Scrammy Cager and his nephew, William Cager, in Louise Blackstone's yard, 2000.

Franklin "Scrammy" Cager
(b. December 12, 1912)

William Cager
(b. July 8, 1924)

Truck drivers

SCRAMMY: We lived down on Washington Boulevard, right next to the fire department. It was a old house and we was the only black family that lived in that section. See, there was two sections of Elkridge: Down there where that [Dorothy] Richardson girl lives, used to call that the Lower Elkridge. And right now there is only about five houses up there where most of the black people live at.

When I was a little kid, used to walk from down there to Race Road, all the way up there to this school here. It was called old Odd Fellows Hall where they went to and now the old hall is falling down. But they called it Elkridge Colored School. That's the only one they had.

They had a old big-belly stove in there to heat it. Then they had to go down the spring to get drinking water and just drink out of the bucket. One teacher taught all grades. Well, you couldn't learn nothing, not too much, you know, when one teacher teached all grades.

WILLIAM: I was in a one-room schoolhouse in Halethorpe and that went from the first to the sixth. I lived about four or five miles up the road on Devan's farm. We lived with my grandfather in his house on Devan's farm and we had to walk, maybe it was three or four miles up there to that school.

SCRAMMY: I didn't stay there long because my mother, she had sisters living in Baltimore, so she took us to Baltimore and we went to a Baltimore school.

SCRAMMY: They used to, if you was living even out here, they call you "country," like you was just dumb because you come from the country.

WILLIAM: They could tell the country from the way you dress. 'Cause my sister could tell you, when she went to high school in Baltimore, they picked her and all the country people out. They were country to the girls in the city and they could pick you out. You wore different clothes and you hung together.

SCRAMMY: What you wouldn't pay no mind to out here, you had patches and things in your clothes, but when you went to Baltimore—

WILLIAM: See, I married a woman in Baltimore and she *still*—I was a country boy to her, you know? It's a little different. We had to walk from where I lived in Halethorpe to the bus line. We call it a half a mile, but man, when a city person come out there, they just fell apart.

SCRAMMY: Then you got those homemade haircuts. Your family cut your hair—terrible, *terrible*. But you

couldn't get round them. Sometimes they put a bowl on your head, then go round that bowl, that what it is.

Scrammy: I didn't even get to the eighth grade. I dropped out because that's when the Depression was coming in, so I came back here to live with my father up on that farm he was talking about.

So the lady, her name was Miss Norris, she told me she need a chauffeur and a house man and all like that because the first fellow, he had quit. And I took a job with her. The place where she lived is off Ilchester Road. They call that Orange Grove up in there. At that time, it was only three houses that was up there. I know it was 1929, 'cause that's where the Depression caught me and I stayed there. Although when I went there I was getting fifty dollars a month; when I left there I was only getting twenty-five dollars a month.

So when I left Miss Norris, I went to Baltimore. But I still lived out there on the farm and went to Baltimore to get me a job with Mason Transfer driving a truck. I knew if I stayed around in the county, couldn't make no money, because generally only thing you did around the county them days was just working on a farm in spring up to the fall. Then you're with no work, 'cause ice, snow, and all like that. The ones that actually made any kind of money back in them days, they worked on the railroad, working on the tracks. They was the ones that could work year-round.

See, the people that worked the railroad, they was somebody. And most all down in that section around Race Road, them people worked the railroad, yeah, they were railroad people. They made top money, like I say, top money—for our people. You worked on the railroad, you was *somebody*. Yeah, they could tell you what train's coming, put their ear down on the track, yeah. A schoolteacher the same way, they made money, too. They was somebody.

William: Or that worked in the post office. We had different sections in Baltimore. You was a schoolteacher, you had your own little section where, you know, you didn't have too much of judges and stuff like that, but schoolteachers and postal workers, yeah, they were somebody to us.

William: On the farm, you know, it was cold. Window bust out, you stuck a piece of rag in it, anything. Then a lot of the houses, you could look, see daylight through the walls. And that house where they lived up there, it was a log house. It only had two bedrooms, but back them days, you know, you take three, four in a bed in one room.

'Cause I mean, you had to prepare for the winter. You smoked that pig and everything like that. Then you put away a barrel of flour. Then you had to can your food in the summer to get over the winter, 'cause it wasn't no work unless you would.

Some farms you had to cut wood in the wintertime, and I think you was only getting a dollar and a half a cord. I was out there about almost a whole week helping my father cut the wood. And you had to stack it up to measure it, see if you had a cord. That had been a whole week, didn't even have a cord, and for a dollar and a half.

William: My mother done housework all her life, working in different people's houses. She worked up there across from the farm.

Scrammy: My mother work up at Lawyers Hill. See, that's where the aristocrats were. She was a cook. This was Dobbins and Murrays and Bowens—used to call them the bluebloods. And that's where most all that knowed how to cook and chambermaids and things, they worked over at Lawyers Hill. Now all them people is gone, but Lawyers Hill is still there and they call that a historic district.

Some lived on the property, but my mother didn't.

My mother, she cooked for Dobbin but she came home every night—and I had to go over and meet her every night. I had to walk a little over a mile. But see, Launds, they had people that stayed there, 'cause they had chambermaids and all like that.

But back in them days, that's the way a lot of our people made their living, especially the females, over at Lawyers Hill. A lot of times, you were somebody if you worked for them people, just like years back people worked for Howard Bruce, they call that estate Belmont.

WILLIAM: The children today, they got it made. We knowed our place, where we go and where we couldn't go. And we didn't have no trouble. Where my uncle used to chauffeur downtown Baltimore? All the nice apartments? We knowed that we could not go in there. And some places had said "Colored Only"? Some of the stores down there that a woman could not try on hats? And men couldn't try on different things? We didn't have the crime and things like we have now. The blacks knowed their place.

SCRAMMY: Only one store you could go down there and that was called Brager and Eisenberg. That's the one you could go in.

WILLIAM: Well, look, where me and him worked at, we drove a truck in St. Mary's County and Calvert County. All there had signs that said "White Only," bathrooms and things like that. You had to go around to the back.

SCRAMMY: And no restaurant you could go and eat, either. You could go in like a horse stall and get something. Then you could catch the Greyhound bus out of Baltimore 'til you got to Brandywine, then you had to set in the back.

WILLIAM: You catch the Greyhound bus from Baltimore to Washington, when you got to Washington going south, you had to sit in the back. And if black people came from Virginia, they was in the back. Well,

our transit, you know, we could sit anywhere on a streetcar.

SCRAMMY: My father told me about even the railroads, he say that B & O Railroad, they used to call Jim Crow cars, they used to have to sit there. Used to catch it and go to town, especially on Saturdays, you know, do a little shopping and things like that. They had a special car for them. They had to sit in this Jim Crow car, just from Elkridge to Baltimore.

SCRAMMY: I was nothing but a kid and hear my father talking about the Ku Klux Klan. But the first time I got scared by them, I was working then, and I was coming up from southern Maryland. And I was coming through Gambrills, and I looked and I seen all this white things and the light, they was dancing around. I didn't know what it was happening, and in this fog, you know, they burn this cross and everything they do. That's the first time I ever seen them like that, right up on this hill. You could see it from the road, see? And you could see that fire up there and you could see these white things. I didn't know what it was at first. I thought it was a ghost or whatever, you know, it scared me.

SCRAMMY: Oh, they'd call you "n" [nigger] alright then, you know. That was just a word they call you all the time around here. They just call you that just for everyday name, because a lot of times if you went to a white person, I don't care how good they knowed you and everything—and some of them were real good— but they had to call you that. Yeah, it was just like a byword.

'Cause I never forget, I was getting some gas down there at the filling station on Washington Boulevard and Levering Avenue. (You could get seven gallons of gas for about a dollar.) Anyway, so this fellow—I knowed him well, too, 'cause he used to work up there at Howard Bruce's farm, his father did—he was a little

smart-alecky. So I gave him a five-dollar bill and he look at it, so I said, "What's wrong with it?" "Uh, it's very seldom you see a 'n' with a five-dollar bill, that's why." And, I guess he was telling the truth.

Yeah, a lot of that went on. But like I say, time changes everything, you know, so it's no more like that. But you had to go to white people to get something done. You couldn't get it with your own people, 'cause they ain't have nothing. Lot of the time you had to go to the white man, he'd tell you, "I'm getting tired of you 'n's' coming in here, asking me for something" and this and that. But he put that name on it.

SCRAMMY: We went dancing up there at Ellicott City. Mostly had guys playing a old banjo, fiddle, that was every Saturday night. Back in them days, you have dances at different places, yeah, we used to do two-step and all like that. But Ellicott City, used to go up there every Saturday, go and meet the girl and have a nice time, you know, dance and all like that.

I tell you, Ellicott City, it reminded you of more like someplace in Europe, you know, with all the real high cliffs, 'cause some say it looked like the Swiss Alps. And it was a lot of homes all up on the rocks and things.

They had the jail up there in Ellicott City and then most everybody in Howard County, if they ever got locked up, they went to Ellicott City jail. A lot of times you meet a couple of your buddies up there. If you was well-known around there, they turn you out in the daytime and let you walk the streets, then you come back at night. And I never forget it, if you had a wife, they even had a room for you to meet your wife. But that was just home people that lived around there that, you know, the white folks know them, see?

SCRAMMY: Back in them days you had to be Republican. And actually, if you were a Democrat, oh, you was

just out of it. See, you voted Republican to get a job on the state road. Yeah, as long as it was a Republican government, you had a job on the state road. If it was Democrat, you got kicked off and a Democrat got the job working on the road, patching it up and anything like that. That's how low you're down on the totem pole.

And back then they always tell you why they want you to vote Republican. They always say that Abraham Lincoln freed the slaves, so that's why a lot of black folks went for the Republican party 'til years later. We would vote down there to the Catholic church. Ones that didn't know how to get down there, they had cars coming down to pick you up. They'd give you a dollar a head to pick up a person and bring him down there to vote.

SCRAMMY: You could go to the doctor then for two dollars. And Dr. Brumbaugh, I went there twice, I think, and he had a place for black, place for white. When you went in there, you had your separate waiting room.

WILLIAM: We used to run down, me and him, to southern Maryland back in the '40s. It was Jim Crow—separate waiting rooms in the hospitals. When I started driving in 1948, things down there, the hospital, all that was separate. Even here in Baltimore, Franklin Square Hospital, it was separate down there. 'Cause when I had a son got bit by a rat? It was Jim Crow, all the hospitals.

SCRAMMY: But St. Agnes was worse than all of them. You got hurt or anything, you couldn't even stay overnight. Like, you had a accident on the road and that was the closest hospital, they bring you there and do whatever they did, but you had to go away from there. And at that time, you know, the Catholic religion was strong, and I say, now how in the world could they do that? They're supposed to be God's people.

SCRAMMY: Sometime a person would have to go to somebody else's house to have the funeral, 'cause their house was so bad off. You never heard of no funeral home or funeral parlors then, you was in the house. Then, lot of time what happened, they'd have big parties. Had one right in here, my wife's grandmother. You had to put a crepe on your door.

WILLIAM: Yeah, so you know somebody was in that house, you had a crepe on that door.

SCRAMMY: You know, some places, they hardly would have any room to do it. Oh, Lord, they just bury you in the ground. And they didn't have anything to do about gravestones.

WILLIAM: Yeah, that just started, that ain't that long started that you know where people was at.

SCRAMMY: My mother, she buried in Calvert County and she still don't have a gravestone. But I know where she's buried at, 'cause you always would have some kind of marker to find out. That's why today they talking about building on people's graves and things like that. They don't know where the graves at.

WILLIAM: We got a whole lot of people up at our church right now that ain't have no marker, but they know they were buried.

SCRAMMY: We had a little men's chorus, it was called Gaines Men's Chorus. We got around pretty good.

WILLIAM: See, it was three Cagers and two Fields. We didn't go out to get paid, we just sang, you know? Somebody might give a little something, but the bulk of what we got, it went to the piano player.

SCRAMMY: Yeah, it was all spiritual, but more of southern style. Yeah, we had got to the point that if they say would be Gaines Male Singers in church, everybody'd be clapping 'cause they know they was going to hear some good sounds.

WILLIAM: See, all three of us, we looked alike. We all had gray hair and the main thing people thought was, how is them old men going to sing? And we'd rock up the church, we'd rock the church up, now! And wherever we went, we could go back again.

We had a president and a secretary of the group. We didn't decide what we sang, we just went on and sang. We didn't have too much to say about where we went, you know, we went all over—Blackstone, Virginia. We went to New York. All around Maryland we sang. And we was dressed up. We had black coats, blue-black pants, and blue coats, and we was all dressed alike.

SCRAMMY: Yeah, we was nice.

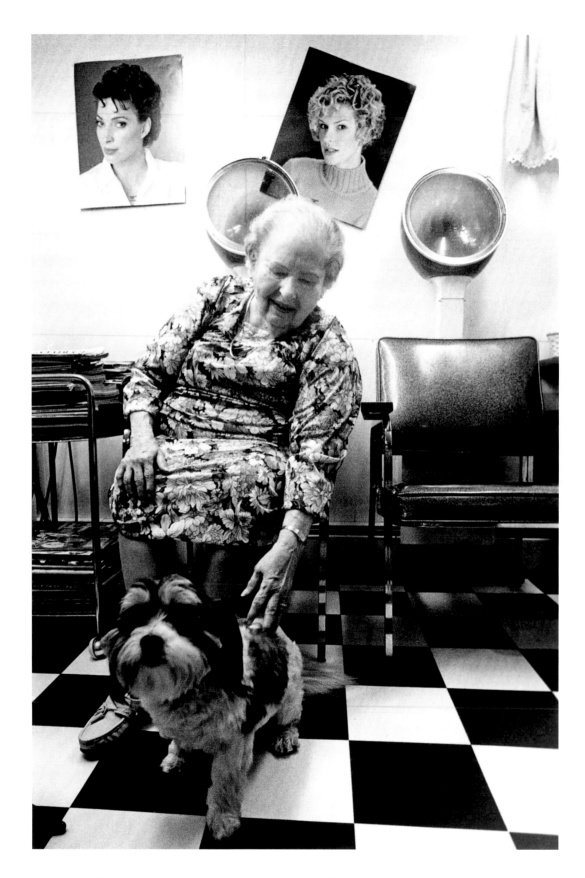

Dorothy Baker with her dog, Daisy, at Harwood Hair Studio, 1999.

Dorothy Baker

(b. November 15, 1921)

Beautician

I opened a beauty shop in 1945. It was the Harwood Beauty Shop. We changed the name in about the last ten years when the men started coming. They'd kid each other that "I don't tell anybody I go to a beauty shop," you know? So I changed it to the Harwood Hair Studio. But it had to be *Harwood.* That was in the contract when they gave me the zoning.

Well, it was the worst of times to open a beauty shop. I opened it the Tuesday after VJ Day. You couldn't get hair clips, you couldn't get bobby pins, you couldn't get a permanent wave machine. Anything that was metal was forbidden. That's when the hair rollers came into use because they were just mesh. It took a couple of years before we could really get back into what a beauty shop used to be.

I started out with a used permanent machine and a bunch of rollers and permanent lotion and stuff. But the funny thing was I was so afraid of the used machine, I was the greatest talker for cold waves there was. I had this offer: Please get a cold wave instead and if you don't like it, I'll give your money back without a moment's hesitation. Fortunately, I never had to do it. Once they got the cold wave, they never wanted the machine again.

We sectioned off a part of the basement. It was a nine-by-twelve room and it was the most amazing thing you ever saw because it had room for three dryers, the shampoo bowl, two chairs for the reception area—well, there was no *area*, it was just two extra chairs. And we even had the toilet in there.

So you come in the open cellar doors—I don't think people even have cellar doors anymore that open up—and you went down the steps. The first day it was very, very busy. Neal Sybert's mother was my first customer and she said, "Well, I'm gonna do something for you." And I thought it was the sweetest thing, she said, "I'm gonna send my friends. I'm gonna tell them they have to come try you, but then it's up to you if you can keep them." So fortunately, I kept them.

When I first started, I was going to be so correct and so I even got a Helene Curtis franchise, which was almost impossible. I just had a good reputation and they decided that even as small as it was, a one-person shop, they were going to give it to me. So I had these letterheads printed up for my first mailing to let people

know I was going to open. And I had across the top, "Beauty is your duty—but my obligation." I decided afterwards that was a little bit presumptuous.

Well, we did everything, but facials I dropped because it was a funny thing: you had to take your shampoo chairs and bring them out in the room and let them go all the way back to lay the person down for a facial. And there were plenty of good places that do good facials that they didn't need us. But at the time I did them, I was the only one that did them.

You used a cleanser, and then you used an astringent to get all the cleanser off, and you would put on a mask of whatever—whether they needed it for oily skin or dry skin. And it did make you look good. Of course, it's strictly cosmetic, we're not taking away wrinkles or anything. But it did get to be a problem because it was a small shop. When you put that chair out in the middle of the room, you better not have many customers lined up.

We did manicures. Pedicures didn't come into play that long ago. If you wanted that, you went to a podiatrist—and now a podiatrist wouldn't even think of doing them. That's strictly with the beauty shop now. But we did manicures, you know, and arching and tinting and the whole bit.

When I first started, it was a dollar and a half for a shampoo and set. And for two dollars, you could have a shampoo and set and an arch. Permanents started at seven-fifty, and I had the range of seven-fifty cents, ten dollars, and fifteen dollars. And when they got fifteen-dollar permanents, they were getting permanents that were really great, I mean as far as the materials. I never cheated on them for the work. If they were only paying seven-fifty cents, they got as much attention as fifteen dollars because that was my reputation.

I was a Redken fanatic—I mean their perms, their shampoos—because they were so into the organic and the things that we talk about now like they're new, you know? And even when you had to mix your own shampoos (they only sold you the concentrates), they were very special. I thought about it sometimes, because my prices didn't go along with having a Redken line, but that made me feel good that I had the best.

'Cause originally permanents were an ammonia solution that you baked in the hair with the permanent machines, and man, that was trying. You had these tremendous heaters that are put on each curler, and you check around to make sure one of them is not smoking or steaming. But when you got done, you had curls.

Nobody ever got burned. But to picture it is just outrageous, because you'd have about thirty-five curlers that were heavy metal that you wound and put the clip down on. And when you got all those metal curlers in the hair, then you attached them to the machine. And it was thirty-five of these monstrous-looking clips that, with a wet pad, then went over the hair and would steam it when you turned the machine on. And it could run for maybe six to ten minutes, depending on the texture of the hair.

It was a very careful procedure because if somebody said it's burning and they're pointing here, it might be up here that it's touching. So, oh, you really padded them well in-between everything. It was quite fascinating. And, I mean, you just can't imagine what it looked like. You'd have to see it.

The tint manufacturers had been around a long time, but they were more harsh on the hair and you were particularly careful with them because they could cause blindness. And when you're working around the head and you've got the eyes right here, you're really careful.

So it's turned into a much, much more simplified business, but you have to be much better educated, too. You do have to know your products. I always said, no

matter how well you think you know how to do something, read the directions, because from one month to another it could change.

If Jackie Kennedy wore a bouffant with a pillbox, bouffant was it. But when it originally started was because of the rollers, and that was in the '40s, but it takes that long for the people to change into it. Now I would love to see the ones that still go with the bouffant, as much as they do look very attractive, I'd like to see them change something. But you know, if the people are happy, let them be happy because that's what we want.

Now even the people that still have a bouffant don't use a lot of hairspray. You use some spray, but I think some of them were actually lacquered to death. I don't know if anybody could possibly touch them, it would break first.

After the bouffant, you went into what was most popular, the feather bob. And that was layered all over with a very soft perm and it just was feathery. You could brush it through and shake your head and you had a great hairdo. It was one of my favorites because it was layered to the extent that you couldn't mess it up. If you run a brush through it, it just fell in place. And I like things that are soft and feminine but no trouble.

These precision haircuts got shorter and shorter until we finally got to where the women were wearing the sideburns, and I think some of them are very attractive, though they scared me at first. I always kept up with all the style magazines and the first time they put a thing in. Precision haircuts—it was right up to there, and sideburns. It was easy to keep, and of course it was probably a very good thing monetarily 'cause you'd need haircuts practically every three weeks. But some of them went a little bit too far.

At one time, Lana Turner had this really easy hairdo. It was a pompadour and then it come down into a page-

boy, and it was very simple and very easy to keep. And I think from age six to sixteen to sixty, they wanted that. I don't know if they thought with that they'd look like Lana Turner or if they just really wanted the hairdo, but so many people could wear it. It was an easy hairdo to wear. But that really struck me funny. We didn't have too many that come in with pictures, but that picture—I don't even know what it was in—but it got to be a regular routine.

Remember the Farrah Fawcett flip? Well, a lot of them wanted that—when they had a face rounder than mine. And I'd say, "I wouldn't dare wear that. My face would be three times as big! Oh God, I don't want that." You could talk to people. I mean, you never *say*, "Well, no, I won't do that," you know, but *mean* that.

Mainly, the reality checks come in with the coloring. Because it's important as they got older, you know, somebody that had black hair, and then when your skin's getting paler and you should have gray hair—and that's a little hard to take for people because it's a shock. But when they do it gradually, get a little lighter and a little lighter, some of them have turned out to be the most beautiful silvery-haired people that they can't imagine why they ever tinted their hair.

But the advantage I have, I guess, is that I was at it so long that I can look at some of them that are now eighty years old and think of how beautiful and how lovely they kept their hair all these years and it's really nice.

Now I always get a kick out of when people say the "gossipy" beauty shops, you know? You just can't do that. You can listen to people and be interested, but never enough that you are going to repeat that—unless it's some real good news and they want it repeated, then we'll tell everybody.

But the only thing I've never let out of the shop that we've had around when I opened it, I put up this little

sign: "It's nice to be important, but it's more important to be nice." And I told the new operators, they close the door when they take that sign down, because they have to remember that. We're not big-time that way. I've kept up with my styling classes. I always wanted to be a good beautician, not somebody that's just gonna do every head the same and all that. But it's still more important to be nice, and I guess big-wheel people wouldn't agree with that, but I do.

I'm the last person after the last customer on Saturday. When they're through with everybody else, they decide to feel sorry for me. I just let them play with it, do whatever. But now that I'm this old, I just don't really care. I just wish I had more hair. I had the most elaborate mop of hair you ever saw, and people really didn't like to do it too much because there was so much of it. Now I'd be so grateful to have some of it.

Well, I've been on the Democratic Central Committee, but I was an officer in the United Democratic Women in Maryland. We had the First District Democratic Club back around 1942, and then the women weren't that welcome because the men were supposed to have all the clubs and all that. But we were fortunate in some of the men that were here, and we'd go down before the legislature and stick our nose in and make ourselves known.

Well, they even started giving women some jobs. My mother-in-law wanted to get a job. She was the housewife that, you know, didn't work and she decided that she wanted a job. And she couldn't think of anything that she knew to get a job, so she went to one of the men to talk about it and see what she might be able to get—some gravy job, you know? So they made her inspector of beauty shops!

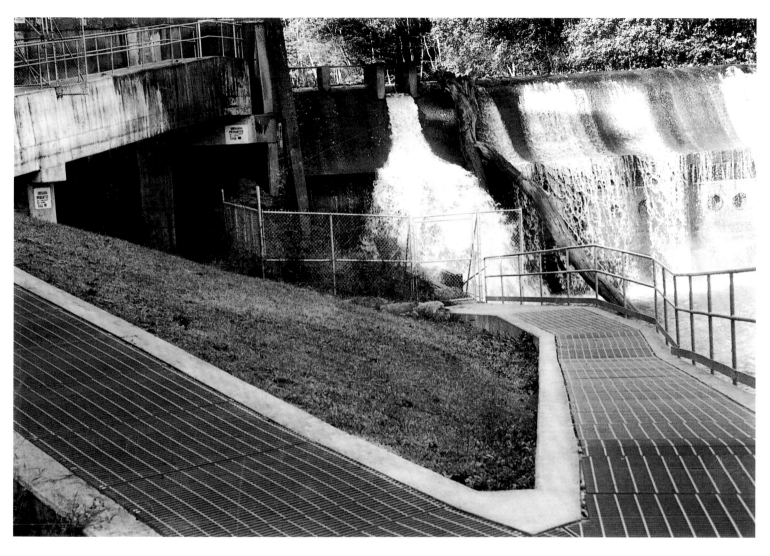

Bloede's Dam, 1906, one of the first hydroelectric dams to house generators within an underwater structure, Patapsco Valley State Park, 2001.

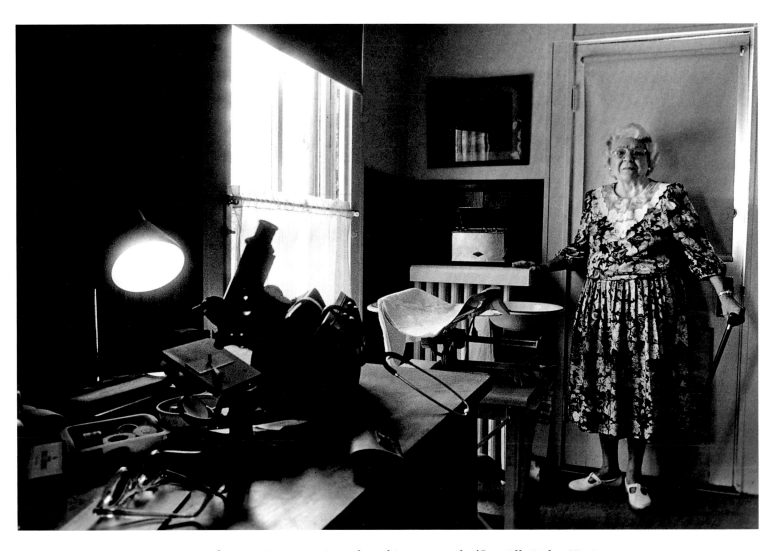

Peggy Ford in Dr. Benjamin Brumbaugh's preserved office, Elk Ridge Heritage Society at the Brumbaugh House, 1999.

Rosemary "Peggy" Ford

(b. May 28, 1925)

Florist and vice chair, Democratic State Central Committee

We used to take Sunday walks. And as teenagers, we'd always walk over the viaduct bridge to Relay, or we'd go up River Road, you know, take walks up there to the swinging bridge. There was a swinging bridge that went across from the Howard County side to the Baltimore side, across the river. And I mean, it was a *swinging* bridge. You'd walk across that thing and hold on to both sides of the ropes, and if you had a milkshake, by the time you got to the other side, it would be all churned up. And you could either come down the other side of the river back to Avalon, or come back across the bridge and go back the way you came.

The Cascade Trail was all up in the hillside of the state park, and it was rocks and crevices and all that sort of stuff, little streams. It was a trail that had been made. You know, back before the war, we had the CCC [Civilian Conservation Corps] camp up there and a lot of work was done in the state park then to make it nice. Yeah, to take a walk up there, it was nice. And if you made it to the swinging bridge, you done good 'cause that's a long way up.

I remember the things that used to scare me to death. Some of the young guys would walk the iron fence over the viaduct. And of course, the more that we young girls would say, oh, don't, don't, don't, you know, the more they were determined to prove that they could do it. So I think we got to the point where we didn't say anything and hoped they wouldn't do it.

There was a place called Hollywood Movie, which was over in Arbutus, and we'd walk over there. It was a gang of us that would go every Saturday. I think we would end up with twenty-five cents and that took care of the movie and a box of popcorn or a drink. And you had to go every Saturday, because in those days they had the serials, you know, that you went one week and you'd have to go back the next week to find out what happened to the guy that was left hanging the week before. So we'd walk there. It would take us about a half an hour. It would probably take me three hours to get there now if I tried to walk it.

Yeah, it's neat, those memories. I think they say something about memories becoming a treasure, you know, because they are. They can always lift you up when you get down in the dumps about something. You can think about all the good times you had.

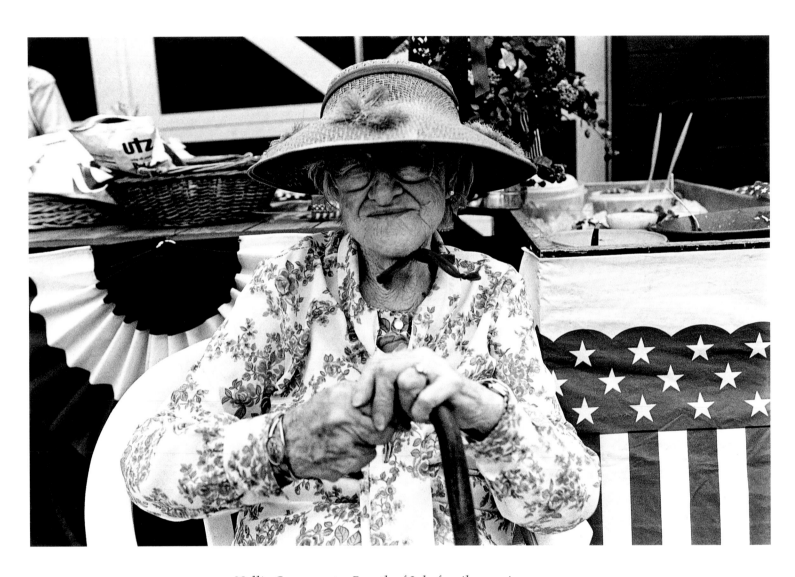

Nellie Coomes at a Fourth of July family reunion, 1999.

Nellie Walter Coomes

(b. March 20, 1909)

Merchandiser, Woolworth's

My grandfather's sister was married to a colonel at Oriole, which is below Princess Anne, Maryland, right? It's right on the body of water there. And when my grandfather went down to visit his sister, Mary, my grandmother, she took care of the children—and my grandfather fell in love with her and took her out in the boat. And she said she married him because she was afraid he was going to drown her so she married him. And she had, I think, six kids by him.

So then my father and mother both lived in Baltimore and they belonged to a club, which was a lot of dancing. And when my mother went to this club to pay her dues, my dad said to her, "What did you pay?" And she says, "I paid ten cents." He said, "Oh, goody for you. I'll just dance with you!" And he danced through life with her—for ten cents.

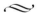

Everybody called my parents Mama Nettie and Daddy Dick because there were so many children growing up there, so they all called them that.

Daddy made wine, because we had grape arbors at the back of the house and then a bigger one up a little bit further, and then we had a hundred up the yard.

And he just made wine like he was going out of business.

It was fun making wine. I picked the grapes, I pulled them off of the stems. He came home from work, he worked on them—and when they were needing attention, he gave them attention. And he saw to it that he had a hundred gallons every year down in that basement in charred kegs, he had his own kegs. Gave the damn stuff away because it was fun, it was good fun.

So Daddy said to the principal of the school one time—he came to our house every Monday night, because Daddy sort of looked after the school property and every Monday night Mr. Yingling was there. So Daddy said to him, "Well, John, I don't have any wine I can give you, but I will have a gallon I'll send to you."

So he gave it to my sister Reba to take to school. And she didn't see him in the office so she left it on the desk. And when Yingling came in, he saw that wine, he almost flipped. And he told Daddy, he said, "I could've lost my job on account of that wine!"

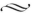

My brother Earl came home with lice in his head and Mother said, "Earl, what are you scratching?" He says,

"I don't know, but it's been worrying me all day." (He had curly hair.) And she said, "You come here." She took a fine-tooth comb and she says, "Uh-huh, you got lice." So, she got busy, told Daddy, and he says, "I'll take care of him." So he got kerosene and gave him a good dose of kerosene on his head and put him to bed.

The next morning, he got up and he says to him, "Mm-hmm, we'll wash that out and you won't have lice anymore." And he didn't.

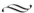

My Aunt Jane's friends had a daughter my age. They lived out in Forest Park in Baltimore, but they also had a home on the Magothy River. And if Peggy wanted me down on the Magothy River, that's where I went. I got on the train and went to Baltimore, and got on the train and went to near Annapolis, and that's where I spent four years of my life, from fourteen to eighteen. Peggy got married and then I saw her a lot, even though she was married and I wasn't married then.

But that was my life that I enjoyed very much. We danced, and we swam with our boyfriends that were bouncers at the dances and they were lifeguards at the beach. We just had a ball—four girls, four boys.

I got married at thirty-one. I didn't want to marry him—he wouldn't let me go. He says, "We're going to get married tonight or else!" And in the car I got and started for Towson where he had the license, God, a month I guess. And then it started raining, so Dave said to the kids on the road, "Where's the minister?" And the kid says, "Up the street here." And Dave said, "Yeah, but it's raining and it's late." The kid says, "Wake him up." That's what we did—we woke him up. So that's when we got married.

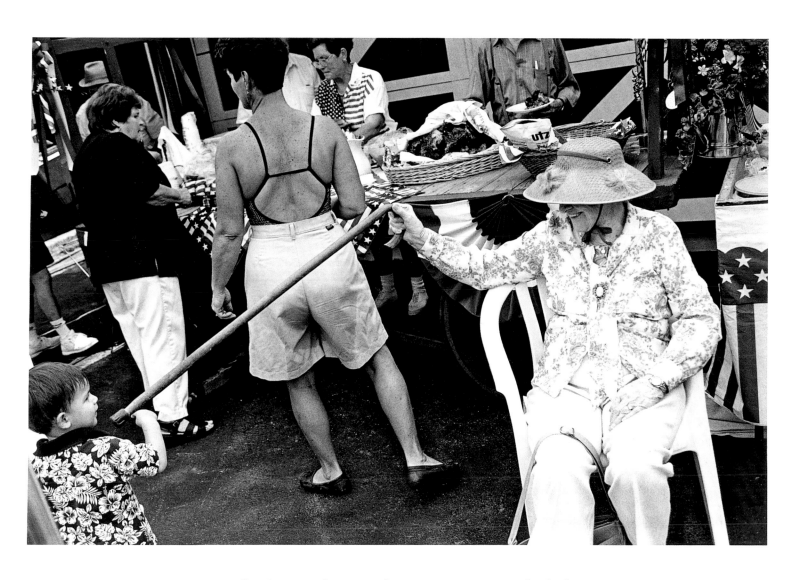

*Nellie Coomes playing with a youngster at a Fourth of July
family reunion, 1999.*

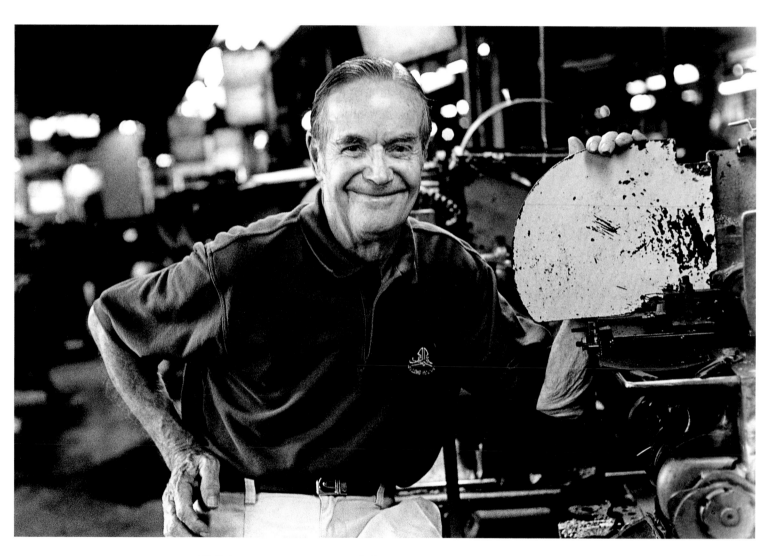

Phil Owens at a Brown and Sharpe automatic screw machine,
Davis and Hemphill, Inc., 1999.

G. Philip "Phil" Owens
(b. December 3, 1917)

Vice president, Davis and Hemphill, Inc.

They used to call this whole hill Herring Hill. It was West Elkridge, but a lot of people used to call it Herring Hill. And down the bottom, down by the railroad tracks, that was called the Gut down there. Lower Elkridge was called the Gut and this was called Herring Hill. There was rivalries, friendly rivalries, but nothing that amounted to anything.

Used to be in those days you knew everybody in town. I could go up the road today and remember practically everybody that lived in the houses. Today, I don't know who lives in half of them.

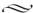

We used to jump trucks on this hill back here, on what is now Route 1. (Previously, all US 1 traffic ran down this little road going up here. I guess it must've been about in the early '30s when they built this road here.) Back in those days they didn't have the powerful diesel engines that they have today, and when the trucks'd get on that hill, they'd have trouble. I mean, they just about made it over.

And at that time, they didn't have boxed-in vans like they have now. They just had a tarp over it—and sometimes nothing over it. And the banana trucks and what-not hauling different things, they would only creep up that hill about five mile an hour and you could hop on the back of the truck to help yourself to the bananas or whatever it was.

It used to be really a circus back there. If we had an ice storm or a bad snowstorm, you could go back there and watch cars going every which way down that hill there, trucks jackknifing. They didn't have any salt on the road or anything like that.

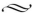

Davis and Hemphill was one of the largest jobbing screw machine plants in the country. During the war we used to make a lot of parts for the communications for the navy. When the war came along, I was twenty-five years old, so I enlisted in the navy. I had got my examination and got all ready. I was married at the time and moved out of my apartment, sold my automobile and whatnot, and I was supposed to report the next morning for induction.

And Mr. Davis, Jr., called up ten at night and told me not to report because he had gone over to the Washington navy department and got a deferment for me. Unbeknownst to me, he had been down to Annapolis

and tried to get a deferment for me and they turned it down, and he finally went over to the navy department of Washington.

I really didn't want him to do it because I was really gung-ho to go then. But anyway, I didn't get in the service. All of my brothers were in, but I never got in.

During the war, you worked sixty hours a week—ten hours a day for six days a week. You'd report seven o'clock in the morning and work 'til five-thirty, a half-hour lunch. They used to have a bell. They'd ring it at lunchtime and ring it in the morning, and I think the old bell is still on the building. Well, if the wind was blowing from the east, you could hear it up this far. It all depends on which way the wind was blowing, how far you could hear it.

When I first went there, I went as a helper on a screw machine, which is just put the bars in the machine for the operator to run it. It wasn't really any formal training program, you just learned on your own. If you wanted to get ahead, you watched what was going on and went ahead and did it. I went to work for twenty-five cents an hour.

When I first started to work there, the first week or so when I'd come home after work, my ears would ring so. It's a steady hum and it would keep me up. After a while you got used to it, but I don't think you ever got over it, because my ears ring constantly now. I guess it was probably up to 130, 140 decibels, because these bars in the machines would be turning over at 5,000 revolutions a minute, five or 6,000 revolutions a minute, and with all these bars turning at that rate...

When you're machining these parts, you had to keep them cool. You have to have a constant flow of cooling oil. And that splashed all over you and your clothes would be saturated with oil when you come home.

And you know how bad the trichlorethylene and these things that they're banned now? At that time, after these parts come off of the machines, they're dirty and got chips and cuttings on them. We had a department where they cleaned them and they'd get the solids off of them. And then to remove the grease, we had a degreasing still with boiling trichlorethylene. You would put the parts in a container, dip them down in there and take them out, and they'd be perfectly dry.

Well, the ones that actually dipped it, they had protection to keep their hands from getting burnt more than anything else. But we used to take that trichlorethylene—and our shoes would be absolutely soaked. We'd soak our shoes in it, soak our clothes in it, and put them back on.

At first they used to have sawdust. They'd put it on the floor to soak the oil up because that oil would splash all over the place from the machines. And they'd put the sawdust down, then take it out and burn it, and put new sawdust down. Then they come out with this sort of pellet stuff that absorbed the grease. It wasn't quite as bad as working in sawdust and it dried out better than the sawdust did, too.

And the *smell*. You know what oil smells like? That's what it smelled like. And there'd be a lot of smoke. Occasionally something might catch on fire, but most of the time they didn't. The oil kept the parts cool enough and the tools cool enough that there wasn't no actual fire there, but it would be hot. And of course, oil going on something hot makes a good bit of smoke, and there was a lot of smoke fumes.

And the oil—no matter how often you took a bath, the water would stand out like bubbles on you. It got in your skin. And we did have some problems with people that were really allergic to it would have a bad

eczema. And there were a couple cases where, you know, people just couldn't work there on account of it.

We had a big tank outside and the trichlorethylene was put in a tank. And then periodically we had somebody come in, emptied the tank, and took it out. And where they put it, I don't know. They were supposed to be taking care of it properly. Whether they did or not, you didn't know.

We did have a union for one year, because they went on strike after one year and they stayed out on strike for a year, and then they voted them out when they came back in 1971, I think it was.

I was a supervisor. I couldn't belong to the union anyway. But half the people walked out, the other half kept on coming in. I don't really believe that they ever had a majority, because I think the company was doing all that they could for the people and paying them what they could, and treating them as fair as they could. But of course you always have disgruntled people, and all you have to have is a few rabble-raisers to stir something up.

They would throw a bunch of carpet tacks and things at you, and you drive in and the first thing you know, you had two or three flat tires. And they might bang the side of your car as you went by. No real violence, but it wasn't nice. It was pretty nasty.

The people that worked there, half the crew kept on coming back. And then we brought some help in and we also contracted some of the work out to other companies. So we kept going and kept the customers pretty well satisfied.

In fact, one of my best friends belonged to the union and we never had any trouble over it. But you know, personally, I couldn't even talk to some of them about certain things because it would be illegal for me to be in touch with them. It was pretty bad. Some people, some of them wouldn't speak to you after it was over with.

Sam Merson, Elkridge Volunteer Fire Department, 1999.

Samuel E. "Sam" Merson

(b. December 12, 1928)

Contractor and builder

We moved over on Railroad Avenue—and the railroad was close right there. We knew all the fellows that worked on the railroad, you know, the Taylors, and old big Buck Jones. We used to go up there a lot of times and what they called a wait train* used to come in on the siding. Mr. Toomey had coal bins up there and a lumberyard, and pipe and cement products used to come in on that spur line and unload. But we used to be up there all the time when the wait train came in. Of course, I'm talking about the days of the steam engine now.

They would let us go up, and I can remember as a kid looking down and seeing how high it was from the engineer's perch, you know? I thought that was really high. But then they would let us go in the caboose.

And in those days, well, the brakemen and so forth, they had almost contests, like which one could cook the best, you know? We used to go in and we could smell the coffee and so forth and it used to smell so good. And that was one of my ambitions, which I never got to do, was ride cross-country in a caboose. That doesn't sound like a big ambition, but I always loved the railroad.

And then we used to walk along the railroad track, too, just walk. We had to walk there to get to some of these places that we were going to fish and all, and we always loved walking along the track. It had a special smell. It's a cross between creosote, I guess, and just a smell that a train makes—the metal going along on the rails, you know, the metal wheels against the metal, it makes a smell.

Living close to the railroad, too, well we had a lot of hobos then riding on the trains 'cause it was the Depression. And a lot of times they'd be in a car. It wasn't exactly a flat car, it was a long coal car, but it wasn't the full height. And they would be standing in there,

*A short freight train (steam or diesel) that would be switched from the main track to the rail siding to allow a faster train to pass or to unload pipes, cement, coal, or other goods. Freight cars were usually detached from the train to unload and then picked up on the return trip.

like maybe six or eight of them. We'd all wave at them and, of course, they'd wave back.

But a lot of them used to drift to our house for something to eat and my mother would always give them a cup of coffee and a fried egg sandwich. That was the recipe. And of course, when they were sitting out there, we would all be looking out the window at them, just looking at them, you know, to see what they're doing or how they were acting or whatever.

But my mother never turned one of them down, although we had meager things for ourselves. And I have read that the hobos—if people would give you something to eat, they'd mark it someplace on a fence or something.

Of course, it was against the law for them to ride the cars, but I think they kind of looked the other way a little bit. But I have seen them riding under the undercarriage on freight cars, which is very, very dangerous. Now how they stood it, riding under there, I don't know, but they did. They would be laying down under there, I guess hiding so they couldn't be detected. It was very dangerous, but they would do that.

And then another time I saw when we were walking—there was a stream that ran down through Guytons. It originated from a spring but there was always some water in it, and we used to put little pieces of stick in there and make out it was a boat, and then follow it all the way down, under the railroad and down to Deep Run. You know, that was one of the "boys" things that we did.

But when we were doing that one day, there was a hobo. He had a little fire there and I don't know whether it was a can of beans or something. He had a forked limb that he had the thing hanging on and he was heating that. And we always thought that was neat, you know, and every once in a while, we said, let's make a fire and cook something like a hobo.

~

The house that I lived in on Railroad Avenue, it was gravel there, and the traffic going up and down made so much dust we couldn't hardly open our windows during the daytime 'cause our house sat I guess within ten feet of the road, our front porch. And all the road up along the river, that was gravel—up the Patapsco, you know, going to Orange Grove and all that area.

When we lived in the house there, they had a train station up in Elkridge. And in the wintertime, when it was snowing, we could always hear the scraping of the shovels. They were up there—this was early—shoveling the platform off so the people getting ready to get on the train would have a clear path.

That station, when it burned down, I was on that fire. I was a member of the fire department and we were working up at school on a Saturday and they alerted us. In those days, they had all kind of systems. The janitor at the school, he was in the fire department, and his wife called him and said the fire engine was going to pick us up at the school. And he had yelled to us and we went out in front, and the engine picked us up coming down the road.

We went down there and the station, I guess it burned like half down, but they tore it down because it was literally destroyed. But we had to lay the hoses over top of the track, and they stopped the trains for a little while until we got the fire down, and then we went back and put the hoses under the track, and then the traffic could go ahead. But that was a big thing. And that was a sad day, too, 'cause we used to hang around that station a lot when we were kids. People now wouldn't think much of it, I guess, but we did.

~

I joined the fire department in 1944 when I was fifteen. In those days, I used to get out of school down at Elkridge High School. Mr. Murphy was the principal. If you kept your grades up, he would let you attend fires during the daytime. They had a special signal, a bell

that they would ring. So they would ring and the fellas that were volunteers, they would be excused to go on the fire. That's during the war, of course, when a lot of the firemen were in the service.

Well, we had to run up the road to the firehouse, which was I guess over a quarter of a mile. Once in a while, somebody would pick us up and take us up in the car if they were going in that direction.

We had twenty-two hydrants in Elkridge when I first joined the fire department. It was twenty-one in what they called the metropolitan district, plus one at Davis and Hemphill. They had a sprinkler line in there and they had a hydrant there. So, what we had to do if we were outside the area of water—later years we had a water wagon, what we called it, it had just water on it—so we would run that in conjunction with the pumper and then hook up so we had a water source. That was always filled, ready to go. So any house or building fire of any kind, that would automatically run with us, except the pumper would go first and then the water wagon would come next.

Sometimes we had to draft out of streams or a pond or whatever. Either you walk all the way back to the engine if you're back in a big field, or, if you were fortunate enough to have a stream there that was clear water, well you could fill it up there, see? And we did that many a time, filled up right out of the stream. But it took a lot of time fighting a fire like that when there was a lot of wood involved and dead trees and all falling. You'd have to stand there and squirt it with those Indian tanks we used to carry on the back. That was a tank filled with water, and then you had a nozzle and you squirt it. 'Cause if you didn't, well, then it could flare up with the wind and set another fire in the next field or something.

But the first engine that we had, Old Daisy, it just carried the water on it and it just had an old pump. It

wasn't very much. But then, through the Office of Civilian Defense, they got a front-end pump on it, which really pumped good then. The only thing about it, it would freeze if you didn't drain it.

And we were having bingo, so they pulled it out of the firehouse to make room so the ladies could set up the tables. And we had to respond to a chicken-house fire, it was up toward Dorsey. We got up there and the pump was frozen from sitting. It was a real cold night and whoever used it before didn't drain it. So we had to pull up to the heat of the fire to thaw out the pump before we could throw the water on the fire, which made us feel, you know, about that big when we were there on the scene and no water on it yet.

Well, the chicken house was pretty well gone when we got there, 'cause that was about a three- or four-mile trip, I guess, and it was already started real good. The time you got there, it was burning pretty good.

But over the years, all of us have belonged to the fire department. Daddy was on the board of directors, and all of us—that's six of us boys—have belonged to it. Sometimes, you know, we could compose a crew of Mersons.

I remember one time down on Main Street, we had a call for rescuing this cat. And Chief Lanahan, he went up there after the cat—and the cat scratched him all up, really tore him up. So after that, we got calls and the chief would just tell them, he said, "Well, you know what? I have never seen a dead cat skeleton up in a tree yet, so that cat'll get down eventually."

Biggest fire we ever had was the barrel factory fire on Levering Avenue. When I first joined the fire department, there was two places in Elkridge we talked about how we were going to attack it if something happened fire-wise. One of them was Davis and Hemphill plant

because it had a lot of oil on the floor down there and sawdust, and it would really go if it did ever catch. And the other one was the barrel factory, which was a large building. It was all frame, and what they did was recondition barrels for Calvert Distillery over there, so it had some alcohol in them, too. We knew if it ever got going, it would really burn.

So one day it did. It was in May, I guess it must've been '56, '57, somewhere in there. We were living in a house diagonally across from the firehouse. And my brother Bill, he lived downstairs and I lived upstairs, so consequently he'd beat me over to the firehouse most of the time.

So I saw the doors going up, certain doors went up. Well, you knew which piece of apparatus they were going to run. This was the pumper door, so I said, "Uh-oh, we must have a building fire." I was running over toward the firehouse, Bill was raising the door, and I said, "Bill, what we got?" And he said, "Look, turn around. There it is." And it was still dark—and it was the barrel factory.

So the whole thing was engulfed when we pulled up. I drove the first engine in on that and we laid from a hydrant right there on Levering Avenue. As far as the fire goes, you know, it was just so much, but we had a whole bunch of companies come in and help us. The first thing we did was protect an exposed house that was close to the burning building. But that house was so hot, it had asbestos shingles on it, the shingles were popping off like that. But that was the biggest fire we ever had.

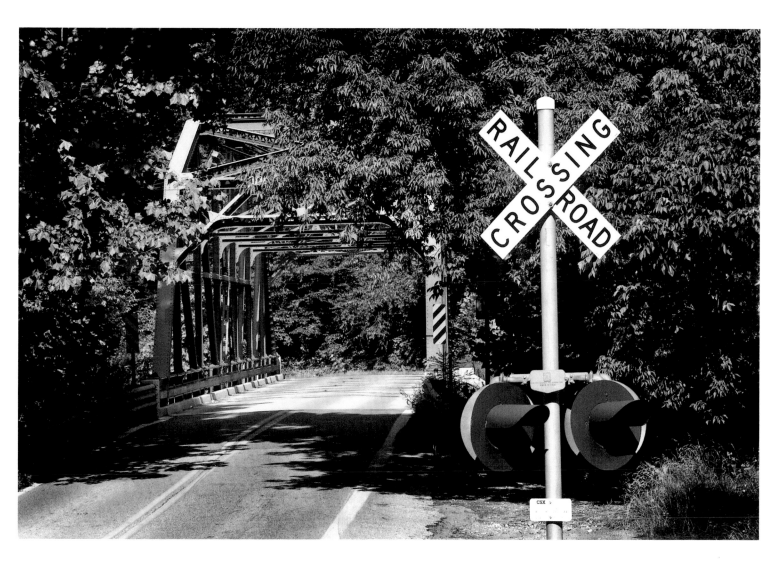

Railroad crossing and iron bridge near Daniels, 2008.

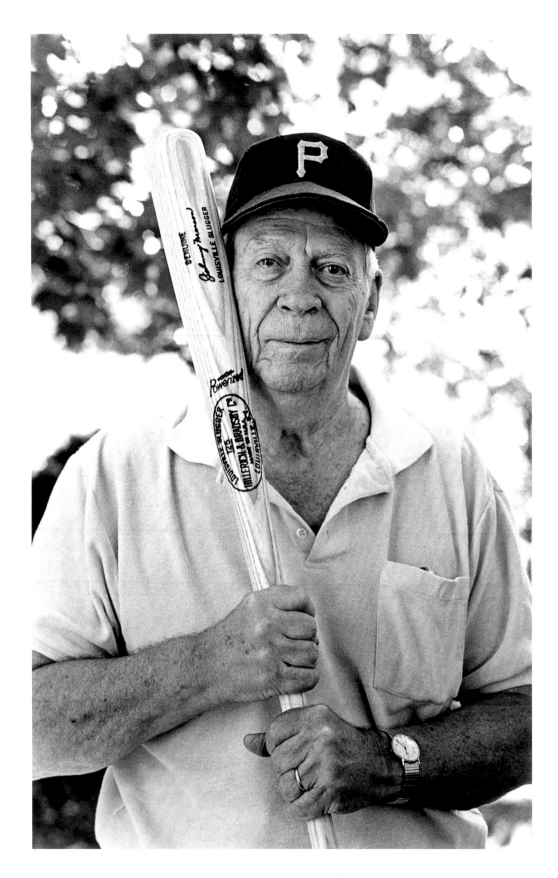

Jack Merson with his Louisville Slugger, 1999.

John W. "Jack" Merson

(b. January 17, 1922)

Machinist, Davis and Hemphill, Inc.; major league baseball player;
captain, Maryland House of Corrections

I always played baseball. I never wanted anything to do but play baseball. Several of my teachers said, "Jack Merson, if you'd just forget about baseball and start learning your ABCs and your English, so forth, you'd be an A student." Well, I was very satisfied with getting my Cs, you know, as an average student in getting by.

I played shortstop most of the time. Of course in high school, if you're pretty good and got a good arm, you're a pitcher, so that's what I did mostly in high school is pitched. And then I played first base if I didn't pitch, 'cause I could hit pretty good.

We had a southwestern county baseball league. It wasn't professional, I mean, it was just sandlot, but we played every weekend. Every Sunday we had a doubleheader. We had eight teams in the league. They were Dickey, and Ellicott City, and Dayton, Arbutus, Savage, Elkridge, Odenton, there's one more. Anyway, we scheduled a different one every week.

And it was one of the best leagues in the state of Maryland, 'cause they had some good ballplayers around. Them old farmers up there and all, they were good. And several years there, the winner of that league went on to play other teams in other leagues in the Baltimore area—and they'd win the thing. They'd win the whole state championship.

Well, those times, that was the biggest thing you had to do. I mean, so many people used to come to the ball games on weekends. They would look forward to it 'cause it was the only recreation they had and they couldn't afford to spend money in going out. And something like that, they didn't charge, you know, it was just a free-will collection. People come around with a hat, you know, they could throw in a penny or a nickel or whatever they wanted to.

My father, he was working on the railroad, he was a station agent. Toward the end when things got real bad, the Depression, the guys with the less amount of time, they kept getting bumped, they say, from one station to the other. Bump, bump, bump.

And Lord, he was bumped. He used to work at Relay Station, he worked at Elkridge and up at Ellicott City, and Ilchester. But then when they started bumping like that, he was down in Hyattsville and Langdon and Muirkirk, down that way. Then he was bumped *out*, then he was done.

So it was just fortunate enough that we had a neighbor who had a pretty good job with the Federal Tin Company in Baltimore. They made tobacco tins, canned tobacco and so forth. And he got Daddy a job. They were making twenty dollars a week and we were paying ten dollars a month for our house that we were living in, with no inside toilet or nothing like that. This was down on Levering Avenue. (The house is not there now, the new road took it out.) But this was back in those times—and it was tough times.

They used to hang mail. They used to have a bag that you got from the post office, which was right down on Main Street there. And it was a special bag that you put the express mail in—some letters on the top and some on the bottom. In the middle, you had a strap that you tightened up and then you put this on a hanger at the track.

This guy in the baggage car on the train used to come by and we used to sit down there and watch him. Engine'd come around this bend (there was a bend about, oh, 500 yards before you got on the straightaway to get to where the bag is), you know, "Here it comes, Jack, here it comes, here it comes!" And it come around the bend and then the engineer would see it hanging.

If it was hanging there, he'd blow a *whoo whoo*, like that, and let the guy know in the baggage car that it was hanging, see, so then he'd get ready. He's standing there and he's got this big hook, it's got an arm on it like that, which would catch the bag. He'd wait 'til he got close there, and he'd bring that hook all the way out and it'd hit that bag right in the middle where that strap was, and he'd grab it and bring the mail in.

One time, I don't know what happened to it, but he hooked the frame and, man, sparks flew everywhere and all. We were flabbergasted, you know, we didn't know what the heck it was. And we look up and I said, "Look, Bill, there goes the mailbag!" He missed the mailbag and knocked the frame flat over, and then the mailbag was flopping down over the hill, down the bank. It almost went out on the boulevard down there. Of course, we had to run down there and get it and took it back to the post office. But that was the one time. They never did that anymore.

It was, oh, so much different. I mean, you get to appreciate little things when you have to live like that. Well, I used to have to cut lawns. I had two lawns I cut all the time in the summertime and I'd just give that money to my mother. I'd get fifty cents for cutting two lawns. That was on a Saturday, of course.

My grandmother lived in this house up here on St. Augustine Avenue. I used to come up there and scrub her bathroom and down her stairs and her kitchen every other week. She'd give me fifty cents for the bathroom and down the stairs, and then if I did the kitchen, too, she'd give me a dollar. Of course, I'd take that home and give it to Mother.

Like I say, my father, at that time he wasn't making that much money. And then, him being depressed because he couldn't provide as much as he wanted for us, at times he wouldn't come home on Friday with the money, you know, he's out playing cards, trying to make money. He never won, hardly ever won, but we got along by donating. My mother said, "No, Jackie, keep some for yourself." I said, "No, Ma, you need it, you need it."

Of course, you could get a loaf of bread for ten cents then. Right down here where the Commercial Tire is now was an A&P store. And when we could, and when Mother could afford it, she'd give us a five-dollar bill with a list of stuff. We had one of these stake-body wagons three of us got for Christmas (not one of us but *three* of us got that), and we'd go down there and get enough food for, I guess, half the week anyway—for five dollars.

They let some people buy on credit. But they were very strict in them paying their bills, 'cause if you didn't

pay your bill, you get no more until you got it paid. That's what we used to do—not at the A&P, but Mr. Sybert and Mr. Earp and the independent merchants. Yeah, they would let you buy, they used to call it, on tick. But that was only for a week. If you didn't pay at the end of the week, well, you couldn't get anymore until you paid.

But like, if you ran out of bread, you'd scrape up pennies or go out and look for it on the street or something. Of course, I used to save ten cents or fifteen, twenty cents. I wouldn't spend it for anything and I'd just keep it in case Mother would need something. Then I'd say, "Mud, I got it" (we'd call Mother "Mud" all the time). She'd say, "Oh Lord, I need a loaf of bread. I don't know how I'm going to get it." I'd say, "Well, I got it, Ma, I got a little bit of money. I got it upstairs." Had a little box bank up there. I could make it rattle a lot of times and not hear anything, you know, but sometimes I have enough to get over the hump.

I was one of the charter members when the fire department first started in '42, '43. We had to depend solely on Halethorpe for a fire engine 'cause we didn't have one around here. And then they started thinking about the Second World War, the bombs, and all this kind of monkey business, so the Office of Civilian Defense approached us about getting a building to house one of their units, which was just a small pumper. But you had to get some kind of transportation to pull a pumper, this was just a portable pumper.

So they found this old Brockway. And then they got a couple of men that could build a big wire basket which boost the hose in on the top, you know, and other ones to fix the engine up. We finally got to the point where we had a pretty good piece of equipment. Well, it was on the radio and all about the unit that had been built here, and they praised it quite a bit. "Daisy," yeah, I don't know who even named it, to tell you the truth.

The fire station was right across here. Well, at first it was a Ford agency and then after that it was a horse stable. That's how we got it, 'cause the fellow that had the horses, he donated the building for a dollar. So after we got the aroma of horses out of there, it was in pretty good shape.

You had to take a basic fire course. The University of Maryland sent out some of their teachers, and we used to have a meeting over at the firehouse every Tuesday night and we learned the basic course. We had a couple of the guys who had had some experience, but none of us knew anything about it.

The first thing I remember us buying was half a dozen pairs of hip boots and a half a dozen sheep-lined coats. And then we had the hats. Instead of the regular fireman hats you have now, we had those airplane-type hats with the flaps on them—you tie them. But then that was only half a dozen, so the first six people who got there, they were the ones that wore those things. Otherwise, they had to wear their own stuff.

Ed Falter used to be the chief over here and his son was in the department. He was kind of gung-ho, you know, young. And we had a colored house down on Freetown Road was on fire, and we went down there and the whole second story was on fire. Anyway, he got off first and he had the hose nozzle, and I said, "Now, wait a minute, Eddie. Don't go in there, don't go in there." Man, he was going up the ladder, you know. So I hurried up there and got behind him, and I said, "Wait a minute. You don't know what's in there." He said, "Yeah, yeah," he said, "I want to put this out." I said, "No, you don't go in there."

So sure enough, we were at the frame of the house, and of course, the smoke coming out of it and all. So I had a flashlight, and I started trying to see what it was in there—and the whole floor had collapsed. There was no floor. And if he'd a gone in there, he'd have just gone right on down through. And to this day, he sees me once in a while, he says, "Jack, I sure am glad you wouldn't let me go in that building that time."

But you can't be too cautious about any of that kind

of stuff 'cause you don't know what's there. I mean, when you can't see what's there, you got to be afraid of it and cautious. And we were taught that way over here to don't lose a life to try to save something else. Say somebody says there's somebody in there, you can't do it that way. You got to investigate and find out before you are too rambunctious and go into it.

As time went on I played, well, you might say, semipro baseball, which is better than sandlots but not into the professional. So I played there a few years and I made out real good, and that's how I got signed to a professional contract. We were playing in the tournament at Harrisburg, Pennsylvania, and I got a good series and the pro scout signed me then.

I had a good year at Uniontown, Pennsylvania, my first year as a C ball. (There was D and then C and then A, and then AA and AAA. Triple A ball is before the major leagues.) So I played at Uniontown and C ball; then York, Pennsylvania, and B ball; and then in AA ball at New Orleans for two years. And then I played one year at the Indianapolis in the American Association. It was near the end of that season that Pittsburgh called me up and I finished the year at Pittsburgh, that being '51.

Then it was Pittsburgh, and then a while with the Red Sox, and then I went with the San Diego Padres out on the Pacific coast for my last four years playing, so we had a very enjoyable time. The best was, I guess,

out at San Diego when we got a place right on Mission Beach. '56 was the last year I played.

I had a couple bats that I liked, you know, that were well-balanced and I could really whip them and all. Of course, you generally break them, just like that one that was broken here. That was one of my favorite bats, too. But that's why I brought it home.

You can see where the ball has been hit and fouled off here, see, it burns. It's the friction when you hit the ball. You can even smell it when you're at the plate, when it first foul tips and all. Those things cost fifty dollars now. I'm keeping it for one of my grandkids. There's a couple other companies that make them, but this is the original one and the granddaddy of them all.

My average overall was about 305. The first year I played I hit 388, which led the league in hitting. Oh yeah, I got records at Cooperstown. And also, the bat makers in Louisville, you know, Louisville Sluggers—when I was playing at New Orleans, they asked me to sign my signature on a bat. You got a special little piece of paper that you sign your name on it, and then they put that onto a metal plate and they burn your name on there. And then when you order the bats, they take that plate and burn that thing right into the bat. You know, everybody that signed with Louisville Slugger, their names are on a little plaque on the wall there. *My* name's up there.

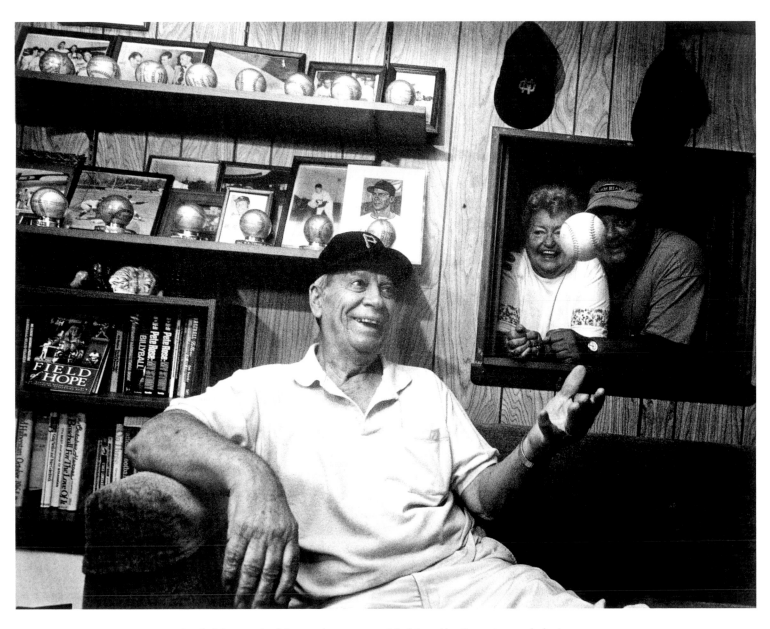

Jack Merson in his trophy room with his wife, Jimmie, and their son,
John W. Merson, Jr., 1999.

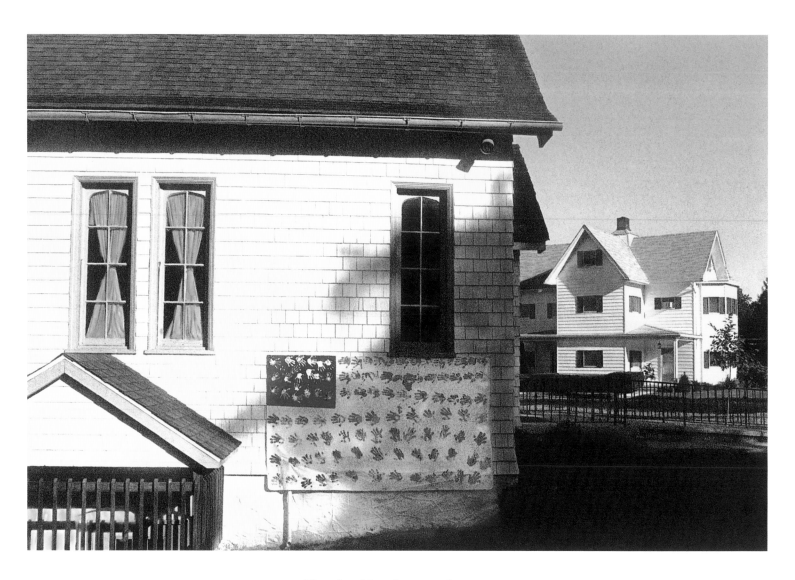

Church with a flag mural, 2001.

RELAY

In the Y junction where the train tracks fork south and west sits a weedy island, a fine vantage for train watching. The ritual begins with the wait, senses keen, the silence laced with anticipation. Finally a whistle sounds and then the faint telltale rumble signaling an approach sight unseen, direction unknown. Where will it come from? Where will it go?

Suddenly the engine heads the bend followed by the next car and the next. An arm, disembodied, waves from an open window; you wave back, a momentary connection is made. The endless freight rolls and rolls past with a great sensual surge: scent of diesel, circus of shapes, rush of wind on skin, an atonal symphony of rhythmic clatter and groans punctuated by harmonic scrapes and squeals. Then it tails off, the last car retreats around the rock or over the bridge, and with that comes a quieting, a return to silence—until the next train.

The rhythms of life in Relay have been calibrated to the comings and goings of trains ever since the first horse-drawn cars stopped here in the 1830s to change teams at the Baltimore and Ohio's relay station, which gave the town its name. Fresh horses came from stables at nearby B & O farms until horsepower gave way to steam, turning the place into a regular pit stop and junction for passengers on the B & O's Old Main Line through western Maryland and on its Washington branch, the first railroad into the nation's capital. You could stretch your legs and grab a hot meal at Relay House, a trackside "mealing station" that evolved into an all-purpose travelers' inn.

After Relay faded as a major transfer station between Washington, D.C., and points west, the B & O still chose Relay as the site of one of its showcase station-hotels, which were sprouting along the main line from Baltimore to Chicago. The resort, it was reasoned, would cater to connecting passengers travel-

ing between New York or Philadelphia and western destinations and revive Relay's role as a point of transfer. In 1872, the sumptuous, Gothic-style Relay Station-Viaduct Hotel rose in the middle of the Y on the ledge overlooking the Patapsco Valley. Built of blue Patapsco granite, with red Seneca stone trim and a multicolored slate roof, the complex boasted a gem of an English garden filled with fountains and gravel paths and flowers and hedges.

In its heyday, summer trains brought city folks out to escape the heat and the village eased into the twentieth century as a bustling railroad junction and a resort for Baltimoreans—and an enclave of B & O money and power. Landscaped Victorian homes studded the hills on the north side of the tracks (the right side, some will tell you), upstaging the workers' bungalows clustered on the south side, across the tracks, in the neighboring village of St. Denis. (The town took its name from one Denis A. Smith, a wealthy local who liked to throw lavish parties in his grand stone house. People called him Saint Denis for his "high doings," among them building the village post office, which subsequently bore his nickname, as did the town it served.)

Trains don't stop at Relay anymore. With the advent of parlor, dining, and sleeping cars, the Viaduct Hotel became obsolete. In 1950, they tore down the grand old station-hotel and the gardens and paths have gone to weed. All that remains is a plaque—and a lone granite obelisk commemorating the backers and builders of the B & O's most ambitious engineering project: Thomas Viaduct, named for the railroad's first president, Philip E. Thomas.

This graceful Romanesque span links the Patapsco's north and south banks at Relay and Elkridge, its existence a testament to the vision and audacity of its Baltimore designer, Benjamin H. Latrobe, Jr. The wide and deep crossing, flanked here by high and rocky ridges, called for a bridge 612 feet in length that would carry the track fifty-nine feet above the river—on a four-degree curve, no less, to give the line sure footing on the south side. And the B & O required that it be built of stone, as would all bridges on the Washington branch. To meet these requirements, Latrobe conceived the largest such structure ever attempted in the country. Even more impressive, it was also the first multiple-arched stone bridge and the first of its kind to be built on a curve.

Detractors dismissed it as Latrobe's folly, said it couldn't be done—that is, until the first six-and-a-half-ton engine and then a second pulled across its length without mishap on July 4, 1835, ending the impasse that had stalled progress on the Baltimore-Washington line. A survivor in its second century, built of the bedrock on which this place rests, the old viaduct with its eight elliptical arches still stands, bearing modern trains, faster and sleeker and heavier, across the Patapsco gorge.

Relay village, which climbs from the tracks to a verdant common, also

survives—a Victorian oasis of rampant porches and tended gardens and pleasant avenues with arboreal names like Elm and Tulip and Magnolia. It is not pristine; the white drone of highway traffic though muted is constant and pervasive. Nor is it autonomous; the few stores have all but disappeared and people commute to work elsewhere, many from St. Denis station, where MARC trains stop on their weekday runs between Baltimore and Washington.

Even with the changes wrought by time and in the name of progress, the patina of the past seems untarnished, undiminished, compared to the hurrying world beyond Relay's borders. Defined by the river, by the railroad that put it on the map, and by the highways that virtually took it off—the true place that is Relay floats within these boundaries, waits at the end of the bridge.

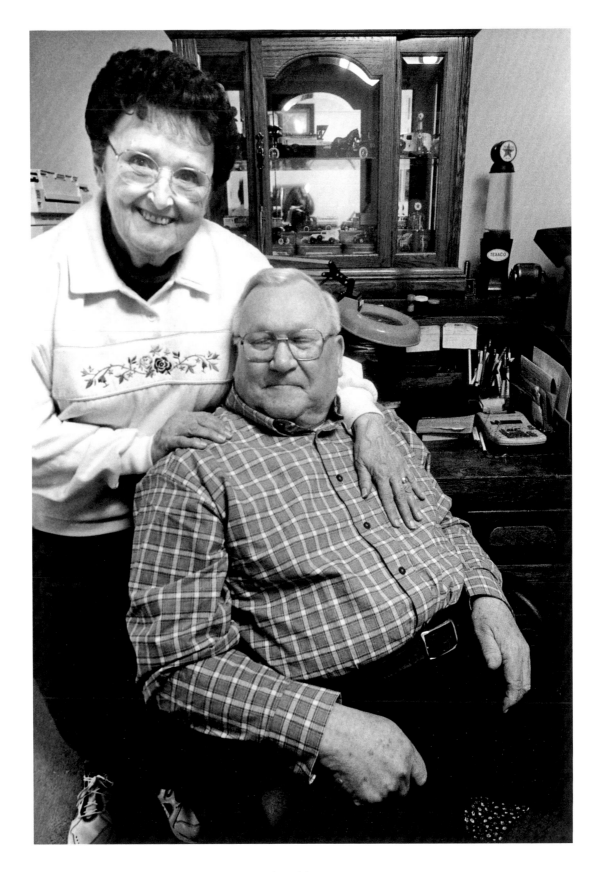

Harry and Nelda Ring, 2001.

Harry L. Ring, Jr.

(b. January 20, 1925)

Owner, Texaco station

Nelda Hill Ring

(b. April 8, 1929)

Administrative secretary

NELDA: Relay and St. Denis were remote communities. They weren't like the Arbutus-Halethorpe community that had the streetcar, that had the bus line. It was kind of isolated. You had the local trains come through and stop, but that was all. So it was sort of a little area all unto itself.

HARRY: Relay was a railroad town. It still is a railroad town—not that the railroad has that much effect anymore with the advent of the automobile, but it was a railroad town. St. Denis was across the tracks from Relay.

NELDA: I think there was a definite caste system there that existed clear up until we got married in the '40s. It still exists today. St. Denis was the working area; that was the "wrong" side of the railroad tracks. They were the laborers. Relay had the more educated people—the lawyers, the judges, the doctors, that kind of professional people, and kind of looked down their noses at the people who were laborers.

HARRY: Yeah, Relay was the land of the big houses. They have some houses today you'd classify as big in St. Denis, but they weren't like the ones in Relay, no way.

≈

HARRY: Well, let's see, my father, my grandfather, my great-grandfather, my great-great-grandfather all come from that general area. They were immigrants from Ireland. My grandfather Samuel Dennis Ring had a truck farm. They would grow vegetables. So my grandfather gave each one of his children a piece of his ground. My father had the first piece and he opened a tavern in Relay, right up on the northern edge of Relay—Ring's Tavern.

It was a ramshackle building that my father built. He started with a little shed. The back of it overhung the side of the place where they had dug out iron ore up in that area. He was going to put a junkyard there and my grandmother wouldn't let him, so then he turned to having a little store. When Prohibition came in, he was a bootlegger for a while, and then when Prohibition ended, he opened the tavern.

He had a pretty good tavern there, a real moneymaker. My father was a little ahead of his time, but he wasn't that bright as far as having vision. But he had a dance floor, when nobody else in the area had a dance floor, with live music on the weekends. He had a dining room, he had a bar, he had all of it. He even started putting out some food. He used to get crab cakes, oh, were they good little crab cakes. He'd put them up on

213

the bar and sell them for ten cents apiece. And he had a jar of onions on the bar, all that kind of stuff. People came from Arbutus, Halethorpe, Relay, and the city. They would come out there on a hot summer night to get away from the heat.

There was an old German gentleman, he would walk up from where he lived in Relay—and he had his chair. Nobody else could have that chair, that was his chair. And he would sit there and drink Rams Head Ale all night and then he'd walk home.

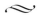

HARRY: Calvert Distillery and the railroad were your two foremost employers. A lot of our friends got their start in life at Calvert Distillery.

NELDA: My mother used to hate it because during the war, evidently they used a very low grade of coal or something to fire up whatever it was they fired up. And on a certain day if it was blowing your way, don't hang your laundry on the line. It would be full of black soot, and you couldn't brush it off because it would smear.

Or when the wind blew that way, you could smell the hops way up into Relay, and even over into Arbutus and Halethorpe. It was a distinctive odor. At first you thought, oh, it smells like popcorn. But after you lived there for a while, you thought, oh, I know what that is. Certain times of day, certain kinds of weather conditions, the trains, too, let off a lot of cinders and soot and dirt, believe me.

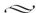

HARRY: Before I had a license I had a '29 Plymouth, and I used to drive it back and forth between my father's tavern and down through a little road over to my grandfather's farm. One day I got brave and I drove down to the grocery store, and there was Mr. Wade [the policeman]. He said, "Ringy, you got your license yet?" "No sir." "You don't have your license?" "No sir." I thought, oh brother, I'm gonna get arrested.

And he poked his head in the door, and he said, "Look, you take this car back up there on top of that hill where you live and don't come down here again in the center of town until you have your license!" Boy, did I get out of there in a hurry!

NELDA: Dr. Brumbaugh, he delivered all of my children. Never kept records, never had a nurse, never had a receptionist. You would go over and you would just look around to see who was there, and you kind of figured out where in line you came. I took three of the four children in at one time for immunization shots and he'd only charge you for one visit because you were in his office one time. Didn't make any difference how many of you there were; it was one family unit in his office one time so you'd pay two dollars.

HARRY: I can remember going over to his place and sit in the office, and he would eat breakfast behind the curtain there. He always said, "Harry," he said, "always eat a hearty big breakfast, eat a light lunch—or no lunch, if you're under pressure—and eat a light supper." He lived to be ninety-six years old.

NELDA: I worked at the [C&P] telephone company in Elkridge when I was going to high school. I worked there part-time, and I used to walk over and work the switchboard, and then walk back home.

We had phone numbers, but everybody had a party line. I can remember Harry's telephone number was 4-6-J and our phone number at home was 3-6-3-R. Now on each of those digits would have four phone lines. It was J, R, and I can't remember what the other two were. We had a separate way of ringing each letter that they would give us.

We were on the first floor of a duplex house. I think there were maybe five positions that took care of all of Relay, St. Denis, and Elkridge. Well, of course, there were times when we had all five working, but it all

depended on the hours and the day of the week as to how many. You'd have as little as two or as many as five working.

It was a board with a great big wall of little lights in front of you with holes, and you took the jacks and plugged it in to talk to the people, you had the headphones on. And you knew when a call was coming in because it would light. The incoming calls were on the lower panel, and if they were long-distance calls, they had what they called a drop. It was a funny-looking little metal thing and the little door would actually drop and wiggle. That was a long-distance call, and we tried to take care of them as much as possible.

And we had little pads of paper so that if you were charged for the call—one was, for instance, to Baltimore, and we had a larger pad of paper that was for toll calls that were out of the area.

I worked on VJ Day, the day the war ended. I was supposed to get off at nine. Well, that was impossible, in the evening that was impossible. That switchboard—every light on the switchboard was lit. People were calling up, wanting to know, "Where can we get married? The war's over now, where can we go to get married real quick?" It was wild. "Where is the closest bus station?" "Where is the closest train station?" It was really wild. And, of course, everybody calling their families. And once in a while, you'd get a long-distance call through from a son that was in the service. It was really wild that night.

I can remember I worked through 'til midnight, and my dad walked over and walked me home, 'cause it was hard to say what was going to be going on because I had to walk [US] Route 1.

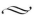

HARRY: The best thing about having grown up here—for me, it was the freedom to live my life. I guess I lived a little bit alone because I was the son of a tavern keeper. That was a stigma. I used to go up on a place called Donaldson's Hill, which was in front of our house, and I located the best dewberries. They're blackberries, really, but we called them dewberries. I used to go up there and we had wild cherry trees, and we had some that weren't so wild. My grandfather had one in particular, we used to climb that tree and eat cherries. But it was the freedom to live your life, to just be free. It was good—it was really good, yeah.

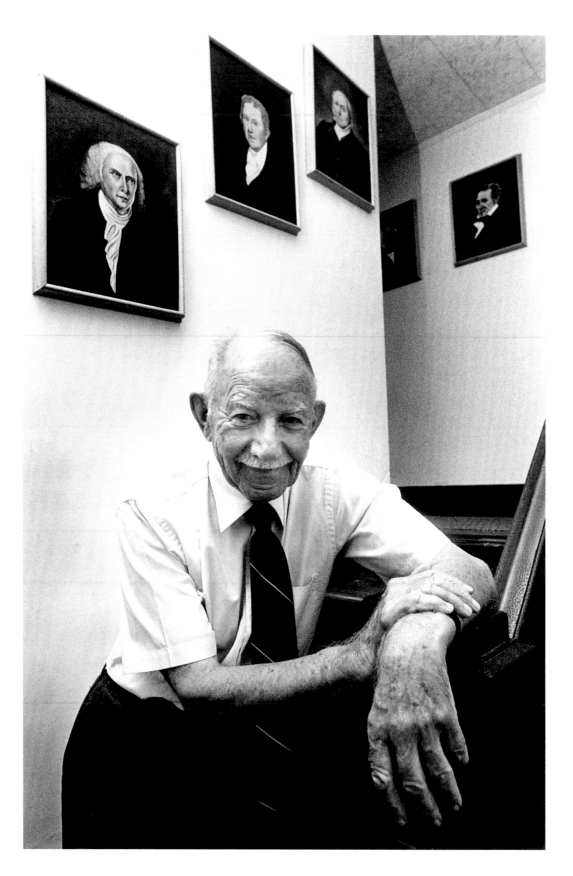

Jack Wade with his president portraits, 2000.

John Wesley "Jack" Wade

(b. March 29, 1916)

Employee, Calvert Distillery; construction worker; artist

The railroad split the two towns, see, Relay and St. Denis. The Pennsylvania Railroad ran towards Dorsey and the B & O ran into Washington. Our house faced the B & O 'cause I used to sit on the big porch and watch the big trains go by at the signal tower.

They used to have the Fair of the Iron Horse. They had the parking lot on the west side of the railroad and then they had the tunnel. And you came through the tunnel and on the northwest side of the track, they had the grandstand and all of the old-time houses—the George Washington Mount Vernon house and all the old houses—up along that line. That was the parade ground coming around.

And the first thing they started off was with the Indians. The Indians had their camp. Sitting Bull, he was there. See, it used to be an Indian camp over there on the west bank of the Patapsco years and years ago 'cause you used to pick up arrowheads down there. The Indians were the first ones to lead the parade, then it was the covered wagons, the stagecoaches, then the old-time trains, and then the modern. That's the way it ran as the years progressed.

I didn't have to pay anything. I went right on in and used to lean up against the rail there where you could watch the parade. And the trains used to go all the way around, used to have all kind of tracks around there. And they had the concession stands, the old-time music.

The fair took the whole farm, see, that used to be a farm ran by the Parkers. Parkers was a colored family, and Edith Parker, she was a nanny. She was a very good friend of the family and they had little cabins all down along there for people that worked the farm.

All this was down along the Patapsco, right into the Wades' property. That used to be all hunting ground, but now it's all warehouses. Took all that beautiful land away.

My father, John Ernest Wade, had a tavern on Washington Boulevard—that was called [US] Route 1 then, *old* Route 1. I used to see them drive cattle down there. We had the big house up on the hill. It was more or less a stag tavern, you know, just men. It was a nice little bungalow, one room, had the great big potbelly stove right in the middle. After World War I they changed, see, then the women started coming in. But the state road came through and they tore everything down.

After Prohibition came in, then my father got on the police force. He became a foot patrolman through Relay and St. Denis. He went out I think it was twelve in the daytime, came home, and went back out again 'til twelve at night. He used to have to be the school crossing guard and everything else.

I remember one time the guy broke out of Spring Grove [state psychiatric hospital], and he happened to stop by the house and ask his way to Washington. The onliest way we had contact with my father was to call Hanson and Coll store, see, 'cause we was always told if anything came up to call Hanson and Coll store. When he got there, he got the messages and called back. It wasn't no real police station—we had to contact community people and there was always somebody around there with a car.

He caught him down on the Washington Boulevard bridge going into Elkridge, and the *Sun* papers came out and they took all kind of pictures. So actually, we were involved in catching a criminal from Relay.

Right up on the hill there was Ruby Ring's farm. I used to work there for a dollar a day. He had a right big farm—cattle, and peaches, cherries. He used to go into the farm bureau down at the co-op in town and pick up pickers in his little truck, had a seat on each side. They come up there, they'd be singing, picking cherries up in the cherry tree. Then he would take them to market. And I used to help him on the farm for a dollar a day during the summertime.

In the evenings, he'd call his cows up by the cattle call—*mmmoooo*—and them cattle would turn around and the lead cow would lead them right up that pathway to the barn. Wasn't that something?

And 'round up on Ring's farm, it was all vast hunting land then, it wasn't built up like it is now. They used to go stock it with rabbits, I think like in January and February, then they'd have a population there. Then when they hunted, there was plenty of game there and that's where we went hunting.

The man that had the post office in there was Denis Smith. He was a big shot of the St. Denis area and he used to have big parties in that house. And they called him a saint because he done so much for the village there, and so, well—let's call the village St. Denis then. And that's what they did, they named it St. Denis. So that's how St. Denis got its name—from Denis Smith, St. Denis! Ain't that something how they got a name?

They had a little old firehouse there and they had a bell. Man by the name of Bud B. used to run the bell. He'd have that bell set up at six in the morning and nine at night. And if any of them kids was on the street at nine at night, they'd scamper home when they heard that last bell. That was the curfew bell. And then six in the morning, he would ring it again. That was for people going off to work for the train up at the Relay and St. Denis station.

Relay had a great baseball club run by Mr. Shakespeare. The diamond was in St. Denis on the field down there in the neighborhood and it batted towards the railroad crossing, that was the outfield. It was running in amongst the village, because you used to have to put screens up at the windows so the foul balls wouldn't break the windows.

Baseball diamonds wasn't like they are now, see? They played wherever they had a little field. It was laid out the same as a regular diamond—beautiful, but it didn't have the capacity in the field. They had obstacles, in other words, like the Green Monster [Fenway Park] in Boston.

Relay had a semipro baseball game and their rival was Elkridge. They'd always play Elkridge on Relay Day; when Elkridge had *their* day, they'd play Relay at

Elkridge. And the funny part about it was, the Elkridge diamond was in St. Denis because Elkridge had no baseball diamond. Then when they built the bridge over Relay into St. Denis, over the railroad, then Elkridge and Relay converged, all the players, and played by the name of Elkridge—but it was still in St. Denis!

We played sandlot. Later on we got in the southwestern county league and they had certain teams—like Savage, Arbutus, Halethorpe, Oella, and Bartgis Brothers—and we 'd have to play them all. Used to play Oella up there in Ellicott City, but used to play up against a big mountain. If they hit to the mountain, they'd have to just rule a double.

Oh man, that was all hometown, the crowd, boy. Now, when we played down in Elkridge, they had a little grandstand there and then people would line up along the left-field line and them places would be packed every Sunday. Well, that's all these people had to go to was ball games.

And it was only double headers on Sunday. They couldn't play until two, see, on account of people were churchgoers. No lights, played until dark. If it got dark, you called the game. But they mostly was over with, 'cause the first game was nine innings and the second game was seven. There was two ball games played, and it used to start at two and it'd be over with by six-thirty, seven. 'Cause it didn't get dark then 'til eight-thirty. There wasn't no daylight savings time then, it was all just regular time, see?

We used to wear the knickers, come up to about here—but you could pull them down a little ways if you wanted to. And regular baseball socks with the colors in them? And regular spikes. Pitchers, you put a toe plate on. The gloves were different. The glove wasn't a basket as they are now, just a ordinary glove that would catch a ball. You could hold it up there and catch it right in the web. Well, you know how they catch them now with one hand. But them days, you'd have to use two hands.

You went on the field and played and picked it up by observing. I picked up my pitching by watching the bigger teams play down in Elkridge. I used to sit in back of the backstop, see how they held the ball, and I could pick it up from there, and I practiced that. That's how I got my breaking ball.

I used to throw a good knuckle curve. I could throw maybe about eighty miles [an hour], something like that, but I wasn't overpowering. But I could throw the inshoot and I had a lot of spin stuff. That's how I used to pitch. A lot of them couldn't believe it, you know.

Buddy Clifford was our coach from Elkridge. And then they had Charlie Smithson and Charlie Petticord. They were hotheads, but they were good ballplayers. They were just like they are in the big leagues now, they get mad and fight. I used to see them get in fights down there.

But Charlie Petticord was a natural-born hitter, 'cause one day up at Relay Day, Fred Slim, he was pitching for Relay. So he went and pitched to Petticord, and he hit that ball clean up to Sam Leonard's store. (Sam Leonard had a store up there in the right-field side of the baseball diamond, way up there near St. Denis station.) Fred Slim looks around, I guess he said, "I'll be damned!"

But well, see, this is what happened: They tore up St. Denis for the interstate.

I worked at the Calvert Distillery. I was a meal-room boy first, worked in the meal room taking care of the meal. It was all government controlled. And they couldn't operate after a certain hour on Saturday 'cause you couldn't operate on Sunday. All that operating had to be shut down and start right back up twelve Sunday night. That's how they used to have to operate 'cause it was alcohol involved, see.

When the bottling part opened, all the women used to work along the bottling line. Used to be the cappers,

and labelers, and they come down and they put the government stamp on. And then it would go on by and be inspected, and you had the packers.

I used to see a guy break the cap off a bottle and take a drink. And I know a guy, he used to take and break a bottle on the sly. Not many of them did that. See, they'd have to go through the guardhouse and Captain West, he was the guard. He was pretty good. He wouldn't say nothing if he caught you. He would just let you know he knew what you was doing, that's all.

One guy run out there, I think he had one in his belt, and he was going down to the tavern there for lunch. And Captain West tried to shake it out of him, but he couldn't shake that bottle loose, and he said, "Ah, get out of there."

They first started out with Old Drum. That was a cheap brand of whiskey, had a drum on the glass bottle. Then they started bottling their brand—Calvert Special, Calvert Reserve, and Lord Calvert—and they stopped bottling that Old Drum.

They used to get the bottles from Anchor Glass, used to ship it in by boxcar. Everything came in by boxcar then. When the boxcar would come in with the grain, used to park it in front of the elevator. And when they opened up them elevator doors, there would be two fellas, they were the unloaders. They had a big scoop that ran by a little motor and they used to scoop that grain out into the elevator, and the elevator would take it up in the loft and drop it into the bins. Then from the bins, it would come down in the grinders, then the grinders would grind it and send it over to the meal bins. That's how it operated then. That would be the barley and the rye, that's what they would unload. It all came in boxcars then, but now they don't do that no more.

B & O used to run an excursion out to Viaduct Avenue. Used to have a carnival out there and they would bring people out from the city. It would come through every year and people would come out and spend time out at Relay Station because it was so beautiful there. It was a beautiful landscape overlooking the valley. They manicured it so well that people came out there just to get a glimpse of it. You could look down over the bank into the valley, and the viaduct was right there. And there was a hotel and they'd spend the night there.

See, the station was built like a steam engine. It was built out of stone and the stone came from its own quarry there. That's where the stones for the bridge came from, all down through there they cut it out.

And they had the post office there. They'd throw the mail off the train by the bag. Mr. Ennis was the postmaster and Mr. Julius Gutschalk was the postman, he delivered the mail. I think he done it first in a horse and buggy, and later on he got a Model T. Sometimes the radiator would get a leak in it. You know how they used to stop it? They put scrambled eggs down into it and that would stop the leak. Didn't ruin nothing, it just keep puffing along. See, an egg when it gets hot, it'll scramble and it stop the leak. That's what they told me.

The viaduct was marvelous, really. I used to take my girl across the bridge, a girl by the name of Evelyn, my girlfriend during baseball days. She was a nice girl. And in fact, I just met her not too long ago. Her brother died and I met her for the first time in seventy years, sixty years. I couldn't believe it. And then later on, her brother's wife died and I met her again. Had to be two funerals to bring us back together again in all those years.

We used to walk up to the viaduct, walked halfway across and looked up at the stars. It was real nice, you know, she was a nice girl. It was nothing out of the ordinary. I was sort of shy, anyhow, I'm a shy person. I'm sentimental, too, I value things.

I used to paint, when I was young, on the side of buildings with mud, stuff like that, and then I started painting a little here and there. But the most painting I did later was instruction from an artist from Philadelphia. When I was up at Valley Forge, she had a class there and I got in with her, and she taught me a lot about painting—about portraits, third dimension, and a bit about coloring. A lot of the stuff I taught myself.

I'd like to paint another president, like a Lincoln. I done a lot of Lincoln. In fact, I gave one of my Lincolns to Calvert Distillery and they hung it. I painted all the way up to Clinton.

∽

I didn't think I'd live to be this long. At forty years, I thought I wouldn't be much longer, but then fifty came, then sixty came. I can't believe it, then seventy came, then eighty came. I'm eighty-three. I can't believe it, 'cause I wasn't too strong and my parents died young. So it's hard to believe all those years.

I feel aged, but I don't let the age worry me. I should be going to doctors, but I don't go. My hands don't feel good, but I'm not going to a doctor with it because at eighty-three years old, you've practically almost lived your life so just let nature take its course, let God take his course, I guess. I think it's better that way.

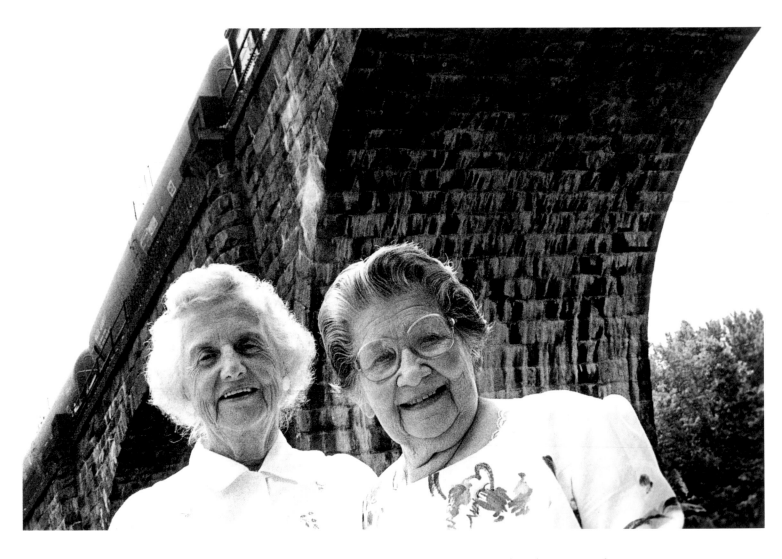

Sisters-in-law Margaret Bennett and Elizabeth Bennett at the Thomas Viaduct, Patapsco Valley State Park, 2000.

Margaret Bennett

(b. March 21, 1921)

Administrative assistant, Patapsco Valley State Park

Elizabeth Bennett

(b. November 17, 1914)

Assembly line worker, Calvert Distillery

MARGARET: I went to St. Augustine's over in Elkridge. I walked a mile and a half every day to go to school, and a mile and a half to come back. We went whether it rained or snowed—we didn't stay home on account of the weather like they do now.

We'd go across this Thomas Viaduct down here and then we'd go through the cut where the trains went. There was a path beside the railroad just wide enough to walk there and then there was a big hill beside it. Well if a train come by, I was petrified.

The viaduct had a railing next to the railroad track and a railing next to the river, it crossed over the river. And it had slats on it. And if you looked down through the slats and see that river, you were really afraid. I used to walk up over that bridge and many a time I would hang on to somebody because, you know, when you're little, things are magnified so many times.

We used to go to church at nighttime. My mother was very religious and we went to all the nighttime things. And she boarded children at the time. (My father died when I was real little.) She boarded about twenty-four of them at one time, counting us. The Catholics would go to school with us and the other ones would go up here to Relay school. And when we used to walk over

the bridge to the church with my mother at nighttime, we'd have flashlights, but we would be so afraid.

MARGARET: We used to have hobos. We had a path that went from this house down to the railroad tracks. See, we're surrounded by two railroads: the Old Main Line runs around this hill and the other line goes across the bridge, and right at the bottom is where they join.

The hobos used to come up the hill to our house when Mom had all those children. No matter how little food we had, she'd always sit them on the porch. She'd fry them eggs or give them bread. They must have passed the word along the track because we had them all the time.

ELIZABETH: Well, we had chickens and we had a fence, but the bandies, they flew over. They rested in the apple tree right by the porch, and at night we'd hear them all fluttering out and we knew it was the raccoons getting them. My husband went out with the gun and many a raccoon he shot, trying to save his foul, but he never did. The raccoons always ate them.

MARGARET: My mother used to shoot them out the top window at nighttime when they were getting her chickens. Yeah, my mother was a protector.

MARGARET: We had a big cigar tree (we used to call them cigar trees because they had what looked like cigars on them) right back here. And it was about this big around and they had to cut it down, and it had this stump in the ground. So my mother had a nail that she had bent over, and she'd lay the chicken down there and she'd put the nail over it's neck—and one swipe of the axe and she'd kill it.

So one time she went away and she said, "Margaret, you can do that." I said okay, I'll try it. I got the chicken and I laid it down there, and I took a swipe—and somehow I must have hit the thing and it rolled on down the hill still alive! And I swore never again would I ever kill a chicken—and I didn't. I never killed a chicken after that.

ELIZABETH: Down in St. Denis the hucksters came regularly. It was a horse and wagon. They used to yell, well, whatever they had in season, like "Strawberries, strawberries, anybody want strawberries?" Oh, I can hear them yet.

And then we didn't have refrigeration and the ice man would come, and we had the bakery. They came every morning and we got all our baked goods from that. Oh, I remember the rag man. "Any bones? Any rags today?" We'd always save our newspapers, us kids, and we'd take our little bundle of newspapers and he'd give us two or three cents. Oh, boy, were we rich!

MARGARET: When I was a child, they used to come up here and the whole river would be stacked with people, all along the river, both sides, fishing for gudgeons. They used to have special trains that brought them out here so they could gudgeon hunt. And then after they'd do that, they'd come up here on our hill and they'd pick violets off the hill. The whole hill was full of violets and people would come up and pick violets.

ELIZABETH: If we didn't have a hook, we bent a pin, put a piece of worm on, and you could catch a gudgeon. Their scales was like a little soft, silvery scale; it wasn't hard like fish scales. And you just rubbed those off and slit the stomach, a little bit of the inside you pulled out, and cut the head off.

And my grandmother, you'd give her a big pot of them and she'd just throw the whole pot in the frying pan and turn them over like a pancake, 'cause they were so small, you wouldn't fry one at a time.

MARGARET: We swam in the river. And it was filthy, all the sewers running into it, and the mill up there? My mother said one time she was swimming in it and she looked up—and here's this big fat pig coming right at her! I mean it was really dirty then, but I swam in it.

Now one time I almost drowned in it. They had the Avalon Dam right down below here and we used to go swimming down there. And the boys used to go swimming naked half the time if they got away with it. The dam broke in the middle and we used to swim over in there.

So one time my uncle from Alabama come up here, so my mother let him take about four of us down there. And my brothers and my husband (that I wasn't married to then) were over on this side, and my uncle said to me, "Come on, let me see if you can swim." And not knowing there was this current through there, he shoved me out through that current. I almost drowned. My girlfriend got me by the finger and pulled me in. And then he sat down at the Relay Station and he wouldn't bring me home until he made sure I was all right.

Margaret: When they were brewing that whiskey up at Calvert Distillery, you could smell it all over the place. And also I remember the dirt from the railway, when the steam engines blew that steam up. We had soot on the windowsills, we had black soot every place you'd look. But the whiskey, when it was a damp day, the clouds were low, it was a really strong odor.

Elizabeth: Well, I loved to smell it. And we disagreed on what it smelled like. We'd say either popcorn or fried bacon or something.

I loved working on the assembly line. These kids today say, "Oh, I hate to go to work." I never remember saying that. I was always so glad I had a job, coming out in the Depression.

We had a fifteen-minute break in the morning and in the afternoon, a half hour for lunch. It was mostly just day shift, except right before Christmas when they got real busy. Then they had a night shift or they had like ten-hour days. Do you know, to this day, every now and then I dream I'm at work? Oh, I forgot to punch my card, I won't get paid!

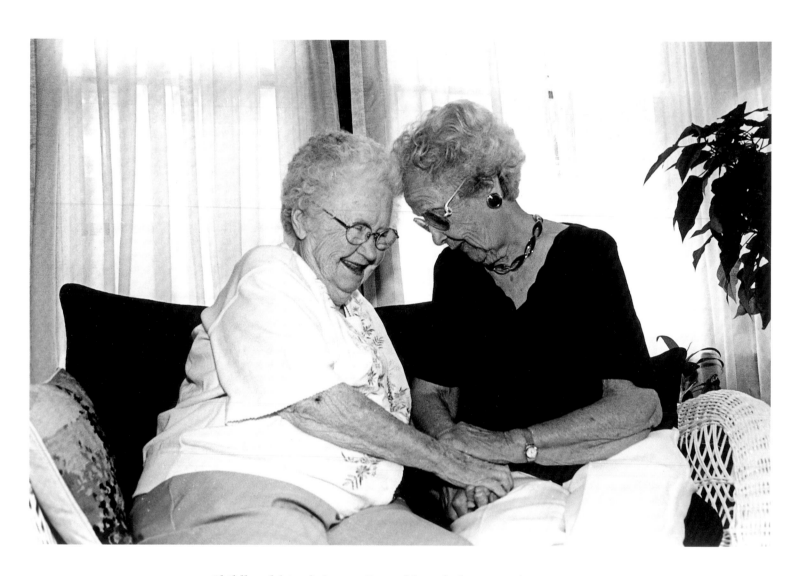

Childhood friends Lenora Reynolds and Flavia Kaufman, 1999.

Flavia Kaufman
(b. June 24, 1911)

Lenora "Nonie" Reynolds
(b. November 21, 1911)

Office workers and homemakers

FLAVIA: We met in 1912. She came from Scotland when she was six months old and she moved behind us. I'm five months older than she was so I had to be eleven months old. All of our relatives were her relatives, too, so we were always real close as children growing up. And well, after we finished high school, we went to business school together.

LENORA: This is how good friends we were: She'd go to her church Sunday school, Methodist—I'd go to mine. I'd walk down out of my Presbyterian Sunday school and meet her. Then I would go to the Methodist church to sing in the choir.

FLAVIA: She'd come to our house, and I would put my toothbrush in my nightgown, run around here, and stay all night. Nonie and I would sleep in this room right on the other side of here. And of course her mother, being from Scotland, she used to say in her brogue, "You little *gurrls* go to sleep!" Then we would laugh and talk some more.

FLAVIA: We lived on Cedar Avenue when I was a child. Down to the foot of the hill it was crushed oyster shells, just a wagon road up to Rings' farm. Mrs. Ring had five children and she named them all after precious stones: the older son was Emerald Ring, the next one was Ruby Ring, then she had a daughter Pearl Ring, then she had a son Jasper Ring, and the youngest daughter was Garnet Ring. And she said they were like precious stones to her.

They were farmers and they had a farm bell. Mother used to say, "When you hear Mr. Ring call the pickers to come in, listen out for the bell, you come in for your lunch." So we listened out for the farm bell so we could go in for lunch. You could hear it all the way from where we lived down here.

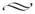

Up on the hill was Gundry Sanitarium for mentally sick people and there was a lady there who had red hair. She always carried her little Victrola with her and she'd come down and sit on the hill. Crazy Carrie we called her, everybody called her Crazy Carrie. She would come down and sit and play her little Victrola for us, and we'd see her walking all around Relay.

She'd collect stray dogs. She'd ask this boy or that boy if they wanted a dog, and then she worried herself to death that if it wasn't taken care of, she'd go back and get the dog the next day.

～

LENORA: What we did on Sunday afternoon—you couldn't roller-skate, you couldn't do anything on Sunday. Sunday was the Lord's day and you couldn't do *anything*. So in the spring all the way up to fall, we walked on Sunday.

And some Sundays, a group of us would go down across the viaduct and go up Lawyers Hill, walk all the way over to Montgomery Road. Then some Sundays, we'd walk up the River Road to Gun Road, and all the way down Gun Road and down Rolling Road again. That's what we did on Sundays.

～

LENORA: Mr. Wade [the policeman] walked every street in Relay. One night I was with Walter—my future husband and I, we were with another couple. (Well, see, we started going together in high school.) And oh, it was a beautiful moonlight night. We went up on the hill there at Gun Road and we were looking at the beautiful moon, and I said, "Oh, here comes Mr. Wade." I said, "I wonder if he'll come over and look to see who's in the car. If he does, fine. I don't care"—'cause we weren't doing anything. So he did and I said, "Hi, Mr. Wade!" He looked like he was surprised to see me, but we were just a bunch of kids having fun.

～

FLAVIA: We were never told anything about sex, anything at all. Mother had me downtown and there was a man on the street, drunk. I didn't know what drunk was, but I saw his big stomach. And Mother told me, "Come on this side 'cause that man's drunk." She didn't want me near him.

And not long after that, Mother was curling my hair. And I patted her stomach and I said, "Are you drunk?" She said, "Why would you ask me that?" I said, "Well, you have a big stomach like that man had and you said he was drunk." I thought she was drunk because she

had a big stomach. That's how much we knew about where babies came from.

But how we knew we had a baby, my sister and I (she was only sixteen months older than I was), we were down across the street playing in their summer kitchen. And my father, when he wanted us, he'd whistle through his teeth a shrill whistle. So I said, "Daddy's calling, let's go see what Daddy wants."

We knew Mother was in bed. My mother always suffered from migraine headaches and it wasn't anything new for us. So when we got up the top of the stairs—Grandma was up there, of course, she lived with us—and she said, "Your mother wants you." Well, we got in there, that's what she wanted to show us—the baby. The baby had been born in the morning. We didn't know anything about it!

～

FLAVIA: When there was a fire, people would yell to let everybody know. And when a airplane would go over—double-winged planes, you know, those little ones like Lindy went across in? There used to be mail airplanes go across here and people would get out and holler, "Airplane! Airplane!"

And one day a balloon went over. Somebody saw it and was yelling, and we went out and looked and saw a balloon going over—it had a little basket under it. And we never saw one afterwards.

～

FLAVIA: The disadvantages were getting out of here—transportation, things to do. They didn't have too much here to do after you got past kid age, you know, teenage. And if your date didn't have a car when you were a teenager—you didn't want a boy that walked from Halethorpe over here and then sat on the porch. I had a couple of those.

There wasn't too much scandal. Everybody was friendly, we all knew one another. We knew who lived in every house in Relay, didn't we? I come down and

pick her up now, we'll ride around Relay and say who lived in this house, that house—see if we can remember. If one can't remember, the other one does.

LENORA: I went to see every new baby that was born in Relay.

FLAVIA: Everybody was willing to help one another. When Mother drove the car, if somebody needed to go someplace, Mother would take them.

LENORA: But you know what? Nowadays very few bother with any neighbors. I mean, people, they stay to themselves here. They used to be more friendly, but not anymore.

See, Flavia and I are going to wait and we're going to die together so we can be in the coffin together and talk.

FLAVIA: It'd be funny if we did, but she's going to be buried in Meadowridge and I'm going to be buried in Loudon Park.

LENORA: Well, we'll meet, hon. We got to meet.

Nellie Williams and her daughter, Denise (far left), 1999.

Nellie Lee Williams

(b. March 7, 1919)

Domestic and office worker, sales clerk, riveter

It was thirteen of us. My mother died when I was four years old and my father died when I was six, so my sisters and brothers raised us. We were the only one black family that lived in Relay, only black homeowners, and we got along all right.

I was born on this very spot, but not in this house. The old house was destroyed by a fire—arson. But we were away from here for about two years. Well, what happened, the house was gonna be renovated and the contractors broke the foundation, so that's the reason we had to get out. And one night, we got the phone call, and we got here and the house was down to the ground almost.

They say they know who did it, but you have to catch them on your property. Anybody in their right mind do anything like that, they're not coming back, so therefore you'll never know. I had my idea, but you don't like to say things that you're not sure of. You know, you can weigh the world down because of two or three people, and so it's best to try not to live above your neighbors or for your neighbors, but *with* your neighbors, and that's what we did.

My father, he was a contract plasterer. He would do houses all through the neighborhood. And I had neighbors tell me that even today, that plastering stuff is still standing—no cracks or anything, because that was the way they did things back in that day.

In the mornings, the house would be full of men. My father would give them their orders and send them out on the truck to do their work. They had some people from the city, too, they would come here and then on weekends he'd pay them off.

And there were neighbors would come to him, not for a handout, but if they wanted any coal or anything like that and didn't have money to pay for it, he would loan it to them and they would pay him back.

If a freight train would stop down there, you would see hobos running off the road here and through the yard until time for that train to pull off again. They would come knock on the door and ask for food. My father would never allow anybody to go away hungry.

And a lot of times, people wouldn't have a place to stay. He would get water, heat it on the stove, put it in a tub, and make them take a bath, yes he did. And he

would let them put on his underclothes, and put them in the bed, and all night long he would sit on the chair with a shotgun across his lap. He said he refused to let anybody harm his wife or his children.

One man, he came and he stole his clothes off the line. So when he came back, he said, "Mr. Williams?" (He was, you know, hard up.) And my father told him, "I'm sorry, I can no longer help you because you bit the hand that fed you." He wouldn't do it. He was very strict, yes indeed.

We always got along. The kids would play together and everything else, but we had to go to a separate school although they had two schools in the neighborhood, one up here in Relay and one in St. Denis. We had to walk five miles a day—two and a half miles coming and two and a half miles going to school.

I started when I was six years old. And we would have to walk up the railroad and up the bank and get on Washington Boulevard and walk from there to Halethorpe. And during that time the roads were narrow and there was a bridge we had to cross over, which went over the railroad. When those big trucks would come along, you had to hold onto the thing until it was over and then you go on about your business, unless sometime somebody would come along and give you a ride. We walked in the summertime when we had to go to school, we walked in the wintertime, we walked all year round.

Well, now, the first school we had to go to was a little one-room wooden school with little wooden steps. Then they built a school on Northeast Avenue which was a brick school and had two rooms. And it had bathrooms and everything, but you had to come outside to go downstairs to the basement for the bathrooms. But it was a fairly nice school. It is still standing today, not as a school but as a recreation center for Baltimore County.

I finished the seventh grade and then I went to work.

We were taught that you had to earn your living by the sweat of your brow, that's what the Bible says, and so we went to work.

I would go to people's houses and clean, cook—no washing or ironing. Or sometimes take care of the children, things like that. I worked for one family in Relay for forty-seven years, that was the Greggs. They were the J. J. Haines Company, they sold carpet and linoleum and everything. The Plitt Mansion, that was the house.

Back in those days people couldn't afford all the doctors. If you had a cold, first you make a onion syrup with sugar and onion. And you take that, make a poultice of it on your chest, then rub your chest down with camphorated oil. And cod liver oil and wild cherry, yeah, it'd be all mixed up together. It comes in a bottle and you would shake it to get to the wild cherry, and all you would get would be the cod liver oil, yes indeed.

I know one girl, she had a fever, 'cause she was in and out the hospital, nobody could break that fever. So her mother told her to come home to her. And we used to play out in the yard with these great big leaves, we used to call it cabbage. She said her mother went out one day and got two bushels of them, put a sheet on the bed, put the leaves on, put another sheet on top of it, and put her in that bed—broke that fever.

And I've heard people say, if a child has a fever, take a piece of cotton and dab it in alcohol and put it underneath the armpit. That will break the fever.

Now, I have trouble with the gout. One of the women from my church, she sent a message to me to tell me, put a white sock on your foot, press a couple of sliced white potatoes inside the sock, and just pack it all around it. It works!

We have always been members of the First Baptist Church of Elkridge. (My father, Joseph Albert Williams,

was one of the founders.) But we used to visit Gaines Church, we used to fellowship with different churches, have revivals and things like that. When my father came here, the blacks would have to go to white churches, and you had to sit up in what they called a peanut gallery. And see, he didn't think it was right, because we all going to church, same God. So why should we be segregated?

Well, they got together and the First Baptist Church was donated to them as long as it stayed a black Baptist church and it would always be there. Reverend Monroe Simms is still our pastor.

Well now, back in those days, you didn't have all this fast music like they have today. We sang I call it sacred—gospel. My sister Martha and I, we were singers. We were known as the Saunders Singers after our first pastor. He died and we took that name. And we sang for years in some of the largest churches in Baltimore City, all down through the country we sang. We would sing accompanied by an organ or piano. And sometimes, if we got in a pinch, we'd just sing, she and I. Well, we sang until my sister got sick and passed.

My father, he was a friend of Booker T. Washington and he spent nights here. Mary Bethune spent nights here. We were small, but they would come here for dinner and everything like that.

I wasn't conscious of anything changing for blacks, but after the federal government stepped in, things really changed for everybody.

I worked downtown in Julius Guttman department store. I was the elevator operator. But if I'm working in a store, and you are my sister, and you come in and you want to try on a dress, you're told you can't try on a dress—and we're *working* there…

So what we did, we wait one day when they were gonna have a big sale, and when the bell rang and the doors opened up, not a elevator moved, not a maid, not a porter anywhere hit that floor. And that's the way we broke it up. Because how would you feel if you can't try on a dress and you're working there? And so that was broken up.

And then after that, things began to move a little bit. Because when my kids were going to school, they had buses coming all through the neighborhood here. But they'd have to walk over half a mile in order to get a school bus—we had a school bus stopping here and stopping there. So what I did, I wrote a letter to the board of education.

And then another thing happened. Somebody's child was killed crossing Washington Boulevard to catch a bus to get to school, see, and *then* I got the bus coming right here to this corner. And before it was over with, they all were riding the bus together, all going to the same school. See what I mean?

We have people coming here and spend the night and say, "Oh, how do you stand those trains? All that noise?" I say, "We're used to it, all our lives." I say, "If you lay there long enough, you'll go to sleep."

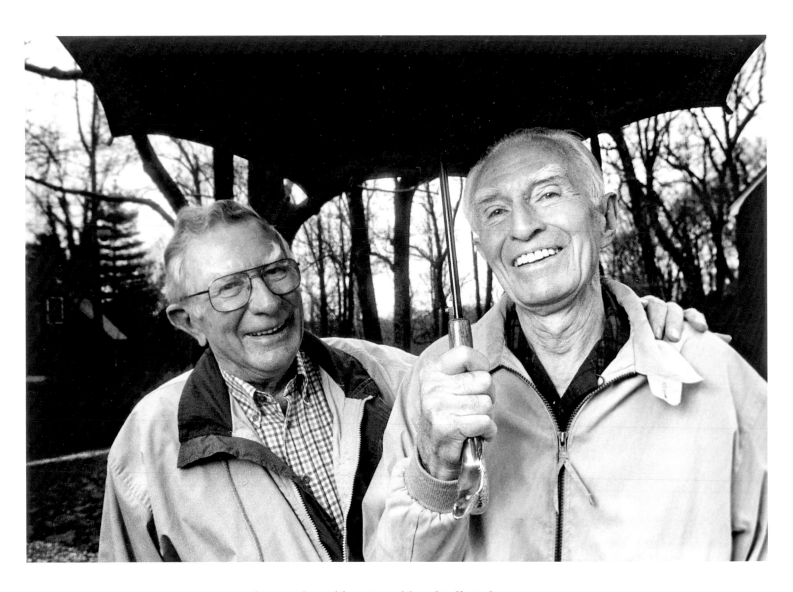

Brothers and neighbors Harold and Bill Hedeman, 2000.

Harold Hedeman

(b. September 4, 1913)

Section chief, Western Electric Company; furniture salesman

William "Bill" Hedeman

(b. December 25, 1920)

Director of Materiel, Bendix Corporation

HAROLD: See, the original B & O Railroad went from Baltimore to Ellicott City. Relay was the place where they changed horses before steam engines. That's the reason that it got its name. Avalon down here was the next stop after Relay. They had regular passenger train traffic for many years, even after we moved here in 1920.

BILL: My father went into business in a grocery store in St. Denis. When I moved here at the tender age of three months, there were ten houses this side of the railroad tracks out to Rolling Road, there were four on the other side. It was a rural country area. A neighbor across the way had two cows, four sheep, and fifty chickens. The milk that I drank came from a cow down over the hill here—a man by the name of Berger that had a cow—that was not TB tested and no purification of the milk. And I drank it. He got all the diseases and I never got any.

HAROLD: I still got the blue bucket that I used to get that milk that we all drank—not pasteurized, straight from the cow.

BILL: The area basically was the summer homes of the wealthy of Baltimore. And the road wasn't even paved.

HAROLD: Gun Road was an oyster-shell road. Originally, it was the Avalon Forge Road. And that's the greatest hill in the world for sleigh riding. The railroad didn't have it cut off then. You could go right on down and we wound up in Howard County.

HAROLD: In those days, we had plenty of ice and snow, I mean *plenty*, every winter. We were sleigh riding and ice skating all the time. We'd sleigh ride down this Gun Road hill—and I'm not kidding, it's the steepest hill in this part of the country—and when you got halfway down that hill, the water was coming out of your eyes, you were going so fast.

But when you got down this hill, you'd have to make a little bit of a left turn. And then a couple hundred feet after that left turn, you went over the railroad in a shower of sparks 'cause the steel rails were there, you know, so then you wound up in Howard County. But when you got to that curve—this was an oyster-shell road now, remember, and in those days when they had a hill, they would make what they call breakers in a

road on a hill, so when the water came down it didn't wash the road away. It hit the breaker and went over into a ditch alongside the road.

So that breaker was right at that curve. It was on a forty-five-degree angle. If you weren't on the left-hand side of that road going down that hill in a sled, I'm not kidding now, you wound up over in that ditch. Because when you hit that breaker at that speed you were going, you were airborne, and you wound up on the right-hand side of the road, down about ten feet from the breaker. And then you kept on going over the railroad. So it was a ride for life down that hill, I mean, really wonderful.

BILL: If a train was coming (we had blinking lights there), what you did is, when you started out, you laid down, you looped the rope over your arm and you held on. And if a train was coming you rolled off your sled, and that was the means of not getting run over by the train. You tore up a few clothes every once in a while. You got a bit of a beating for that!

HAROLD: We rode the trains into the city and back. When I was going to school, I even rode the train from Avalon to Ellicott City, and then got on the streetcar to go to high school.

BILL: I rode it from Avalon down to St. Denis to go to elementary school. And then when I finished Relay Elementary School, I walked from here to Catonsville. I did not ride a bike, I never owned a bike—I did not *want* a bike, because when I walked I could get a ride. There was a family over on Lawyers Hill, their girls were in private school somewhere out in the valley, and often they would pick me up. So it was better to walk then to try riding a bike.

BILL: And how I learned to drink coffee—where I-95 crosses the river down here, there's a cut in between

the hills and there's a stream that runs through there. And at the time I was walking back and forth from school, we had hobos in those days. Those hobos would congregate in there, build a fire, and sometimes wait for the next train they were going to catch to wherever they wanted to go. And they're the ones that gave me coffee out of a tin can.

And if I continued on up the trail through the woods and passed one of the homes up there, invariably Mrs. Clayton was outside waiting for me with something to eat, because I was about as big around as my little finger and she figured I didn't get enough to eat. So it was either a nice cupcake or a piece of raisin bread and butter. But it was always something while I continued on over the hill to home.

BILL: When I went to Relay Elementary School, there were three grades in one room and three grades in another room, and one teacher taught all three grades in that room and there was another teacher taught all three grades in the other room.

Very strict—had a lot of child abuse, as it would be called today, but it was the best thing that ever happened to us, I'll tell you. I had a habit of when I grabbed a pencil, I held on to it and my knuckle sat up, and we had a teacher that said you should have your fingers lying out flat. And she warned me, she said, "If you don't put that finger out flat, I'll…" And she walked up and down the aisle with an eighteen-inch ruler and she'd crack you on that knuckle. Or if you talked, you got smacked across the face. I mean, you learned discipline, and you learned it very quickly. So we never sassed the teacher, never gave her a lot of back talk and disrespect. We respected the teachers.

We all wore patched clothes in the elementary school, and of course, the affluence there was pretty even and consequently we all wore patched clothes. When I went to Catonsville, it was a different story.

One of the lads coming there was driven to school in a Packard automobile driven by a chauffeur. I used to get teased about my patched clothes, and I got teased about my red hair, but I'm here, and it didn't hurt me.

HAROLD: I hunted rabbits a little bit in the summertime. What we did with the rabbits, we trapped them with these wooden traps. It's a trap about, oh, eight or ten inches square with a wire in the back and a door in the front, and the door was hanging on a string where the piece of wood came across the top. There was a thing coming out the middle of the trap with a piece of wood straight up about six inches, and that had a piece of wood across that held the door. On the back end of that was a little trigger that went down into a hole into the trap. You put a apple in the back of the trap, the rabbit went in to eat the apple; when he went in, he tripped the trigger that made the door go down so he was trapped.

So every morning before we went to school, we went out and checked the traps. Some mornings we had one; most we had in one morning would be three rabbits. But we would take the trap home and then when we came home from school, we would kill the rabbits and skin them and we'd have them to eat.

And it was very important because we were very poor people in those days, and the rabbits were very helpful for us for food, as well as the food we got in the summer from our huge garden that we always had.

But one thing my mother said she never liked, when she'd have them in the frying pan, she said, "I don't like to see those leg muscles moving in those rabbits in that frying pan!" I'll never forget that. That's how fresh they were.

HAROLD: Gudgeons were down at Relay, down at the railroad bridge. There was a little dam about four or five feet high a little bit above there. At a certain time of the year, in the spring, they came up to that dam, that's as far as they could get. There was no fish ladder, so the gudgeons came up from wherever they were down the river. And there were millions of them in there, because whatever time you went you caught a whole bucketful of them.

And on weekends there would be people from the city out there catching gudgeons. They were lined up, I'm not kidding now, touching elbow to elbow, lined up on that river. And because we always needed any food we could get, my mother permitted me to stay home from school to fish for gudgeons, if you want to believe that.

BILL: You used four hooks. In other words, it was a spreader that had four ways on it. It wasn't too often that you picked up four of them at one time.

HAROLD: We would catch plenty of them—just about the size of a good-size sardine. Yeah, so we ate gudgeons many times.

BILL: You didn't have a lot of time to run around. In the summertime, we had a very large garden that everything was done by hand. It was hoe and weed and hoe and weed. I mean, there were no tillers, no mechanical items. And then, we'd raise lima beans, we had bushels of lima beans. You had to sit down and shell the lima beans. So you didn't have a lot of time to run around.

HAROLD: My mother canned 300 jars of stuff every summer out of our garden. That was for us, we needed it. I tell you, we were poor people, and that's the reason the rabbits and the stuff out of the garden were helpful to us for food.

BILL: You've heard of dirt poor? We were dirt poor.

HAROLD: Yeah, for instance, when you talk about the height of the Depression, I got out of high school in 1930, right smack in the middle of it. And when my father went bankrupt with that store in 1930, he went

to work for the B & O Railroad, down in the freight office unloading freight cars. He didn't work there too long and he was out of work.

The first job I got was an office boy—twelve dollars a week. And for a long time, that was for our family of four to live on, my twelve dollars a week, 'cause Dad was out of work. I knew I couldn't go to college, so I was one of two boys in the commercial course taking shorthand and typing. All the rest of the class were girls.

And it's a good thing I did because I got a job, my first job after eight months out of high school, as an office boy. They had two teletype machines, Western Union and Postal Telegraph—and because of my shorthand and typing, I ran those machines in addition to being office boy. I wound up being the secretary of the treasurer of the company and eventually I became the assistant credit manager. So just because I happened to take that commercial course, I was able to make a living for my family in that way.

BILL: What killed my father's store was the Depression. And also, people had a bigger selection in Baltimore than they had in St. Denis. *And* he was very foolish. He allowed them to charge things. But I'll tell you this, the man went into bankruptcy, but he paid it all off. It took him 'til 1943 to pay everybody off a hundred cents on the dollar, and at least he taught me something: don't ever be that dumb. And he would never allow us to have the book to see who we should go collect the money from. My father was a very kind and gentle person.

HAROLD: Yeah, but he was not a businessman, let's face it. He failed completely because he permitted people to buy on credit. He let these people run up big bills, like 200 dollars and 300 dollars in *those* days, and they did not pay the bills so he eventually went bankrupt.

BILL: 1930—didn't have any choice, ran out of money.

HAROLD: So he paid off the other two guys that were his partners, and we wound up with nothing, our family. And I mean period. *Nothing!* Yeah, by the grace of God we're here, that's the only reason we're here.

HAROLD: I love trains—especially steam trains. Yeah, after the bridge went in, they had local trains that stopped at every station between Baltimore and Washington. Then they had an express train which was Relay, Laurel, Washington, that's all it stopped. And then, of course, they had the *Capital Limited,* as they called it, and that didn't stop anywhere. That just took you right over.

And from Washington to Baltimore on the steam train ('cause I rode it more than once) it's forty miles exactly. I would have my watch out and usually it was on time. It was supposed to get there in forty minutes—and many times it was there in thirty-eight minutes.

And I'm telling you, there are curves on this end of the line and there are curves on the other end, and there's a lot of straight track in the middle of that route between Baltimore and Washington on the B & O. And when those steam trains were on that straight stretch of track over there, they were going between eighty and ninety miles an hour, because they had to go slower on each end of the line where all the curves were.

Oh, I always loved trains. More than once, I would get over on the boulevard, 'cause Washington Boulevard is right smack alongside of that straight section of B & O track. And when you had a steam train going through there—one of these big locomotives like the *Capital Limited,* you know, a big long train? And those driving wheels are eighty inches in diameter on that train, three pairs of driving wheels on those passenger engines that run those trains.

And when that went by at that speed, I mean, that was a sight to see. The ground was trembling where you're standing, and you can imagine, you know, that big arm that connects those wheels? You can't believe

it that piece of equipment can be going that way, but it's going so fast that you can't even see, you know, it's just a blur. I mean, those wheels and that arm are just a blur going by there.

So, you know, it's a sight to see. So when they changed to diesel engines, I thought, *phooey*, I don't want any part of those things. I'll take the steam train.

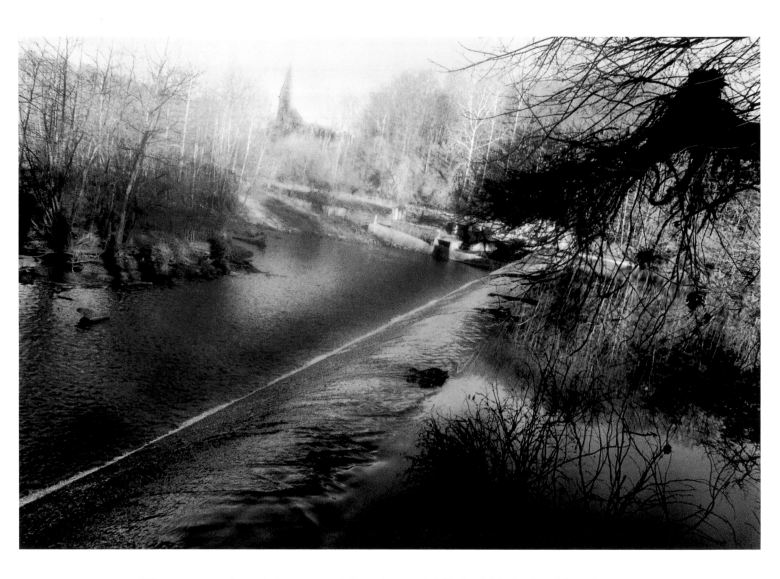

Wintry scene of Daniels Dam and Gary Memorial United Methodist Church, 2002.

DANIELS

You can easily miss the turnoff for Daniels Road. It sneaks up like an after-thought amid the crop of new homes spreading over hundreds of bald acres, homogenizing the landscape. An ordinary street sign marks the way in standard white on green. But this road is anything but ordinary.

Oldtimers still call it the Daniels Road, a verbal relic from the days before sprawl when you knew town from country, and when a road told you exactly where you were going—or where you were coming from, whether Hanover or Hollofield, Frederick or Sykesville. Like those other old Maryland highways, Daniels Road orients to a place, promising both route and destination. Also like the others, it traces to a simpler, less cluttered map from a time when there were fewer places and fewer ways to get there.

It is the lead to a story, a portal into the past: *Once there was a place called Daniels at the end of this road.* Now the road remains, but Daniels simply isn't there.

In 1840, a century before the name Daniels was affixed to the place, the Elys-ville Manufacturing Company built a textile mill here, where the Patapsco plunged over a falls and where the river's course kinked, posing a challenge to the B & O. Its main line ran through Elysville, following a course that caused trains to screech around an eighteen-degree curve, close to the river at the foot of a steep, rocky hill. The railroad tried several realignments, including building two bridges to run the track across the river, which succeeded in slicing off the hairpin and eliminating the worst of the curves.

The mill changed hands and names many times, eventually adopting Alber-

ton after Jacob Albert, onetime mill owner. The name stuck even after James Sullivan Gary took over the Alberton Cotton Mills in 1861.

Alberton boomed, growing beyond the central mill and across the river—half in Howard County, half in Baltimore County, both sides linked by a couple of bridges, including a swinging footbridge for workers. The boom lasted through the Civil War (when the mill produced canvas tents for the government), through floods, and through World War I. But then business slowed down and Daniels nearly went bust during the Depression.

In 1940, the C. R. Daniels Company bought the whole works—mill, dam, village, and land—and gave the place its final name. Thanks to wartime demands for denim and canvas, Daniels revived and even enjoyed a period of post-war prosperity. Then, in 1968, the company, rather than bring the primitive workers' houses up to code, razed all the dwellings but kept the mill going. Four years later, the storm called Agnes turned the river against the town, flooding out what remained of Daniels' industry and the bridge. When the waters receded, they left behind a lost place. In an event of redundancy, a fire gutted the remnants of the main mill in 1978.

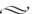

Today, the road winds down through the woods toward the river. Obscured by the trees, the Patapsco rushes into view at the concrete dam. From the foot of the falls, it disperses over smooth river rocks, past exposed boulders and around the ruins of a bridge. These remnant stone-block piers, supports for a B & O span, are now islands, isolated by the waters over which they were meant to prevail. Once linked to the front line of the land, they stand abandoned in midstream, testaments to the river's latent destructive energy.

Just beyond the dam, the road dead-ends at a chain-link fence. Behind the fence is a hillock of mulch and baled straw. To the left, beyond the padlocked gate and the "No Trespassing" sign, new industry has taken root on the abandoned mill site. The names of the two pioneer enterprises, Eddie's Welding and the Mulch Factory, are posted on signs outside the fence. Nature, after all, renews itself in stages after a cycle of destruction. So, perhaps, a devastated place returns to life, slowly, in stages.

Nearby, a steep driveway curves up to a solemn, gray granite church. The pinnacle of the community, it was built in 1879 on a hilltop overlooking the village, no doubt to remind folks of the preeminence of the sacred over the secular and of the vigilant eye of God. Except for ruins, Gary Memorial United Methodist Church is all that remains of Daniels. The old church still commands the view here on Standfast Hill—an impassive witness to change, a rock of ages.

But even as a monument to the past, it bears new growth: a red brick addition

has sprouted from the stone and mortar on one side. People still come home to this church on Sundays, holidays, and reunions, and to mark life passages. Even the Daniels Band—one of Maryland's oldest, continuously running town bands, begun in 1879 and still going strong—gathers here to practice. The place that was Daniels may no longer exist, but the community still holds to center.

Behind the church, a little graveyard climbs the gentle, rock-strewn slope. The oldest of the simple headstones, many of them askew and the inscriptions too worn to read, date to the mid-1800s. In the middle of a weekday afternoon, there is stillness here on this hilltop. The absence of human voices gives the impression of silence, but it is the sort of silence filled with the sounds of wind and water and work.

The view from here is a composition in contrasts, an overlay of present on past against wooded hills: From the valley floor, striking mill ruins—a copper bell tower, a chimney stack, a stone wall—rise above featureless industrial boxes. Across the river and up the hillsides, signs of development appear through the trees. A line of new houses, higher than the church, crests the ridge.

At the foot of the hills, along the river, what once encompassed Daniels' north side has gone to trees and the state park preserve. Pretty though not pristine, the forest here is littered with the vestiges of a lived-in place, iconic traces that heighten its palpability. Those who come here today to fish or to hike walk with Daniels' ghosts.

If you observe well and let your eyes adjust, these signs of settlement become apparent: A mossy fragment of cement curbing in the grass beside the trail. The stone foundation of the old Catholic church embedded in a slope, with stairs now climbing to nowhere. The remains of a car half-buried in a ditch, its body a study in decomposition and metamorphosis. When left to time, nature reclaims place and the trappings of civilization.

Not all the signs are subtle: A little Pentecostal chapel stands in ruins, covered with graffiti, open to the sky. An exquisitely twisted vehicle rests in a glade flaunting patches of still shiny yellow paint and a spiky chrome ornament. Deeper in the woods, a vintage, powder-blue station wagon set amid the trees appears as surreal as a Magritte still life.

This is not a junkyard; why, then, has no one bothered to remove these objects and ruins? Perhaps because they remind that this is not a virgin landscape but hallowed ground with a human story. These objects, the everyday flotsam and jetsam of past eras, may be out of context but they are in place. A sculpture garden of tragedy and loss, they are part of the underlying narrative that runs through this junction of river and rock and earth—a narrative that preserves and celebrates the memory and identity of a community. *Once there was a place called Daniels…*

Bell tower and roof of the former St. Alban's Church, with ruins of a mill building, 1999.

Former mill building with a mound of wood chips and backhoe,
Mulch Factory, 2000.

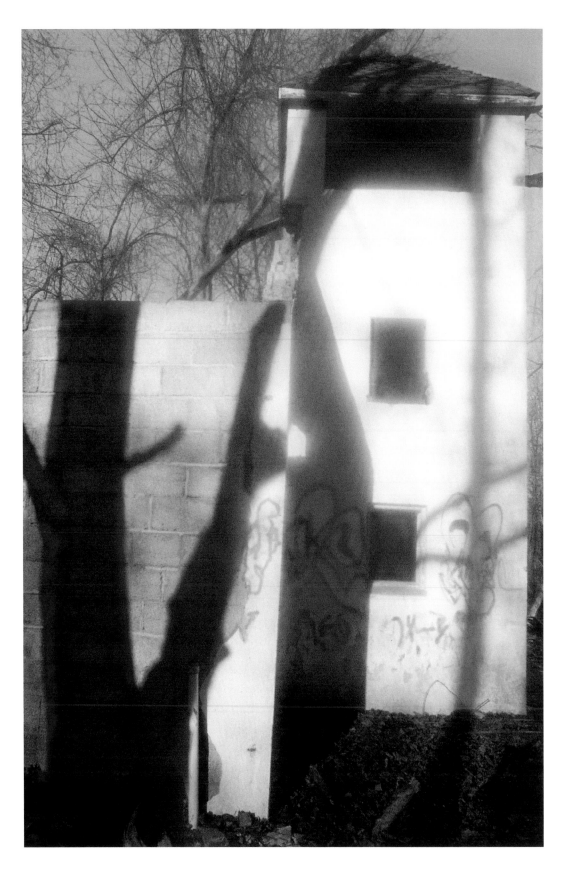

Ruins of a Pentecostal church, 2000.

An abandoned car, 2000.

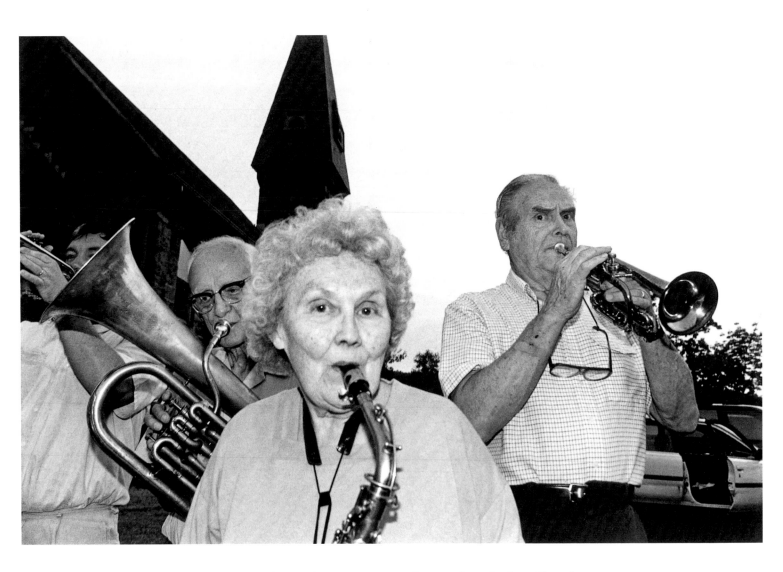

The Daniels Band outside Gary Memorial United Methodist Church, 1997.

Acknowledgments

If there was a moment of conception for this book, it happened back in 1997, the day we discovered Oella. The place, out of this world and utterly enchanting, grabbed hold and we were hooked. We had no idea, then, of the long journey on which we were about to embark.

A couple of independents who had not previously met, we teamed up to conduct a cultural survey for the Patapsco Heritage Greenway (now the Friends of the Patapsco Valley and Heritage Greenway, Inc.), a nonprofit group dedicated to preserving and interpreting the valley's cultural and environmental resources. The Maryland Historical Trust provided funding for the project. Our task was to document, through interviews and photographic portraits, twenty-five living tradition bearers in the stretch of the valley between Union Dam and Elkridge. As it turned out, however, we used up our quota and then some and never got beyond Oella and Ellicott City; the mine was that rich. And so we extended the project for a second phase, pushing on to Elkridge and Relay and Daniels.

We might have parted with the Patapsco in 1999 after completing our field-work and delivering our documents: oral histories, transcripts, notes, and photographs. But we weren't done—or rather this project wasn't done with us. Propelled by its own kinetics, it shifted shape, spinning off new incarnations: exhibits, symposia, storytelling events, community theater, and, finally, this book. Eleven years out from that first foray to Oella, it marks the finish of a long-distance run.

We have many people to thank for helping and encouraging us along the way:

In the beginning, there was Elaine Eff, director of the Cultural Conservation Program at the Trust. She introduced us to the Patapsco and stood solidly behind us for the duration, our rock. Were it not for her passion and commitment, her smart and perceptive counsel, who knows where we'd be.

Charles Wagandt—president of the Oella Company, and a founding member and first chair of the Greenway committee—entrusted us with his pet project and let us run with it. His door was always open, his hand always extended. It has truly been our pleasure to work with him. We also wish to thank John Slater, Kit Valentine, Sally Voris, and the rest of the Greenway group for inviting us to join them in their good work.

Writer Paul Hendrickson greased the wheels of production: He saw a book in the raw and sent us, with his blessings, to Ralph Eubanks, author and director of publishing at the Library of Congress. We are grateful to Ralph for taking us in and acting as our mentor and advocate. And we are honored that our book opens with Dr. Robert Coles's thoughtful words—a gift indeed.

Others have generously offered professional advice and support: every author should have a deft and gentle front-line editor like Michael W. Fincham, who clocked countless hours on multiple drafts. With his fine sense of story and language, his bold fixes and fine-tuning, he made the text sing. Leah Bendavid Val guided us as we packaged and promoted our work to prospective publishers, while Merrill Leffler proffered insider tips on the business of publishing. Jack Greer, Ed Orser, and Louise White each made insightful suggestions on style or content, while Sue Lanman delivered perfect transcriptions. With his artful touch, designer Stuart Armstrong put the Patapsco on the map, beautifully. And, of course, we are grateful to our publisher, George F. Thompson, founder and director of the Center for American Places at Columbia College Chicago, for loving our book and offering us a place at the table.

Fundraising was a critical part of the process. David Adler helped to launch our effort in Howard County. George Floyd, Robert Jeffrey, Mary Ann Scully, Henry Stansbury, and Addison Worthington offered valuable contacts and suggestions. The talented Marty Ittner, designer of our brochure and peripherals, made us look good on paper.

Several fine venues invited us to exhibit our Patapsco photographs and narratives. We are grateful to Cynthia Wayne and Tom Beck, who gave us an elegant show and an opening symposium at the Albin O. Kuhn Library and Gallery, University of Maryland–Baltimore County. Our thanks also go to Howard County Center for the Arts and Enoch Pratt Free Library. We are honored that our project was selected by the Library of Congress to represent Maryland's grassroots heritage in the 2000 Bicentennial Program, *Local Legacies*, and for its place in the library's permanent archives.

This book could not have been published without the generous financial support of individuals, businesses, and institutions in the greater Patapsco community. Their names are listed separately. We would like to thank Laurie Baker Crosley and the Baltimore Community Foundation for acting as our fiscal agent; Rory Turner and Theresa Colvin at the Maryland State Arts Council; and Evie Cohen, Nicole A. Diehlmann, and Ruth Scheler at the Maryland Historical Trust. A special nod goes to the Trust's Orlando Ridout V, who saw gold in the black-and-white photographs of Oella residents displayed at the former Methodist church and inspired folklorist Elaine Eff to approach Charles Wagandt and start digging.

We gratefully acknowledge these legislators for their endorsement of our project: U.S. Senator Paul Sarbanes; Maryland state senators Edward J. Kasemeyer and Allan H. Kittleman; and delegates Gail H. Bates, Elizabeth Bobo, Steven J. DeBoy, Sr., James E. Malone, Jr., and Warren E. Miller.

For their help with this and that, we thank Robert Beringer and Howard Saltzman of the Howard County Department of Public Works, Jane Brown, Mark T. Duigon of the Maryland Geological Survey, Arthur Houghton, Amber Lautigar, Lenore Lautigar, Dr. Gary Rudacille, Brandy Savarese, and Bessie Walter. Many others have offered support over the years; you know who you are and we salute you.

Thanks go to our families and friends for their steady encouragement and love to the very end of the road.

Finally, to the people of the Patapsco, a special thank you—especially to those who so candidly shared their stories and memories with two strangers. We hope that their families will treasure this book as a celebration of their lives and legacies.

Caplan's Department Store on Main Street, Ellicott City, 2008.

Donors

Alex. Brown and Sons
BB&T Bank
BUCS Federal Bank
Citizens National Bank
Clarkland Farms
Consolidated Insurance Center
Kingdon Gould, Jr.
Arthur Houghton
Howard Bank
Howard Community College
Maryland Historical Trust
Maryland State Arts Council
Maryland Traditions
Joseph W. Mosmiller
Dessie and James R. Moxley, Jr.
Old Town Construction LLC
Reuwer Family Foundation
Patricia Rouse
Sandy Spring Bank
James R. and Barbara M. Schulte
Charles Skirven
Slater Associates, Inc.
Southern Management Corporation
Henry Stansbury
Irving Taylor
Taylor Foundation, Inc.
Charles and Mary Jo Wagandt
Whalen Properties

Index

About the Author, Photographer, and Essayist

ALISON KAHN is a professional folklorist and oral historian, writer, and editor. A graduate of Middlebury College and a former Peace Corps volunteer in Benin, she holds a master's degree in folklore from Memorial University of Newfoundland. Her first book, *Listen While I Tell You*, recounts the story of the Eastern European Jews who settled on the island. From this came a radio documentary, which she coproduced for the Canadian Broadcasting Corporation. Her fieldwork includes major cultural documentation projects for the Maryland Historical Trust, North Carolina State Arts Council, Virginia Foundation for the Humanities, and Reginald Lewis Museum of African American History and Culture in Baltimore. She was the editor for several books on regional culture or oral history. Formerly on the editorial staff of National Geographic Society's *Traveler* magazine, she has contributed, as a free-lance writer and editor, to numerous National Geographic Society books and publications and has also written for the Smithsonian Institution, Discovery Communications, and Time-Life Books, among others. In addition, Kahn has worked as an associate documentary producer and created award-winning exhibits. Currently an editor at American University, she and her partner, writer and documentary producer Michael Fincham, live—and sometimes work— together in Takoma Park, Maryland.

PEGGY FOX came to photography following her training as a painter at Moore College of Art in Philadelphia, where she grew up. After relocating to Baltimore and serving nine years as director of the art department at St. Paul's School, she embarked on her career as an independent photographer. Largely self-taught, she has balanced her time between assignment photography and fine art, the one people-oriented and the other experimental. The former has allowed her access to many different worlds—corporate, educational, industrial, and institutional—and a variety of applications, including publications, portraiture, and documentary. In her fine art, Fox combines photographic images to create a range of pieces, from painted gelatin silver prints to mixed media on aluminum panels. Early in her career, Fox was featured in a one-person show at the Baltimore Museum of Art. In 1977, she created "Lost in the Cosmos," a 10-by-100-foot mural commissioned by the Maryland Transit Administration for the Johns Hopkins Hospital Metro station. She has received two Maryland Arts Council grants, and her work is exhibited nationally. Fox and her husband, Arthur Houghton, live in Cockeysville, Maryland.

ROBERT COLES is a Pulitzer Prize-winning author, child psychiatrist and medical doctor, and professor of psychiatry and medical humanities at Harvard Medical School. Called a national treasure by some, Coles was awarded one of the first MacArthur Foundation fellowships in 1981 in recognition of his remarkable breadth and creativity, and, in 1998, he received the Medal of Freedom from President Bill Clinton. Best known for his explorations and documentation of children's lives—notably the *Children of Violence* series,

for which he won the Pulitzer in 1973—Coles has resisted professional pigeonholing, variously identifying himself as teacher, oral historian, social anthropologist, and storyteller. A founding member of the Center for Documentary Studies at Duke University, he was cofounder and editor of *Dou-bleTake* magazine, which featured photography and writing about ordinary people and their lives in the documentary tradition. A prolific author, Coles has written literary criticism, biographies, reviews, poetry, social commentary, and children's books. He resides in Concord, Massachusetts.

ABOUT THE BOOK:

Patapsco: Life Along Maryland's Historic River Valley is the fifteenth volume in the *Center Books on American Places* series, George F. Thompson, series founder and director. The book was brought to publication in an edition of 750 clothbound and 2,250 paperback copies with the generous support of the Maryland Historical Trust, the Friends of the Center for American Places, and other donors who are listed on page 253, for which the publisher is most grateful. The text is set in Trump Mediaeval, and the paper is Grycksbo matt art, 150gsm weight. *Patapsco* was printed and bound in Singapore. For more information about the Center for American Places at Columbia College Chicago, please see page 262.

FOR THE CENTER FOR AMERICAN PLACES
AT COLUMBIA COLLEGE CHICAGO:
George F. Thompson, *Founder and Director*
Brandy Savarese, *Associate Editorial Director*
Jason Stauter, *Operations and Marketing Manager*
Amber K. Lautigar and A. Lenore Lautigar, *Publishing
 Liaisons and Editorial Assistants*
Purna Makaram, *Manuscript Editor*
Glen Burris, *Book Designer*

The Center for American Places at Columbia College Chicago
600 South Michigan Avenue
Chicago, Illinois 60605-1996, U.S.A.
www.americanplaces.org

Distributed by the University of Virginia Press
www.press.virginia.edu

16 15 14 13 12 11 10 09 08 1 2 3 4 5

Library of Congress Cataloging-in-Publication Data

Kahn, Alison Joanne, 1954–
 Patapsco : life along Maryland's historic river valley / written by Alison
Kahn and photographs by Peggy Fox ; with a foreword by Robert Coles.
— 1st ed.
 p. cm. — (Center books on the American scene; 14)
 Includes index.
 ISBN-13: 978-1-930066-77-9 (hardcover)
 ISBN-10: 1-930066-77-5 (hardcover)
 ISBN-13: 978-1-930066-78-6 (pbk.)
 ISBN-10: 1-930066-78-3 (pbk.)
 1. Patapsco River Valley (Md.)—History. 2. Patapsco River Valley
(Md.)—Social life and customs. 3. Patapsco River Valley (Md.)—Biography.
I. Fox, Peggy. II. Maryland Historical Trust. III. Title. IV. Series.

F187.B2K34 2008
975.2'71—dc22 2008034127

PUBLISHER'S NOTES: This publication has been financed in part with
State Funds from the Maryland Historical Trust, an agency of the Maryland
Department of Planning. However, the contents and opinions do not neces-
sarily reflect the views or policies of the Maryland Historical Trust or the
Maryland Department of Planning. The epigraphs on page vii come from
the following sources: Stewart L. Udall paraphrasing Henry David Thoreau
in *The Quiet Crisis* (New York: Holt, Rinehart and Winston, 1963); John
Steinbeck, *The Grapes of Wrath* (New York: Viking, 1939); and Kwakiutl
Indian belief, as quoted to anthropologist Franz Boas. The line also appears
in Kim R. Stafford's poem, "There Are No Names But Stories," in *Places
and Stories* (Pittsburgh: Carnegie-Mellon University Press, 1987).

Frontispiece (page iii): Elaine Lynn, a teacher from Elkridge, peers through
the window of her family home in western Howard County, 1999.

Center for American Places

AT COLUMBIA COLLEGE CHICAGO

THE CENTER FOR AMERICAN PLACES is a nonprofit orga-
nization, founded in 1990 by George F. Thompson, whose
educational mission is to enhance the public's understand-
ing of, appreciation for, and affection for the places of the
Americas and the world—whether urban, suburban, rural,
or wild. Underpinning this mission is the belief that books
provide an indispensable foundation for comprehending and
caring for the places where we live, work, and commune.
Books live. Books endure. Books make a difference. Books
are gifts to civilization.

Since 1990 the Center for American Places has brought to
publication more than 320 books under its own imprint and
in association with numerous publishing partners. Center
books have won or shared more than 100 editorial awards
and citations, including multiple best-books honors in more
than thirty fields of study.

For more information about the Center, please send inqui-
ries to the Center for American Places at Columbia College
Chicago, 600 South Michigan Avenue, Chicago, Illinois
60605-1996, U.S.A., or visit the Center's Website (www.
americanplaces.org).